THE STORY OF THE
HOLY LAND

A VISUAL HISTORY

PETER WALKER

LION

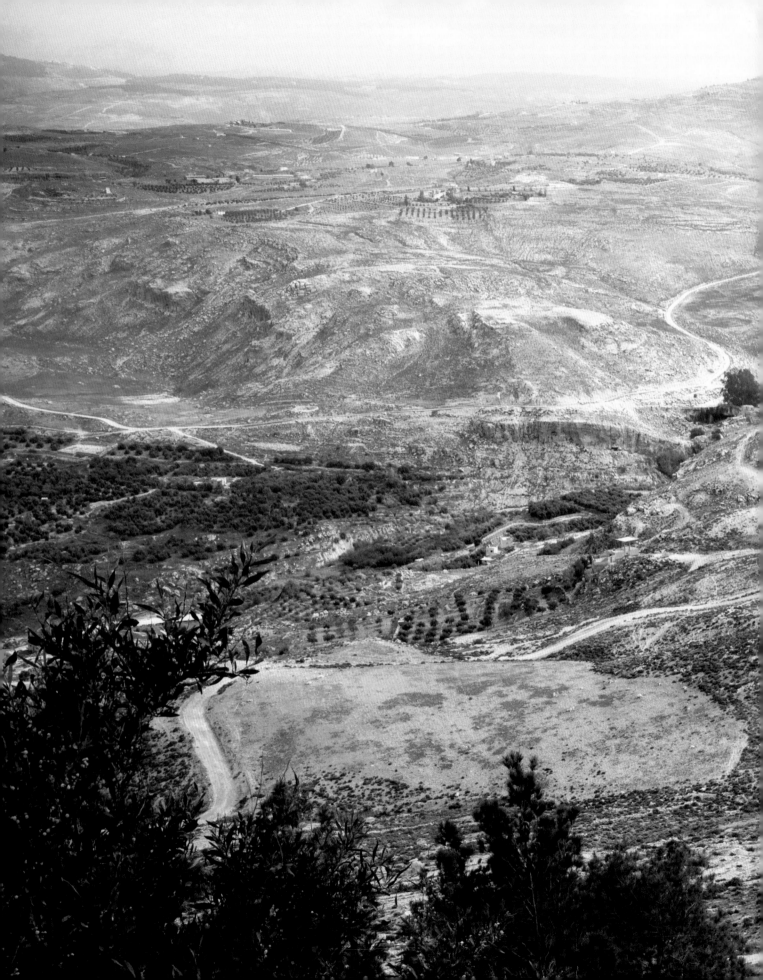

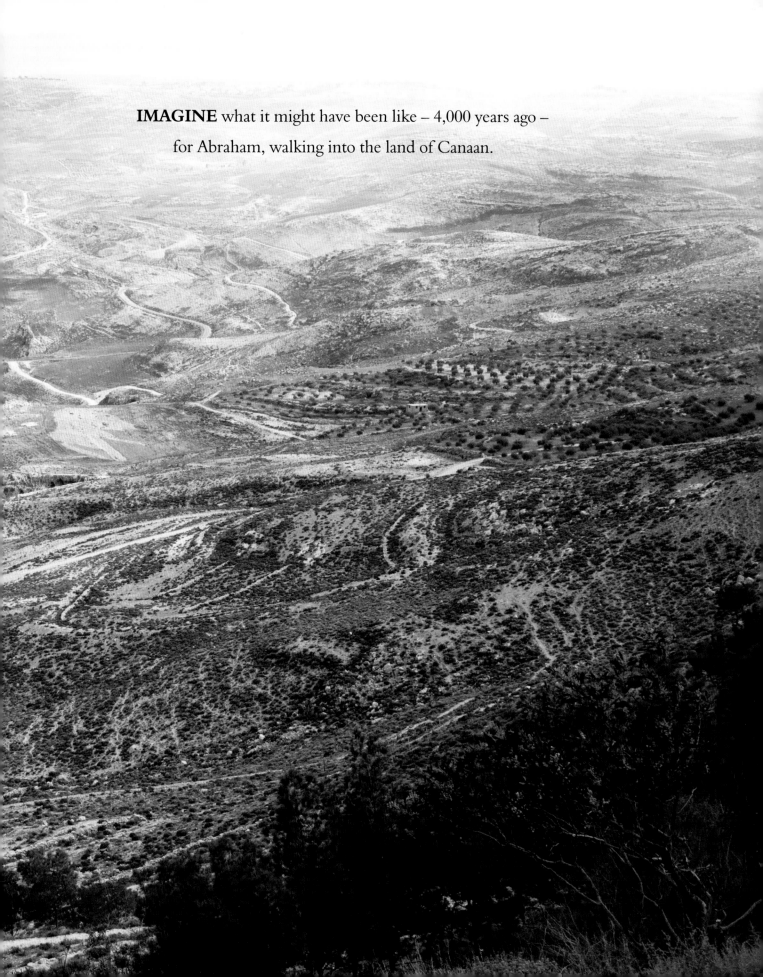

IMAGINE what it might have been like – 4,000 years ago –
for Abraham, walking into the land of Canaan.

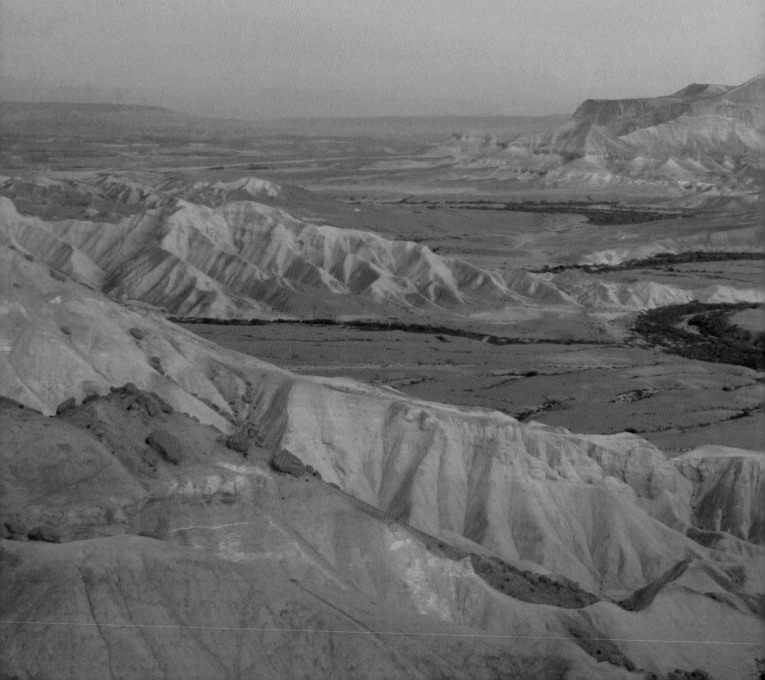

From its geography alone, he might have sensed

that this central hill-country would be strategic in the future:

bounded on the north by the solid massif of Mount Hermon,

and on the south by the vast tracks of the Negev desert…

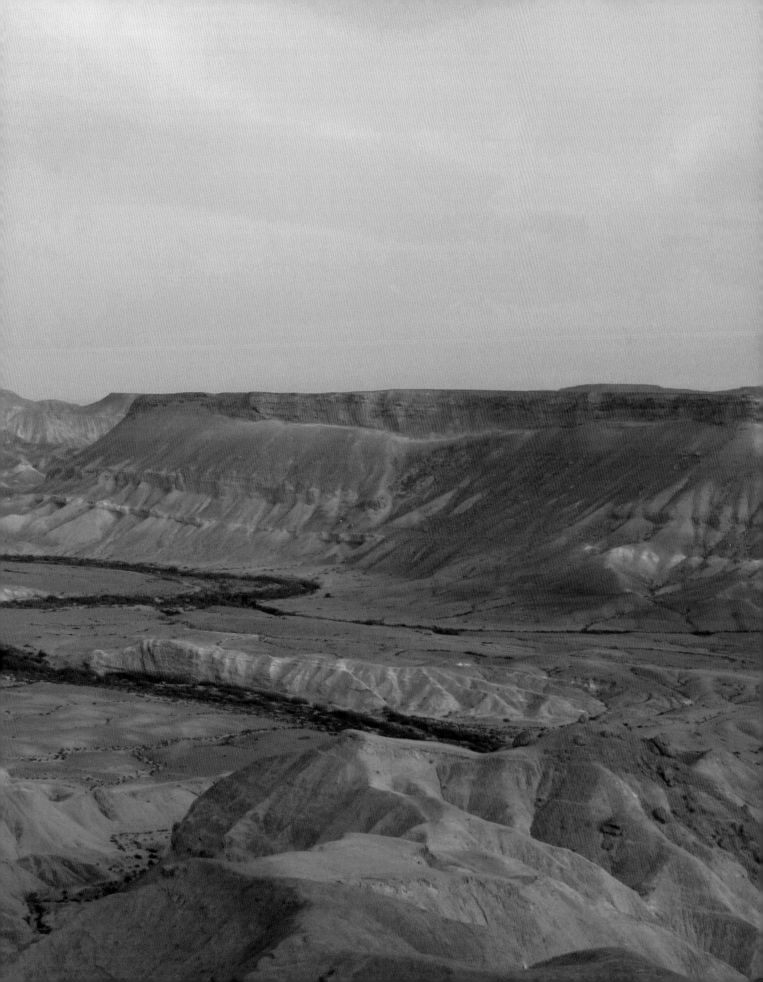

With the fresh waters of the River Jordan to its east
and the Mediterranean to its west,
this might well be an area
with some remarkable potential.

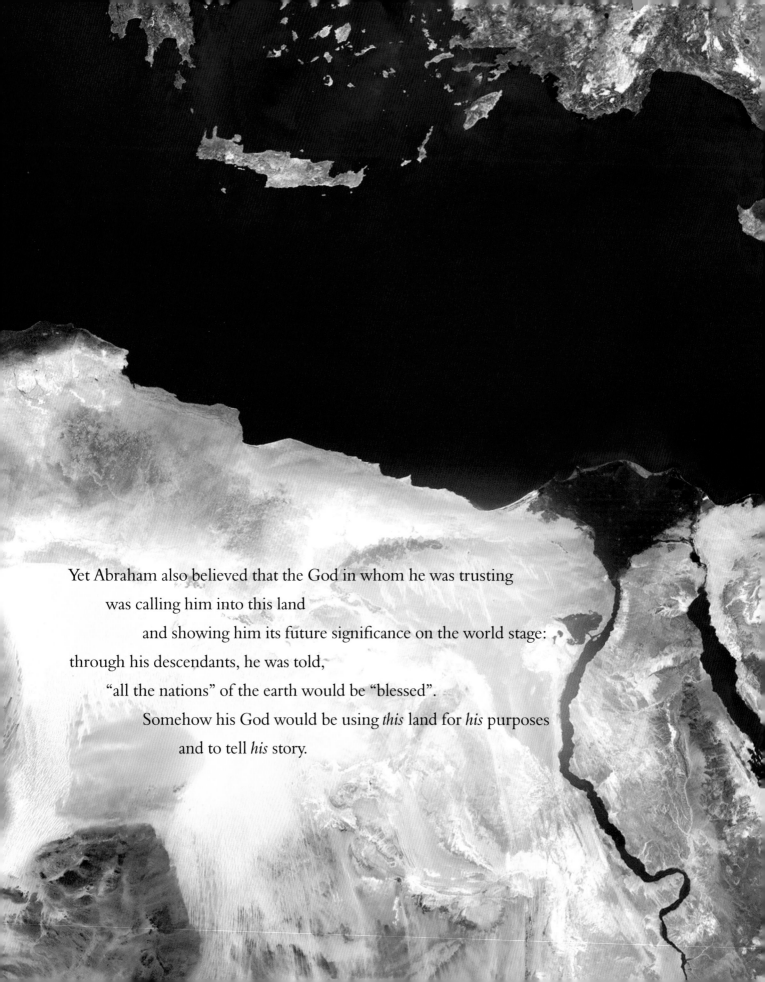

Yet Abraham also believed that the God in whom he was trusting

was calling him into this land

and showing him its future significance on the world stage:

through his descendants, he was told,

"all the nations" of the earth would be "blessed".

Somehow his God would be using *this* land for *his* purposes

and to tell *his* story.

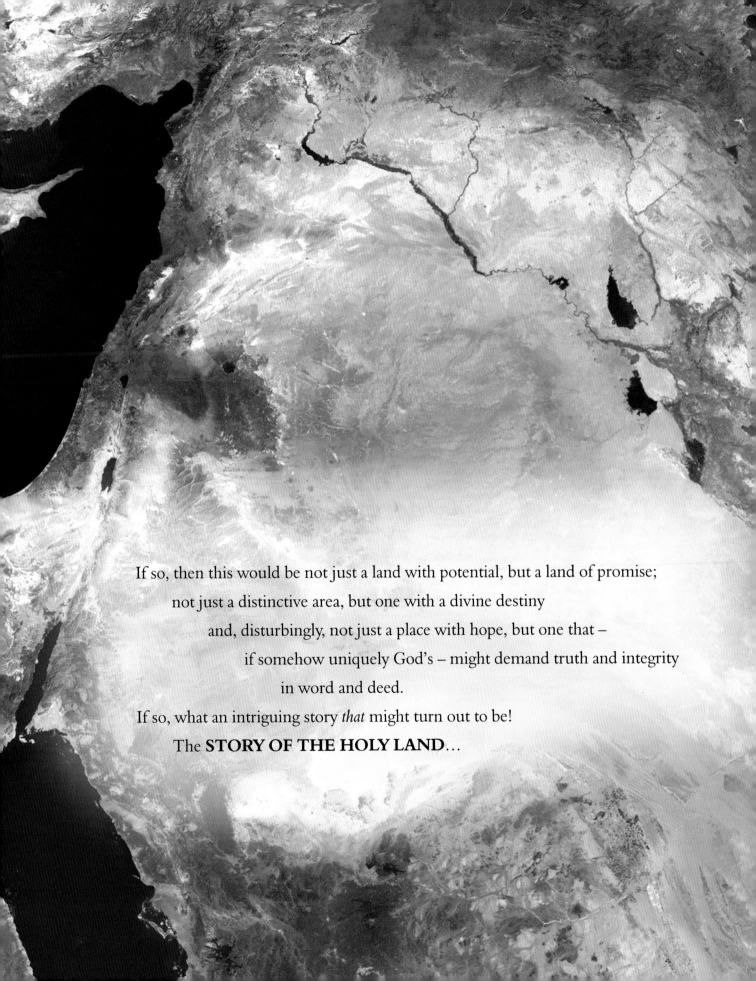

If so, then this would be not just a land with potential, but a land of promise;

not just a distinctive area, but one with a divine destiny

and, disturbingly, not just a place with hope, but one that –

if somehow uniquely God's – might demand truth and integrity

in word and deed.

If so, what an intriguing story *that* might turn out to be!

The **STORY OF THE HOLY LAND**…

THE STORY OF THE HOLY LAND: A VISUAL HISTORY

told in seven chapters, focused around seven key centuries...

1. Canaanites and Israelites (1950–1050 BC)

The Era of the Patriarchs **14**
The Conquering Century (1260–1180 BC) **22**
Settling in the Land **28**

2. Tribes and Kings (1050–587 BC)

The Era of Samuel and Saul **36**
The Crowning Century (1020–930 BC) **40**
Decline and Fall **46**

3. Refugees and Greeks (587–40 BC)

The Era of Exile **54**
The Returning Century (530–430 BC) **58**
Greeks and Romans **62**

4. The Crucial Century (40 BC – AD 70)

Herod the Great **72**
Jesus of Nazareth **78**
The Early Church and the Fall of Jerusalem **86**

2000 BC

1950 1050 4C

1050 587

587 4C

5. Romans and Byzantines (AD 70–630)

The Aftermath **96**
The Constantinian Century (AD 310–410) **100**
The Rule of Byzantium **108**

6. Muslims and Crusaders (AD 630–1291)

The Arrival of Islam **118**
The Crusading Century (AD 1099–1184) **126**
Saladin and the End of the Crusades **132**

7. Ottomans and Westerners (AD 1291–1948)

The Mamluks and Ottomans **142**
The Returning Century (AD 1820–1917) **146**
The British Mandate **154**

Since then... 164

Further Reading & Acknowledgments **172**
Map of the Holy Land **174**

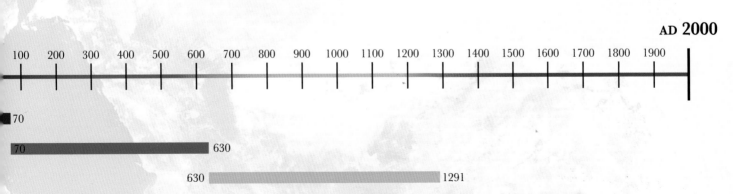

AD **2000**

100 200 300 400 500 600 700 800 900 1000 1100 1200 1300 1400 1500 1600 1700 1800 1900

70
70 630
630 1291
1291 1948

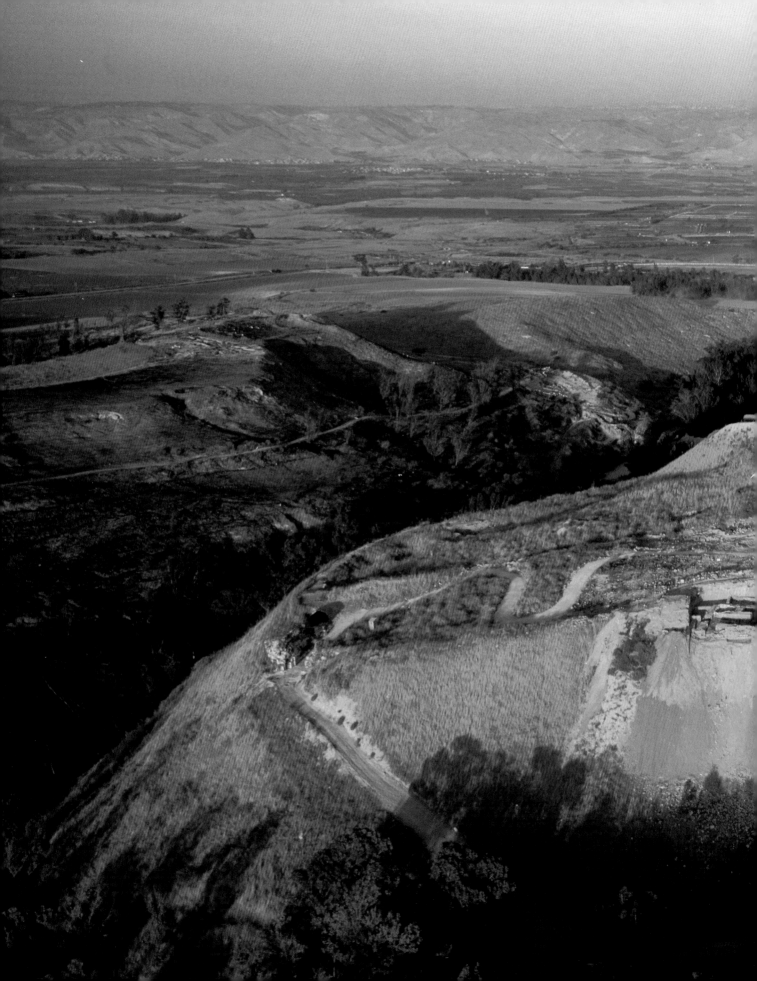

CHAPTER 1

CANAANITES AND ISRAELITES
(1950–1050 BC)

A man walks southwards into an unknown land.
Accompanied by his wife and the members of his clan, he is not entirely alone.
Moreover, he has his faith – faith in a God who has promised to guide him
on his journey and to give his descendants a place in that land
in the distant future.

The Era of the Patriarchs

That's how the Bible begins its own story of the "Holy Land" – the land that will be at the centre of all its subsequent dramas. Like all good stories, it is related to us through the lens of an individual and his family – in this case, Abraham and his wife Sarah – thereby enabling us to access these ancient events vividly. Our imaginations can immediately identify with these fellow human beings in their hopes and struggles.

They were coming into the land from the city of Haran (some 450 kilometres to the north), but their family had roots way over to the east – in the Chaldean city of Ur, located on the flat plains in Mesopotamia beside the great River Euphrates. How would this new land compare?

First impressions

Answer: it would be entirely different – almost in every way. As Abraham's family-clan made their way down the central hill-country, they would have been struck by its undulating hills (at that time substantially forested) and,

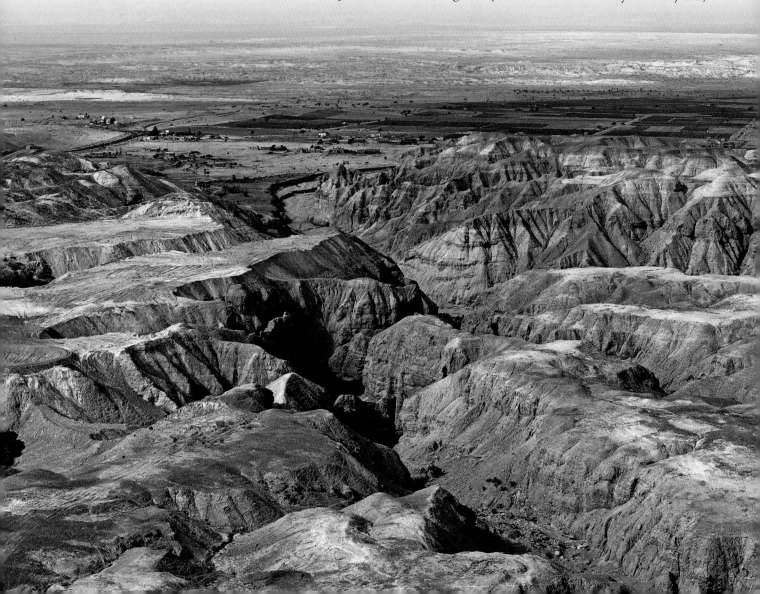

above all, by the fact that this was a region that received its water not from a river (as in their grandparents' home area) but primarily from the sky. For six months each year, there would be intermittent rain borne from over the Mediterranean on mild south-westerly breezes. This was a green and fertile land – irrigated from the heavens!

As Abraham would later discover (when visiting the area down by the Dead Sea), these prevailing winds also caused a rain shadow. As the hills sloped away to the east, the rain clouds would tend to evaporate, leaving below them a harsh desert. Yet this only made it clear that for a nomadic shepherd like him, the best places to travel would be along the ridge of these central hills: here there would be ample grazing for his sheep and goats and, if he stayed a while, some good opportunities to grow crops.

Left: The barren landscape to the south-west of the Dead Sea, associated with the story (in Genesis 19) of Sodom and Gomorrah.

. .

Right: A vast temple (dedicated to the god Nanna) built c. 2100 BC in the city of Ur – in modern Iraq or ancient "Mesopotamia" (that is, the "middle of the rivers" Tigris and Euphrates).

. .

Below: The fertile hill-country (together with the terraces built in the third millennium BC) which greeted Abraham.

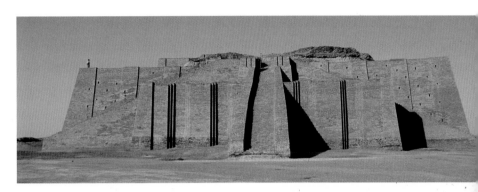

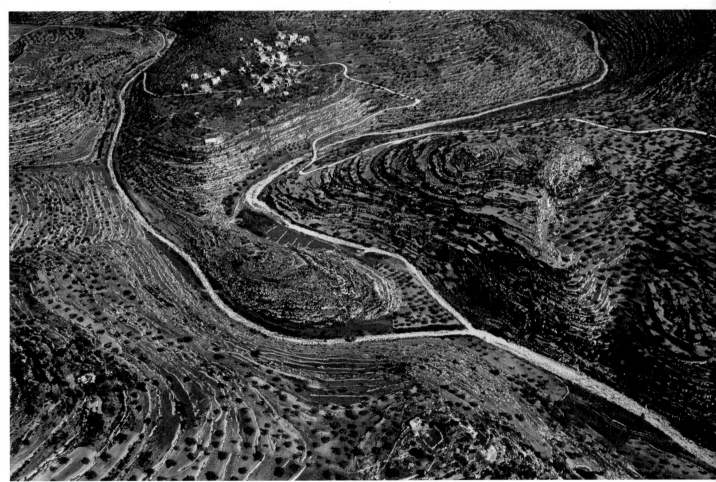

Stories from small places

That's why almost all the towns mentioned in the book of Genesis are located along the land's central "spine": Abraham builds altars in Shechem and Bethel; when his nephew Lot chooses to live in the Jordan Valley down by the Dead Sea (in the area of Sodom and Gomorrah), Abraham then spends much of his time in the area of Mamre and Hebron (where he and Sarah are eventually buried). We see the same pattern in his son Isaac, and in his grandsons Jacob and Esau, who at different times are in Shechem, Bethel, and Bethlehem. Both Abraham and Isaac also visit Beersheba (also on this central spine, but further to the south). The story shifts from this central hill-country only when Abraham and Jacob establish contact with their relatives back in the Haran region in order to find a wife from among their extended family (Rebecca being brought to Isaac, Jacob working many years to win the hand of Rachel).

To Abraham, however, all these towns would have seemed tiny when compared with Mesopotamia (for a millennium already the centre of powerful civilizations). By contrast, the largest city in this entire region was

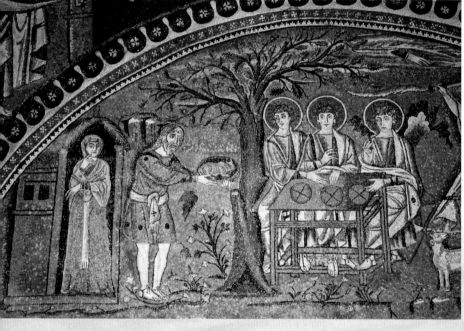

Left: The story of Abraham (with Sarah in hiding) offering hospitality by the oaks of Mamre to three guests (Genesis 18) has been taken by Christians as pointing to God as Trinity (here depicted in a fresco within the church of San Vitale in Ravenna, Italy).

..

Below: The town of Shechem (associated with Abraham and Jacob, but also the burial place of Joseph – see Genesis 12:6; 33:18–20; Joshua 24:32) rose to prominence in the nineteenth century BC; these walls (and the city gate) were built about 200 years later.

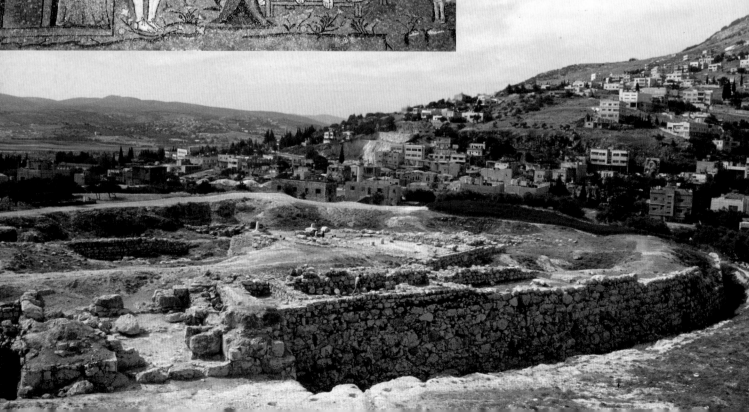

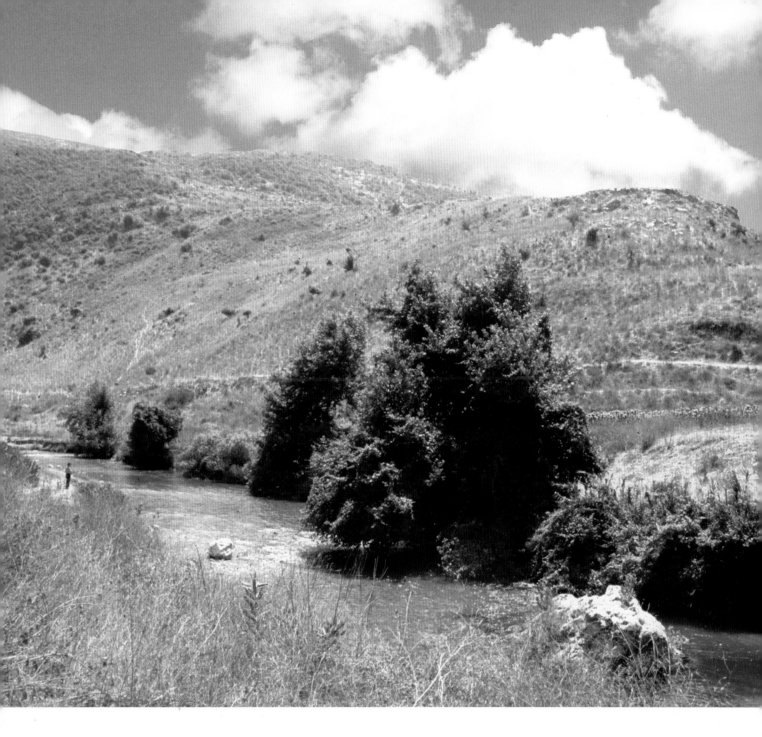

Above: Genesis 32–33 describes two key events in Jacob's life near the River Jabbok (to the east of the River Jordan), as he travels away from and then back to the Land: his encounter with God at Bethel and his reconciliation with his older brother Esau.

Hazor (see pp. 44–45), back towards Damascus; there was also a series of trading centres along the coast, with commercial links to the Mediterranean world and, above all, to Egypt. The hill-country, however, was far removed from the main trade routes. If anything, this green and fertile land was a deserted backwater.

Modern archaeological research has concluded that this land (known since before the year 2000 BC as "Canaan") had seen a significant drop in its population: falling from perhaps 150,000 inhabitants in 2700 BC to around 100,000 by the year 2000 BC. Those centuries at the end of the third millennium (now known as the Early Bronze Age IV) have thus been described as a "non-urban interlude" and as a comparative "dark age" – especially in this hill-country.

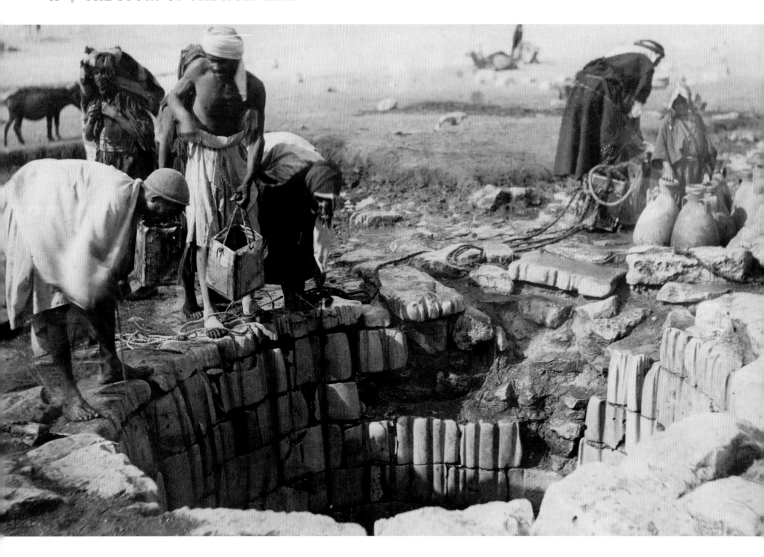

The reasons for all this are now obscure: if there were no military invasions, then perhaps there was some societal breakdown or a change in trading patterns. In any event, this is the situation that greeted Abraham and Sarah. So there may have been many others like Abraham – "Amorite" people (an Akkadian word for "westerners") coming down from the north who were content with a semi-nomadic existence. Abraham may have been part of a gradual population shift; the hill-country had become something of a vacuum waiting to be filled.

At this distance in time, inevitably, uncertainties remain about how we reconstruct this early history of the Land. Even so, the biblical tradition that the Israelites' ancestors migrated from Haran is strong: many generations later they would still recite the phrase, "A wandering Aramean was my father" (Deuteronomy 26:5, RSV) – because those whom Abraham left behind in Haran gradually began to speak Aramaic. As for the precise dating of Abraham's journey, there are several features about the Genesis stories which fit the general ethos of that Middle Bronze era: for example, the patriarchs' distinctive names (not repeated later in the Bible), their lifestyle as semi-nomads, and the political vacuum.

Above: This ancient well in Beersheba (here seen in November 1919) could well have been used by Abraham and the patriarchs (see Genesis 21:31).

Top right: Terracotta vase from Jericho, 1750–1500 BC.

Right: This archaeological trench at Jericho has revealed traces of a wall dating to 6000 BC.

Quiet centuries

Around the middle of the seventeenth century bc there is a small resurgence: there are now significant small cities beginning to flourish in Hazor, Ashkelon, Lachish, Jericho, Megiddo, Beth Shan, Gezer, and Shechem; yet only the last of these is in the hill-country visited earlier by Abraham. Significant developments seen in these cities include:

some very impressive fortifications (for Beth Shan, see pp. 12–13); enclosed cisterns and sophisticated drainage systems; numerous religious artefacts; and an increased number of civic buildings for the elite (with palace complexes being built in Hazor, Shechem, and Lachish).

Yet archaeologists detect another gradual decline in cultural development by c. 1500 BC. The reasons are obscure: possibly famine, or perhaps Canaan was adversely affected by the Egyptians' conquest of the significant trading centre of Avaris (in the Nile Delta) or especially when Pharaoh Tuthmosis III overran Canaan itself.

During the next 300 years (1500–1200 BC: known as the Late Bronze Age) these political changes would mean some comparative prosperity for those places on the main trade routes, which were overtly under Egyptian control, but the central hill-country of Canaan would continue its decline. Recent studies (drawing on the fourteenth-century Amarna letters) suggest that during this period there may have been up to thirty small city-states in Canaan, each about thirty kilometres from the next. Yet there were frequent border disputes between them, and the effective tax burden of Egyptian control caused a downward spiral in population numbers. Life was, as it were, haemorrhaging away from Canaan's central heartland.

It was into this situation, as we shall see, that some of Abraham's descendants – after having been forced to live outside the Land for many generations – would return.

Left: The small River Jordan, sometimes only 10–15 m across.

The Conquering Century (1260–1180 BC)

Five hundred or so years since the time of Abraham, his descendants found themselves in a strange, unexpected place – Egypt. They are now known as "Hebrews" but soon they will also be called "Israelites" ("Israel" had been a new name given to Abraham's grandson Jacob, because he "struggled with God"). The majority are living in the eastern end of the Nile Delta (called Goshen), working as slave labourers in bricks and mortar for the massive building projects of Pharaoh Ramesses II. How on earth had they got here?

Leaving the Land

Answer: famine. The land of Canaan, as we saw, could be fertile but, if the expected rains did not come, it was necessary to move on. Starting with Joseph (Abraham's great grandson), the clans associated with Abraham eventually migrated westwards towards the "breadbasket" of Egypt and the delta of the great River Nile. At least there you could rely on a predictable supply of water!

This migration may have occurred before or during what Egyptologists call the Second Intermediate Period (c. 1700–1542 BC), when Lower Egypt was taken over by the Hyksos ("rulers of foreign lands") – people who had migrated there from Asia. Their eventual expulsion by the native Egyptians – and the destruction of their commercial hub, Avaris – marks the launch of Egypt's so-called "New Kingdom" (the Eighteenth Dynasty). For the Israelites, however, it would mark a dramatic reversal in their fortunes: no longer welcome, they were seen as aliens – migrant workers ready to be exploited.

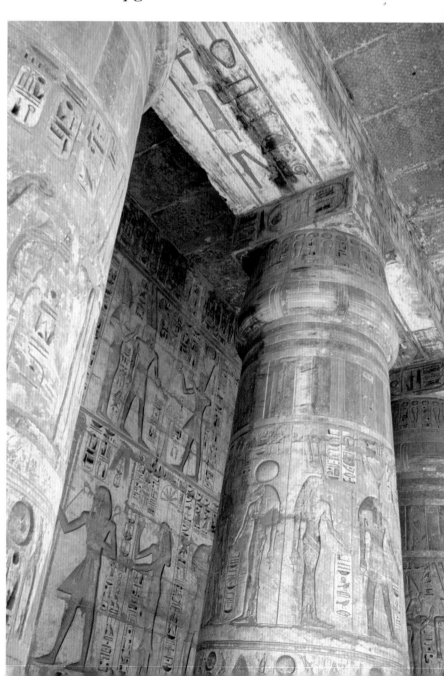

Right: Columns in the Mortuary Temple of Ramesses III (1186–1155 BC). Genesis 37–50 relates how Joseph (several centuries earlier), though sold as a slave, had emerged as Pharaoh's right-hand man, surrounded by all these signs of Egyptian power.

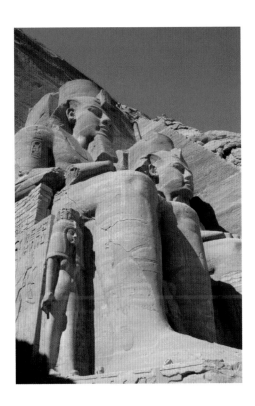

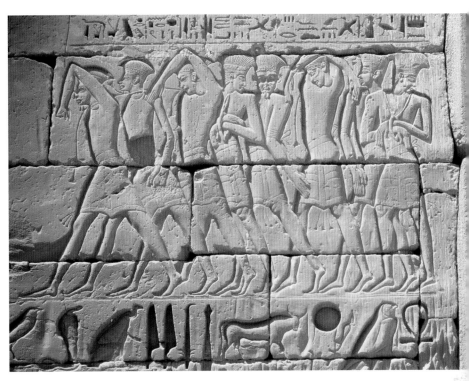

Intolerable pressure

Around 1320 BC Egypt's rulers began to rebuild Avaris. They urgently needed cheap, manual labour. Ramesses II then turned up the pressure in 1279 BC, launching his building campaign for a completely new capital named in his honour (Ramesses, or "Ramses" as in Exodus 1:11). By around 1250 BC the situation for the Israelites had become unbearable. Would their prayers to be delivered from this escalating oppression ever be heard? How could they escape?

Looking back on this, we see what a tall order this escape was. Their grandparents may have told them frequent stories of a fertile land to the east, but few had ever been there: were those reports over-exaggerated? The only feasible route towards this supposed Canaan was along the coastal road (the "Way of the Sea"), but this was heavily guarded by a long line of Pharaoh's outposts. As for Pharaoh being willing to let them go – the whole thing was impossible! But *not* – so they later claimed – if God was with them.

Above left: Four giant statues at the entrance to the funerary temple of Ramesses II (1290–1224 BC).

...

Above right: Stone relief of Philistine captives, depicted in the gateway of the Mortuary Temple (Medinet Habu) of Pharaoh Ramesses III.

Dramatic rescue

So begins the greatest rescue story ever told – the "exodus" (or exit) from Egypt. It's a tale of redemption; of delivery from slavery to freedom, involving power games and the eventual defeat of an oppressor. It is a tale of adventure, setting out into the vast unknown of an inhospitable desert and trackless wasteland; filled with acts of bravery and human frailty, stupidity, and unbelief; with amazing coincidences and miracles which those involved would interpret as revealing none other than the hand of their freshly rediscovered God. No wonder their children's children would continue to remember this episode for generations to come – celebrating it each year and re-enacting it as though *they* had been there. This was an epic, foundational event, without parallel – an event that would forge the Israelites' character and form their national and religious identity.

The drama begins with Moses (born to Hebrew parents but providentially brought up within Pharaoh's own household and thus given an Egyptian-styled name). Moses goes out into the desert by himself and has a fresh encounter with Abraham's God, now revealed by a new name, Yahweh ("I AM who I AM"). Charged with this new vision, Moses and his brother Aaron go back to Pharaoh, but feel very weak at the prospect of demanding the Hebrews' release. Suddenly, however, the land of Egypt

is afflicted by a series of nine natural disasters in the space of nine months (July to April). Pharaoh's resolve to keep the Israelites begins to weaken; eventually it collapses when Egypt's households (including his own) wake up to find their oldest sons have died – an event remembered as the Passover (when, according to Exodus 12, Yahweh "passed over" Egypt in a terrifying act of judgment, while sparing the children of Israel).

The Israelites then flee and are given a miraculous safe passage through the treacherous swampy area of the Sea of Reeds. Soon afterwards they are at Mount Sinai, where Yahweh reveals himself powerfully and gives the Ten Commandments – simple but ever-profound

rules to govern the worship and lifestyle of this newly redeemed people. A little later they are at Kadesh Barnea (only 110 kilometres from the southern end of the Dead Sea), but take fright at the report they hear back from some spies (whom Moses had sent to investigate the land of Canaan); so they are led on a more circuitous route – all described in the book of Numbers.

Below: Looking out over the Sinai Peninsula (through the window of space shuttle Columbia), we can sense the enormity of the Israelites' task.

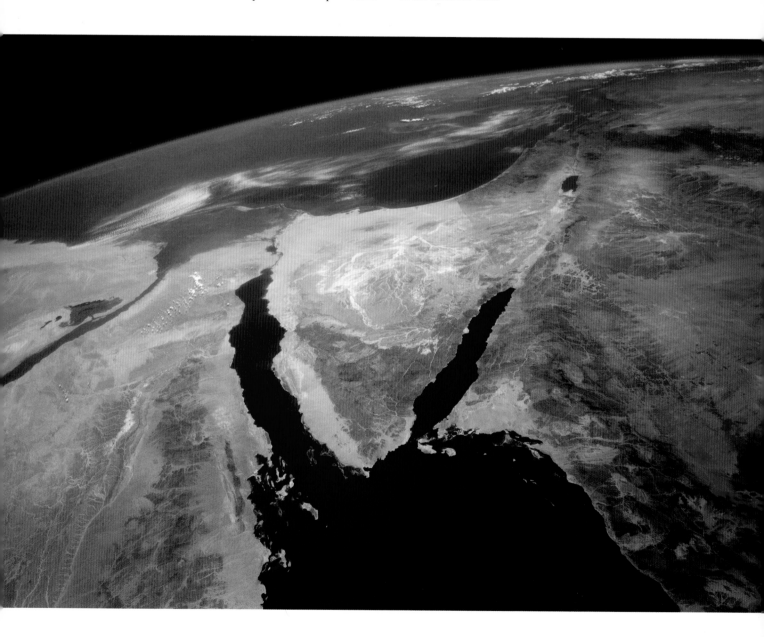

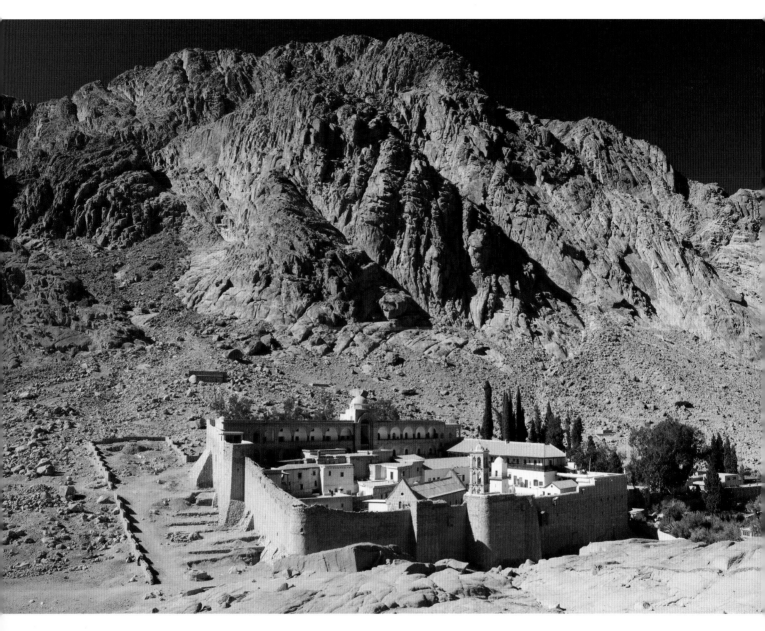

Above: The traditional site of Mount Sinai (Jebel Musa) in the south of the Sinai peninsula. St Catharine's monastery (Greek Orthodox: founded in the sixth century AD) contains the supposed site of the burning bush (Exodus 3:2), as well as a library containing priceless ancient texts.

Left: Wall painting (c. AD 245) from the synagogue in Dura Europa (in modern Iraq), depicting Moses and Aaron leading the Israelites through the Sea of Reeds.

Poised to enter

Eventually – indeed a whole generation later ("forty years" in the Bible's terminology) – they reach Mount Nebo, from where Moses and the Israelites could look out westwards and see at last the goal of all their journeyings: the Promised Land.

For this new generation of Israelites, there was perhaps a sense that the real challenge had only just begun: they needed to go down, cross the Jordan, gain possession of ancient Jericho, and then the small towns in the hill-country. This task, described in the book of Joshua (the name of Moses' successor as the Israelite leader), would require obedience and discipline, some limited fighting, and then much skill in cultivating the land.

For Moses, however, this was goodbye. The Israelites' great leader (remembered ever afterwards as the "friend of God" – see Exodus 33:11) would die before entering the Land. In a series of moving farewell speeches (in Deuteronomy) he therefore pleads with the Israelites that when they finally enter the Land, they should not forget the God who has redeemed them: "Love the LORD your God with all your heart and with all your soul and with all your strength" (6:5).

Above: One of the desert's flat rocky plains near Mount Zin (in the Negev desert, not far from the Israelites' camp at Kadesh Barnea).

Right: Seeing today what Moses saw: the view from Mount Nebo, looking down into the Jordan Valley and across to the hills of the "land of promise".

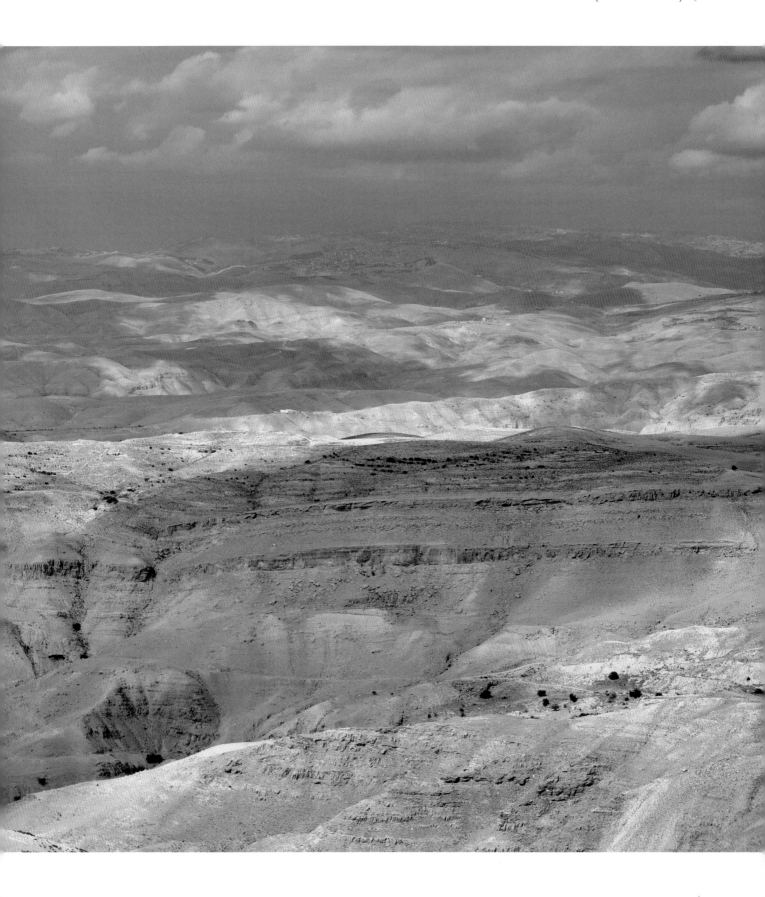

Settling in the Land

A young girl helps to bring in the harvest. It all looks so relaxed – as does the picture of young shepherds watching over their flocks, leisurely in the late afternoon sun. Yet there is something different about her. She is a foreigner, and has a determined look.

Rural tranquillity?

Her name is Ruth, and a whole book of the Bible gives her story: how, despite being from the enemy lands of Moab, she had come as a young widow to Bethlehem with her mother-in-law; how she eventually married the owner of that harvest field, Boaz, and gave birth to a son who became the grandfather of another shepherd boy – called David.

It is some 150 years after the Israelites had entered the Promised Land – and these idyllic scenes of rural life suggest all is calm. Yet it is not. The Israelites' first arrival had not been trouble free (see the book of Joshua); and now there are simmering tensions among the dispersed tribes as they develop the Land (see the book of Judges). There have also been famines. Has Yahweh forgotten them? Will he ever send a ruler to bring order out of this chaos? The author of Ruth gives a clear answer: yes, Israel's God is still at work – even in the events of daily village life – bringing about his purposes.

...

Shepherds with their flock of sheep near Bethlehem.

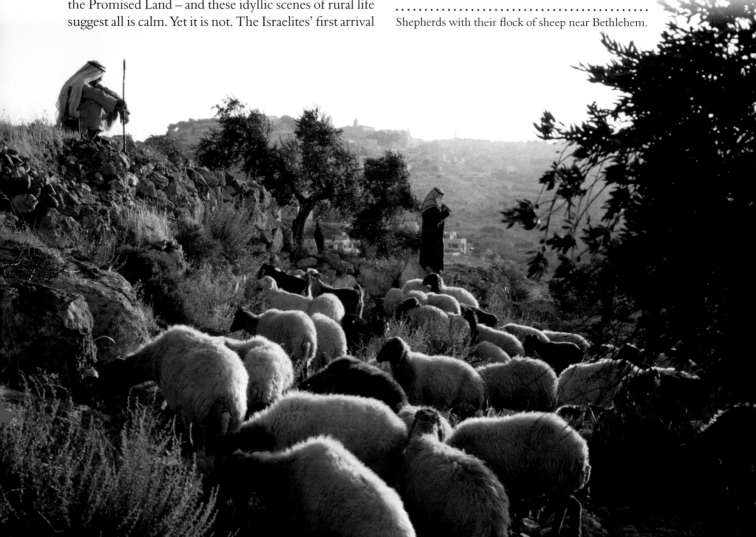

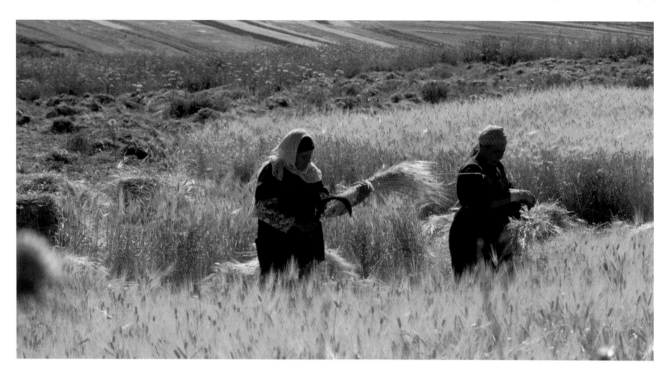

Population shifts

The Israelites had faced challenges as soon as they entered the Land. Although the central wooded hill-country was sparsely populated, the resident Canaanites in their small towns and villages had not readily welcomed these intruders. There were inevitable skirmishes in Jericho and Ai, then in the Hivite and Jebusite areas around Jerusalem, and also, many years later, as the Israelites pressed north. Thus one of the Bible's oldest and most dramatic stories describes how the Israelites (c. 1110 BC) seized the northern valley of Jezreel (vital for grain production) through the leadership of Barak and a skilful, plucky woman called Deborah.

Opposition also came from those on the western coast. Around 1180 BC the Sea Peoples (some fleeing from troubles in mainland Greece) had arrived, occupying five cities in the south-west of the Land. These different groups all needed places to live and lands to cultivate – leading to inevitable tensions.

A hundred years later the descendants of the Sea Peoples, known to us as the Philistines, would put significant pressure on the Israelites, now established in the hill-country. At some point during this period the members of one Israelite tribe (Dan), though originally allotted an area along the Mediterranean coast for their territory, decided to relocate to the far north (below Mount Hermon). It was evidently easier for the Israelite tribes to expand northwards, rather than westwards.

Above: Women gathering in the wheat harvest in the hills of Judea.

Right: Working on a threshing-floor on the terraced hillside just outside ancient Nazareth.

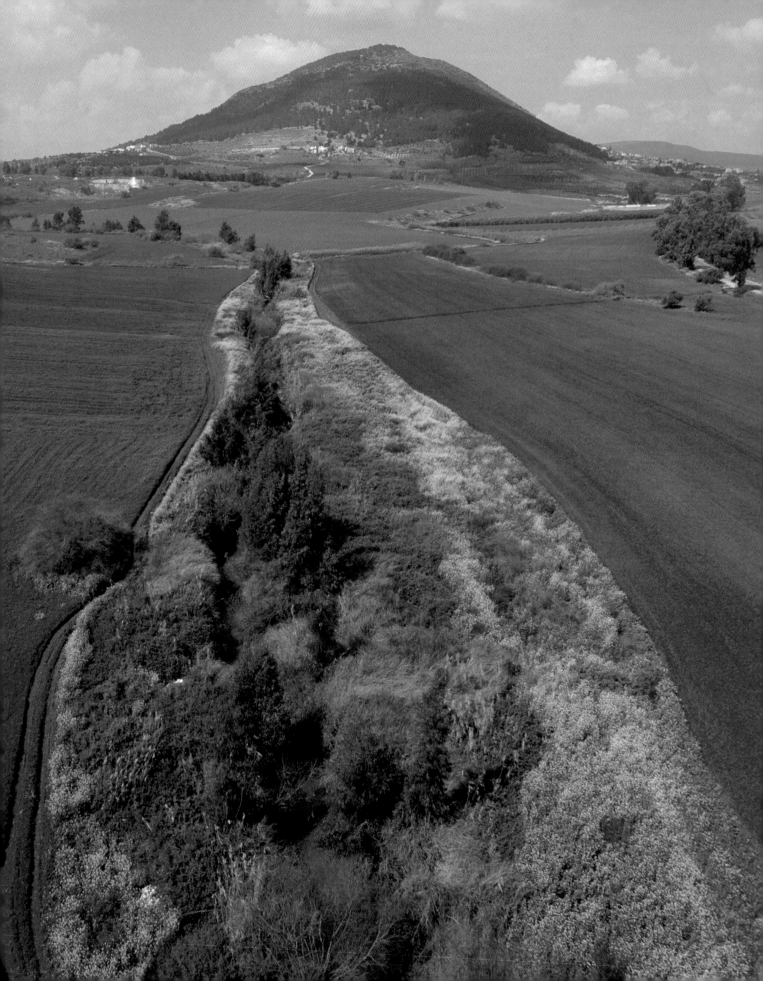

Telling remains

The archaeological evidence for this era is fascinating. Several towns show signs of being destroyed by fire; but these are spread randomly over a 200-year period and it is far from clear that these destructions were all caused by the invading Israelites.

However, there are clear signs of population growth – especially in the northern hill-country of Samaria (associated with the tribe of Ephraim). One archaeologist has estimated that by c. 1200 BC the number of villages and unfortified settlements here had jumped within a generation from 23 to 114, with a population growth from 14,000 to 38,000. Apparently the Israelites, even if they could not displace the Canaanites from some of their central towns, were settling in places not previously occupied. One key factor making this new habitation possible (amply attested by archaeology) was their novel use of covered cisterns (for storing water and irrigating the land), as well as their adding to the number of hillside terraces.

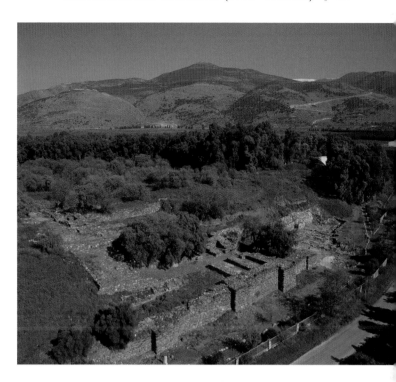

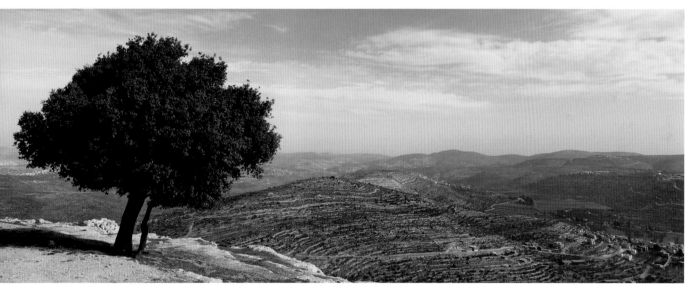

Above right: The northern settlement of Dan in the foothills below Mount Hermon.

Above: The distinctive terraced landscape of the northern hill-country, populated and cultivated by the Israelite tribe of Ephraim.

Left: 10,000 Israelite soldiers, commanded by Barak and Deborah, came down from Mount Tabor to defeat the Canaanite forces under Sisera in the Jezreel Valley (Judges 4–5).

Archaeology also suggests that in some ways there was no radical rupture in the culture: pottery styles remained similar – though perhaps showing a slight drop in the level of the craftsmanship. So in some towns, where presumably the Israelites took over without a fight, archaeologists cannot easily detect the change. However, some things do stand out. After c. 1200 BC none of the local temples are rebuilt, votive figurines cease to be made and, significantly, the number of pig bones discovered drops off dramatically. It seems that these newcomers did not eat pork.

Challenges and compromises

Evidently, then, the Israelites had brought their distinctive religious beliefs; they did not forget all the lessons so painfully learned in the desert. Thus during the twelfth century BC they establish Shiloh as their cultic centre – a fixed shrine for the previously portable tent, which had housed the "ark of the covenant". And presumably, if they stuck to their values, other residents in the land (or newcomers) who were attracted to this new Israelite faith might in time join their community.

However, compromise was always a danger – as Moses had warned. If things started to go well for them, Yahweh might easily be forgotten. Pagan worship and values, which made fewer moral demands, might creep back in, allowing religious syncretism. This would then be a far more long-lasting battleground for the Israelites than those initial military battles. Hence, at the end of his campaigns, Joshua gathers the tribes at a central location, Shechem, for an act of "covenant renewal"

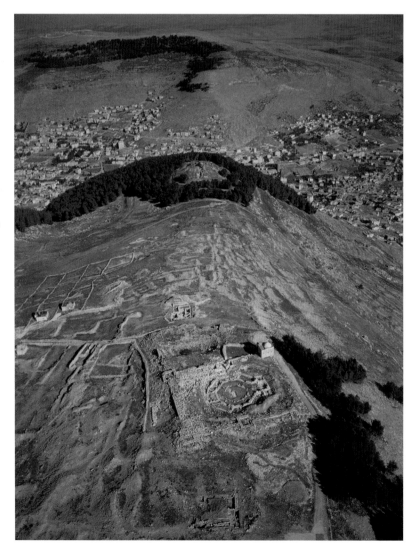

Above: The peaked hills of Shiloh, where Israel's ark of the covenant was kept in the centuries before Solomon.

. .

Left: Mount Gerizim (*foreground* – see also pp. 66–67), with Mount Ebal beyond, above the ancient site of Shechem (see p. 16).

. .

Right: "Israel is devastated," boasts Pharaoh Merneptah on this stone slab commemorating his victories. He reigned 1213–1203 BC.

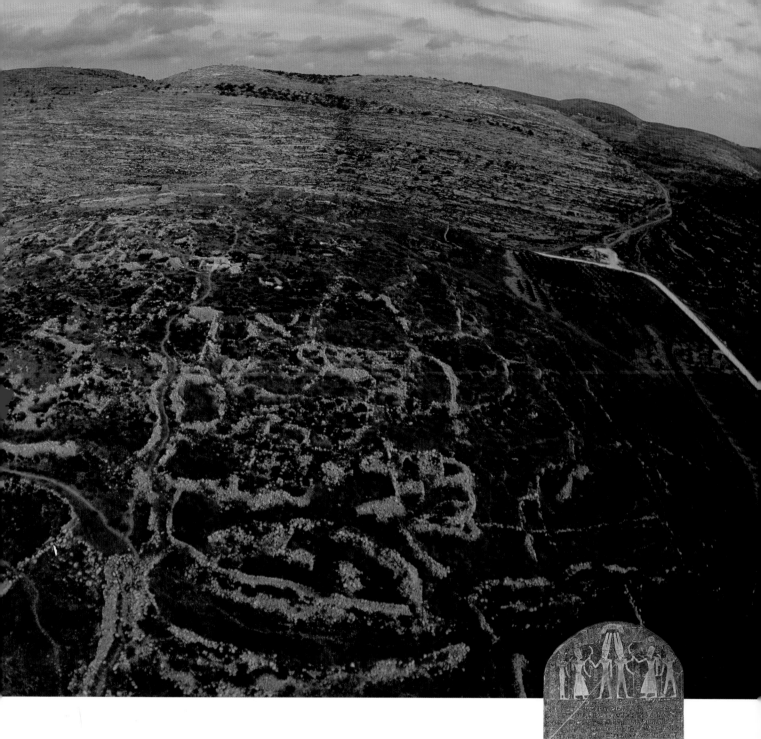

in the service of Yahweh (Joshua 24). Looking up at the distinctive twin peaks of Mount Gerizim and Mount Ebal, he challenges: "choose for yourselves this day whom you will serve" (verse 15).

"We will follow the LORD!" they affirm. Yet it would not always be so. The book of Judges relates how everyone "did what was right in their own eyes" (NRSV). Some leaders are seriously compromised – Samson, Jephthah, and even heroic Gideon. What the Israelites needed, on the human level, was someone who could give them a strong political and religious lead; someone who would draw them together as a nation and as the people who worshipped Yahweh.

That's why the writer of Ruth was so interested in what was happening in those fields outside Bethlehem...

CHAPTER 2

TRIBES AND KINGS
(1050–587 BC)

A woman stands, muttering.
Nearby an old man, seated on a chair, wonders if she is drunk.
In fact she is praying. She has come here annually to Yahweh's shrine in Shiloh,
longing that this time next year she will have had a child.
Next year, to her joy, a son will have been born.

The Era of Samuel and Saul

This is another tiny vignette in the long story of the Holy Land; but from such is its history made. Like Ruth a few years earlier in Bethlehem, so too this woman, Hannah, will give birth to a significant child – the prophet Samuel.

The quest for a king

This was a key time of transition for this emerging "nation". After nearly 200 years of the Israelites spreading throughout the Land, the time had come for some centralization. Samuel would grow up in Shiloh – with an old priest, Eli, as his guardian – and then, after being the tribes' effective leader himself, would respond to their insistent demands by anointing first Saul and then young David as their kings.

Had the people forgotten that they were meant to be ruled by God alone as their king (not a monarchy but a theo-cracy)? Were they rejecting Yahweh? Perhaps. Yet, through all the twists and turns (graphically described in the book of 1 Samuel), the biblical writers also sense that their God was taking his people's request, even if based on mixed motives, and using it to move things forward towards an even better outcome – the appearance of a godly ruler, David.

...

Below: The ruins of Shiloh – the sanctuary where the ark of the covenant was guarded, and where Hannah left Samuel under Eli's care (1 Samuel 1–4).

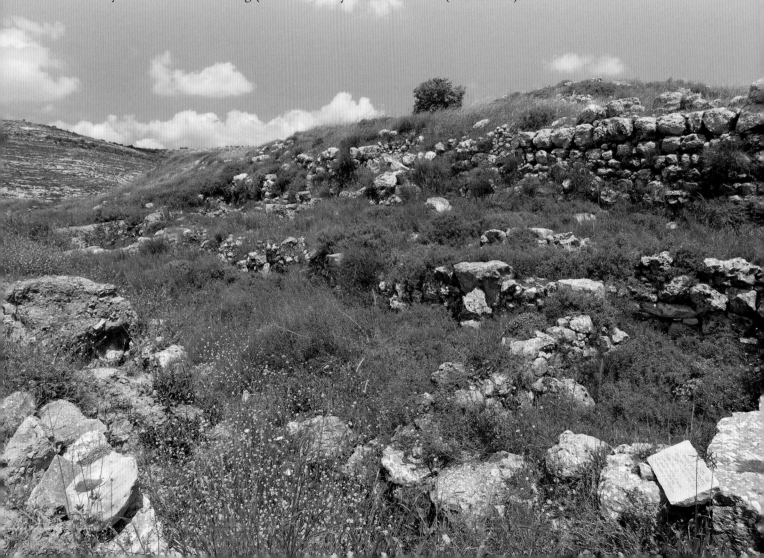

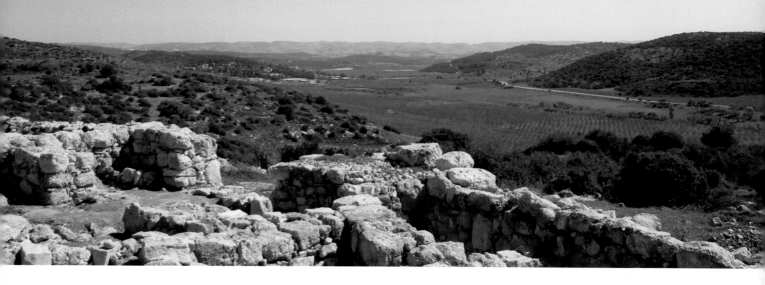

A constant enemy

The young nation was under fairly constant attack – both from the Ammonites, east of the River Jordan, and from the Philistines, in the low foothills to the west. Border disputes and skirmishes occurred regularly – with Samuel, Saul and his son Jonathan all having to fend off the enemy.

This conflict gave rise to some memorable stories. One concerns the ark of the covenant. Eli falls off his chair and dies after hearing the news that the ark (recently taken from Shiloh onto the battlefield for the Israelites' protection) has been captured by the Philistines and placed in one of their temples (dedicated to their god, Dagon). Yet, a few months later, there is great joy in the town of Beth Shemesh when its inhabitants see two cows coming towards them out of the Philistines' territory, pulling a strange load: the ark was making its way home, unsupervised!

Another concerns young David. Visiting his older brothers in the army, he responds to the taunts of the Philistines' hero, Goliath, as he challenges the Israelites to single combat. Disdaining any armour, David goes forward bravely, equipped only with some stones and his sling. The stone finds its mark – in Goliath's forehead – and the Philistine drops down dead. Israel's enemies flee and David's reputation starts to soar.

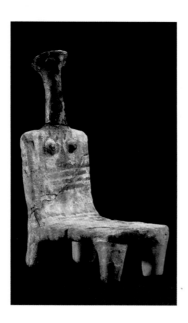

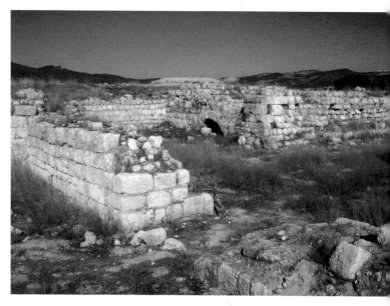

Above: The Elah Valley, where David fought Goliath.

.

Far right: Beth Shemesh (or "house of the sun"), where the ark was restored to the Israelites (1 Samuel 6:9–18).

.

Right: A small terracotta statuette (just under 13 cm tall) known as "Ashdoda", depicting a goddess worshipped by the Philistines in Ashdod (twelfth century BC).

Rivalry and tragedy

Yet King Saul, ever insecure and now secretly envious, cannot cope with this. For a while David is admitted into the royal court, but eventually flees for his life – hiding first in the Judean wilderness and then taking refuge, bizarrely, among the Philistines. It's the only safe place to escape the claws of Saul's enraged paranoia.

Saul's life had been marked by moments of brilliance and promise, but towards the end he acknowledged that he had played the fool. In his last forty-eight hours we see him terrified on the eve of battle, consulting a medium in his desperation to get the deceased Samuel's advice, and then going out to face the Philistines on the

hills of Gilboa, where he is critically wounded. He asks his armour-bearer to run him through with his sword but then does the deed himself.

It's a tragic end. And David too, though he is the king-in-waiting, is filled with grief: "O mountains of Gilboa... How the mighty have fallen... Saul and Jonathan... lie slain on your heights!" Yet it now clears the way for David to start his celebrated reign.

Below: Looking west towards the hills of Gilboa, where Saul and Jonathan died in battle (1 Samuel 31; 2 Samuel 1).

The Crowning Century (1020–930 BC)

So a new king is crowned. With the death of Saul, David can return to his own land and begin to exercise his leadership. To begin with, this is only in the south (for seven years he is based in Hebron, the burial place of the patriarchs), but gradually he wins over those further to the north who have remained loyal to Saul's descendants.

So began David's pivotal rule over all the tribes of Israel – an era later considered the high-water mark in their history. Under David (from c. 1010–970 BC) and then his son Solomon (c. 970–930 BC) the people of Yahweh were united under strong central leadership and controlled a vast region – with tribute being paid by foreign peoples living beyond Damascus and even on the Euphrates.

David's jewel: Jerusalem

The dispersed tribes were now brought effectively into one nation, and it needed a new capital. In a brilliant strategic move – like a master builder dropping a capstone into the top of an arch – David united the northern and southern parts of his kingdom by establishing Jerusalem.

For centuries *Jeru-shalaim* (or "city of peace") had been a Jebusite town – a Canaanite enclave surrounded by expanding Israelite tribes – but David dispelled the Jebusites and started to build his palace there. By modern standards this "City of David" was minuscule – a narrow spur of land approximately 100 metres wide and 300 metres long – but it had the great advantage of being easily defended (surrounded by steep valleys on every side except to the north), and of having a continuous supply of fresh water immediately to the south. Its position on the central spine of the country made it the ideal place for David to establish his rule.

Right: The City of David (on the Ophel Ridge), surrounded by the Kidron Valley (*to the right*) and the Tyropean Valley (*left*), with the Temple Mount area in the distance to the north.

. .

Left: The hill-country within the tribe of Judah (15 km to the south-east of Jerusalem), looking towards the village of Tekoa (*middle distance on left*). Joab engineered a visit to David from a "wise woman of Tekoa" to persuade him to re-admit Absalom to Jerusalem.

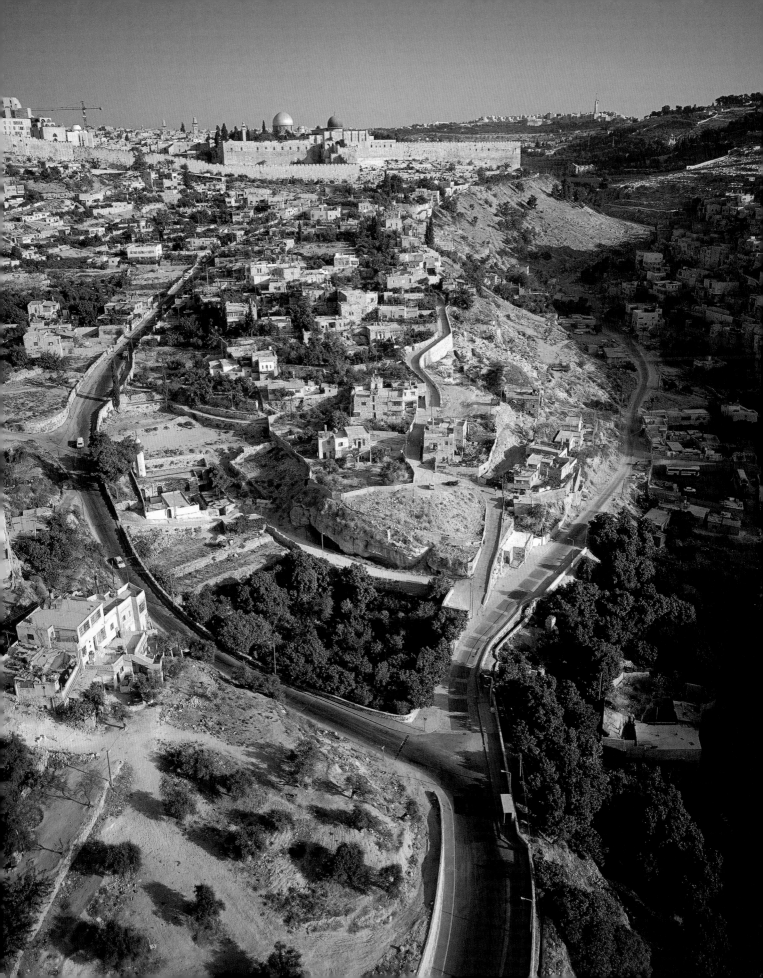

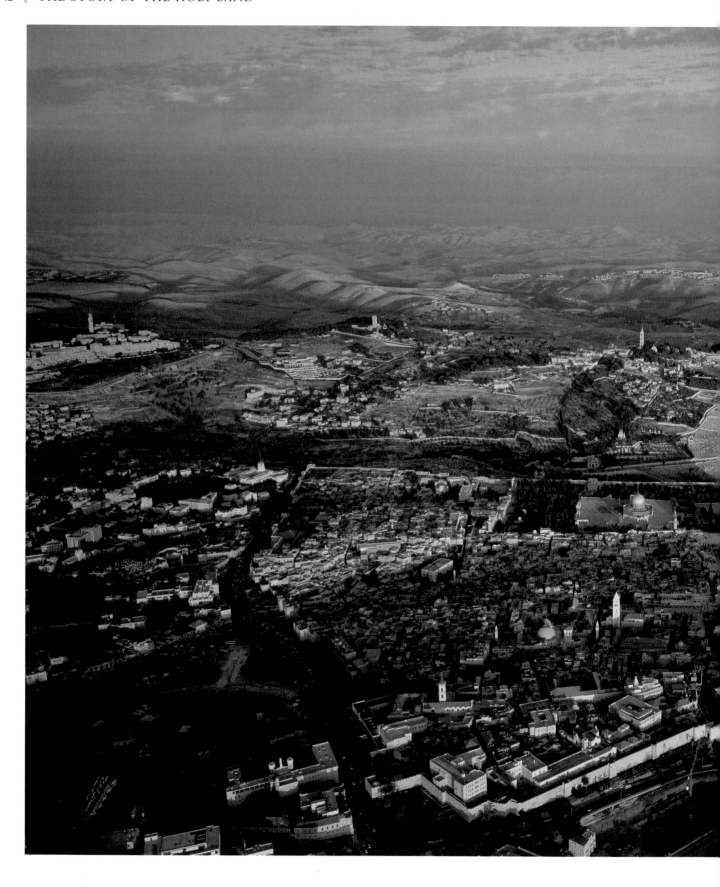

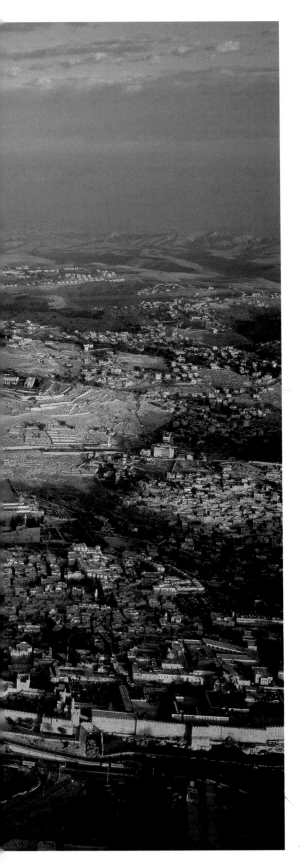

Troubles at home

Yet not all was peaceful. David could defeat both the Philistines and the Ammonites, but Israel itself was uneasy. Civil unrest needed a strong hand. Reading the vivid account in the book of 2 Samuel, it seems David, the successful warrior-king on foreign fields, hoped he would not have to fight for peace at home. Tough actions were normally deputed to his commander-in-chief, Joab.

There were also problems within the royal court and within his own family – not just his adultery with Bathsheba and his ensuring the death of her husband, Uriah. There was the bitter rivalry between his sons, and uncertainty over the succession. One of his sons, Amnon, rapes the sister of his older half-brother, Absalom, who promptly murders Amnon. Absalom flees from his father but after three years David relents and allows him back into Jerusalem. Father and son do not meet for a further two years, after which Absalom rebels and seizes the throne in Hebron. David flees – over the Mount of Olives and into the desert. Absalom promptly takes control of Jerusalem, but then Joab leads David's troops into battle in a forested area.

David expressly orders his troops to spare Absalom's life, but in the melee Absalom's head gets caught in an oak tree's overhanging branch. When David's troops report this back to Joab, Joab goes back and plunges three javelins through Absalom's body. On hearing the news, David is distraught ("O my son Absalom!… If only I had died instead of you", 2 Samuel 18:33). Eventually, persuaded by Joab that his reaction is humiliating the troops who have fought so loyally for him, David gets up. He encourages his men, and with a heavy heart returns to Jerusalem. This is all a tragic vignette in the life of David – a cruel personal thorn in the midst of his public success.

Prayers from the heart

David is rightly remembered also for his writings – over seventy psalms are attributed to him. Some are more military in flavour (such as Psalm 18), but most have an endearing personal quality as he brings his needs humbly before his God. These include confessing his wrongdoing with Bathsheba (Psalm 51) and, most famously, his reflection on "the LORD, my shepherd" (Psalm 23). Biblical writers remember him – despite his faults, which they do not hide – as a "man after God's own heart" (1 Samuel 13:14).

He also wanted to build in Jerusalem a "house" or temple in honour of Yahweh. However, it was revealed to him (through the prophet Nathan) that this was not what God wanted: Yahweh would build a "house" (or dynasty) for David, but the sanctuary which would "house" the ark of the covenant would be built by his son, King Solomon.

. .

Left: The evening sun catches the Mount of Olives. David escapes over these hills, into the desert beyond, fleeing from his son Absalom.

Above: Chariots began to feature in Israel's life under kings such as Solomon and Jehu.

Glory and dedication

Solomon's reign is remembered for many things: the nation's increased prosperity (which attracted the visit of the Queen of Sheba); his fortification of various cities in the north of the country (such as Hazor) as a defence against the Arameans focused around Damascus; and building a small fleet of ships to bring exotic gifts from southern Arabia (and possibly even India). Yet his lasting legacy, as far as the biblical writers were concerned, was Jerusalem's Temple.

With stones cut from nearby quarries, it was built on the highest point of the hill just to the north of David's City, and adorned with lavish furnishings of gold and bronze. More remarkably, Solomon also signed a commercial contract with King Hiram of Tyre that enabled him to make its roof out of Lebanese cedar. Hiram's workforce, they agreed, would haul the timber down to the Mediterranean, and Solomon's workforce (working in shifts, one month in three) would then float them down the coast and bring them up to Jerusalem.

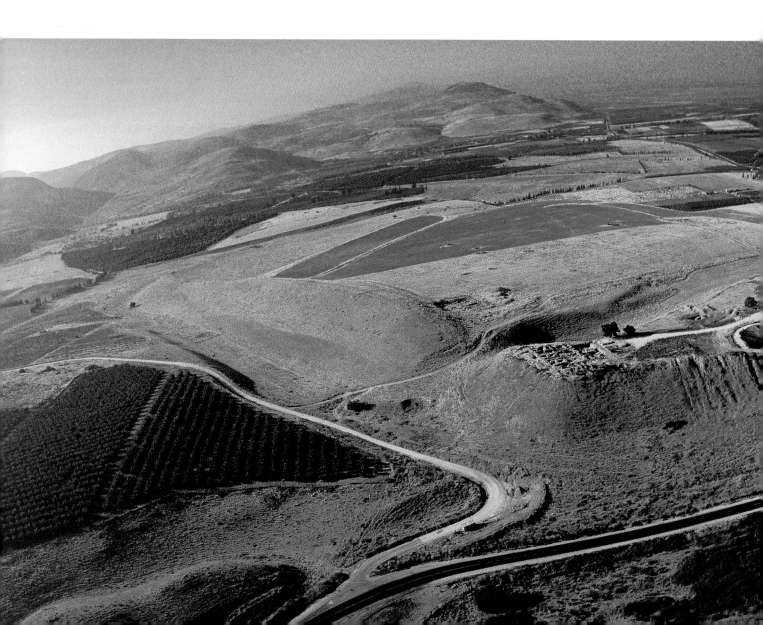

After seven busy years of construction, the dedication of the Temple was an occasion of great thanksgiving: people came up to Jerusalem from far and wide to celebrate this crowning achievement and enjoy the festival for two whole weeks. "Praise be to the LORD, who has given rest to his people," Solomon prayed; "may he never leave us nor forsake us!"(1 Kings 8:56–57).

Right: View from the hills of Moab south-westwards to the Gulf of Aqaba, the southernmost tip of Solomon's kingdom where he kept his fleet.

..

Below: The *tel* of Hazor, the largest city in ancient Canaan, 16 km north of Lake Galilee (see e.g. Joshua 11:10; Judges 4:2); occupied by the Israelites, it was rebuilt during Solomon's reign, but later destroyed by the Assyrians (2 Kings 15:29).

Decline and Fall

These great words of Solomon at the dedication of the new Temple in Jerusalem marked a great climax in the history of Israel. Yet from now on it would be downhill all the way.

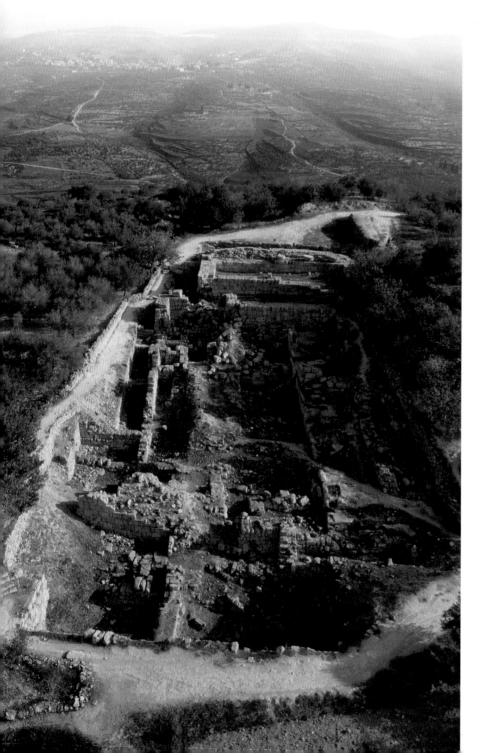

That, at least, is how it is seen by the writers of 1 and 2 Kings. As they describe the monarchs who follow David and Solomon, they tell a tale of steady decline: a story marked by disunity, discord, and (critically for them) disobedience to Israel's God. Why else would the great kingdom established by David have been divided so soon into two warring factions (with the ten northern tribes of "Israel" splitting off from "Judah" during the days of Solomon's children)? Why else would it have all ended in disaster, defeat, and despair – with the eventual destruction (in 587 BC) of Solomon's Temple at the hands of invading, godless armies? God, they believed, had made key promises to David, and established his dynasty like a "lamp" in a dark place (see, for example, 1 Kings 11:36; 2 Kings 8:19); but now, through the follies of his successors, the light of that lamp was all but extinguished.

Top right: The hill-top city of Samaria (later refounded as "Sebaste" by Herod the Great).

. .

Right: The gentle hills in the region of Samaria (or "Ephraim"). Before being settled by the Israelites, much of the hill-country would have been covered with forests.

. .

Left: Excavations in the ancient city of Samaria (the capital of the northern kingdom of "Israel" from c. 875–722 BC), showing the royal palace, associated with kings such as Ahab (871–852 BC), married to Jezebel, and Jehu (841–814 BC).

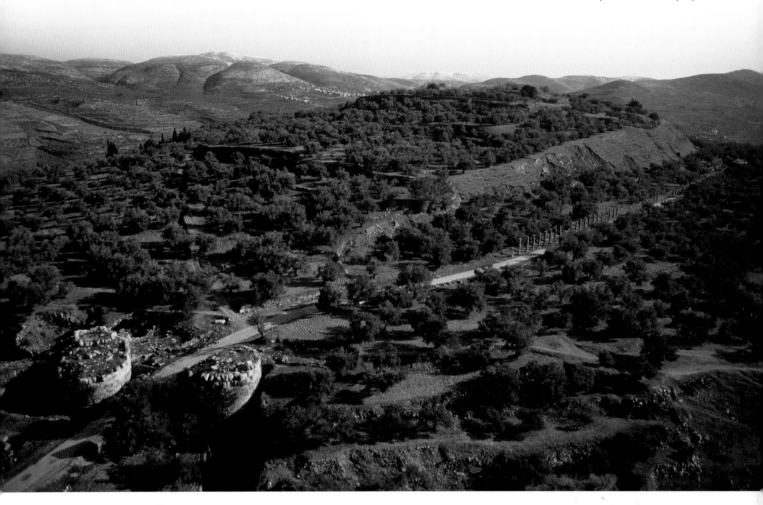

A nation divided

A man called Jeroboam led a revolt and established himself as the ruler of a separate kingdom (based initially in Shechem, though eventually the capital moved to the city of Samaria). Meanwhile the two tribes of Judah and Benjamin in the south remained loyal to Solomon's son Rehoboam, who ruled from Jerusalem. In the next two centuries both kingdoms were continually riven by coups and counter-plots, with a consistent bitter rivalry between north and south.

The only real exception came in the middle of the ninth century BC, when Joram, king of Judah, married Athaliah, one of the daughters of Ahab, king of Israel. Yet this attempted rapprochement soon fell apart and ended in near disaster for Judah: Athaliah seized power as the queen mother in Jerusalem and murdered all the remaining princes – except for young Joash, who was smuggled into the Temple courts and raised there in hiding for seven years. Then, one Friday evening,

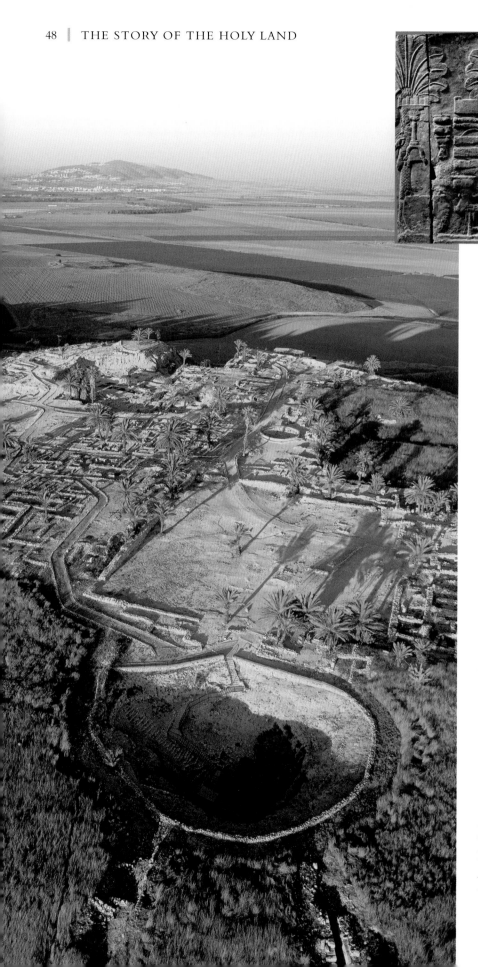

Above: Assyrian scribes and soldiers, as depicted on a relief from the palace at Nimrud (730 BC).

...

Left: The ancient *tel* of Megiddo (with its circular staircase down to its hidden water supply), scene of numerous battles.

he was crowned king by his uncle, and Athaliah was swiftly put to death by a mob. David's royal line in Judah had thus survived – but only just.

So there were struggles deep within the nation. Beyond its borders, too, trouble was brewing. With Egypt to the south and the increasingly expanding empire of the Assyrians to the north-east, the small nation of David's successors would always be in danger of being buffeted by its more powerful neighbours and easily trampled underfoot.

This was especially true for the inhabitants of the northern kingdom of Israel, which lay across the main highway (the *Via Maris*, "Way of the Sea") linking Egypt with Damascus. They often heard the sound of armies marching along the Jezreel Valley, past Megiddo, and through one of the narrow cuttings in the Carmel mountain range (see pp. 34–35). The hill-country around Samaria was slightly safer, but not much. Initially the northern tribes were involved in skirmishes with the Aramean kings of Damascus; but then, from around 800 BC, there loomed – behind and beyond Damascus – the awesome might of the Assyrians. As the tidal wave approached, their leaders made frantic alliances and

peace treaties, but eventually nothing could prevent the wave from crashing down upon their heads. So in 722 BC the northern kingdom of Israel was invaded by the Assyrian emperor, Shalmaneser V, and many of the population were promptly deported back to cities in his far-away empire.

Jerusalem's reprieve

This was a devastating blow – the effective disappearance into oblivion of ten of the twelve tribes of Israel. And the inhabitants of southern Judah would understandably have been asking when *their* turn would come. Just twenty years later, it looked as if the end was in sight. Shalmaneser V was succeeded by Sargon II (722–705 BC) and then by Sennacherib (705–681 BC), who launched a campaign against Judah's inhabitants because their kings were refusing to pay him any tribute. Coming down the coastal route, Sennacherib then turned inland to besiege and destroy the Judahite fortress city of Lachish. Next stop: Jerusalem.

King Hezekiah, along with the prophet Isaiah and all Jerusalem's inhabitants, therefore woke up one morning in 701 BC to find the Assyrian army commander outside their walls. Three of their number are sent out to parley with him, hoping for a quiet word in Aramaic which might lead to a peaceful resolution. The commander, however, calls out in Hebrew – in the full hearing of the inhabitants on the walls: "Do not listen to Hezekiah, for he is misleading you when he

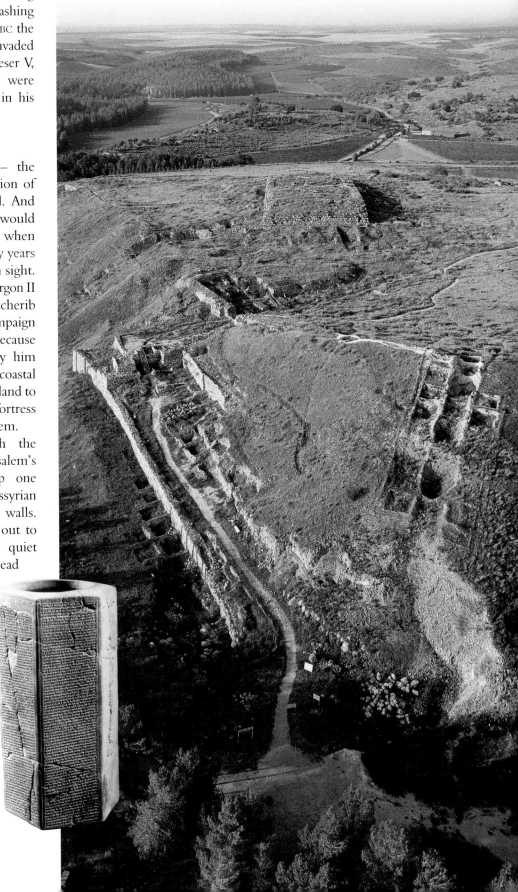

Far right: The city of Lachish, overcome by Sennacherib.

. .

Right: A six-sided baked clay document (known as Taylor's Prism) records Sennacherib's first eight campaigns (up to 691 BC).

says, 'The LORD will surely deliver us.' Has the god of any nation ever delivered his land from the hand of the king of Assyria?" (2 Kings 18:32–33). And he promptly lists the various cities and kingdoms overrun by the Assyrian emperor – including, of course, Samaria.

Hezekiah is distraught; putting on sackcloth he goes into the Temple to pray. Then Isaiah sends to him a prophetic message:

> The LORD says: "Do not be afraid… the king of Assyria [has] blasphemed me… He will return to his own country, and there I will have him cut down with the sword… He will not enter this city… I will defend this city and save it, for my sake and for the sake of David my servant!" (Isaiah 37:6–7, 33–35).

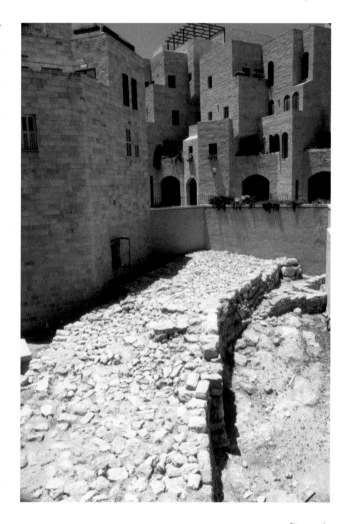

And so it turns out. Sennacherib is troubled by news that the Egyptian army is on its way; and then his own army, while encamped near Lachish and Libnah, experiences a devastating number of sudden deaths. So the Assyrian king beats a retreat back home and, sometime later, is killed by two of his sons in a palace coup.

The ending of the light

Jerusalem had experienced a dramatic reprieve. Looking back on this incredible deliverance, its inhabitants began to wonder if perhaps this city associated with David might be inviolable: perhaps Israel's God would *always* guarantee her protection? Yet this so-called "Zion theology" would come in for some fierce criticism from Isaiah's prophetic successors, such as Jeremiah. Eighty years later (in 622 BC) Jeremiah would stand in the Temple's entrance and warn the incoming worshippers not to keep reciting "the Temple of the LORD!" – as though somehow God's presence in his Temple meant it could never be destroyed. No, Yahweh was looking for his people to reform their evil and idolatrous practices. Yes, the current king, Josiah, was seeking to bring this about, but the people were seemingly set on their evil ways; and this house, which bore God's name, had been abused by them – effectively

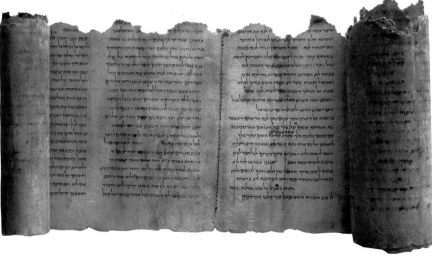

Top: The "broad wall" (now within Jerusalem's Old City), built by King Hezekiah to ward off the Assyrians.

being turned into a "den of robbers". So Jeremiah solemnly pronounced: "My wrath will be poured out on this place; and I will thrust you from my presence" (Jeremiah 7:15, 20).

Jeremiah's message was, of course, deeply unpopular. Twenty-five years later, however, Jerusalem was overcome by the troops of the new superpower in the region, Babylon. Jerusalem's king, Jehoiachin, was led off in shackles to Babylon, together with other leading figures. Jeremiah, the prophet of doom, lived to see his words come true and found himself in exile in Egypt. And then, ten years later, in 587 BC, King Nebuchadnezzar sent his army to destroy the city of Jerusalem and to burn its Temple.

The narrative of 2 Kings thus ends in a sad, sad place: thirty-seven years after being first deported, David's descendant, Jehoiachin, is still in Babylonian exile, far from Jerusalem. There is no Davidic king in Jerusalem, Solomon's Temple is in ruins, and those few inhabitants who remain in Judah are under pagan rule. Throughout the land the majority population is made up of those who have come from elsewhere. Truly, so it seems, the light of the "lamp", first lit in the days of David, has been extinguished.

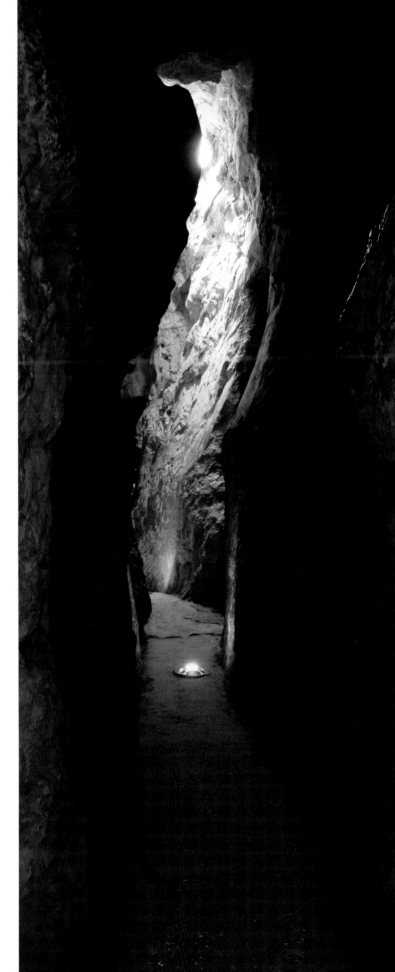

Left: The religious reforms of young King Josiah (641–609 BC) were partly inspired by the discovery in the Temple archives of an ancient scroll (possibly containing the text of Deuteronomy: see 2 Kings 22:8–20). This scroll (one of the Dead Sea Scrolls discovered at Qumran in 1947) dates back to the first century AD.
...
Right: The dramatic tunnel, built on the orders of King Hezekiah (727–698 BC) to bring the drinking water from the Gihon spring inside Jerusalem, prior to the anticipated assault by the Assyrians under Sennacherib in 701 BC.

REFUGEES AND GREEKS
(587–40 BC)

A weary prophet gazes over some broken walls and weeps.
A young priest obeys orders to lie on his side for days on end.
Musicians sit mute, their harps dangling from nearby trees.
All three – unusual pictures – point us to a scene of utter brokenness.

The Era of Exile

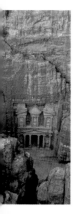

The destruction of Jerusalem in 587 BC was deeply traumatic. Centuries of hope and faith went up in smoke; national aspirations and dreams of independence were buried in the rubble. The population of the city and its hinterland dropped from c. 250,000 to just 20,000 as people fled, going elsewhere in the Land or down to Egypt, with their leaders forcibly deported to refugee camps far to the east by the River Euphrates. Much of Judah came under the local control of their historic enemies to the south-east, the Edomites. Jerusalem, a place of such potential, had become a wasteland.

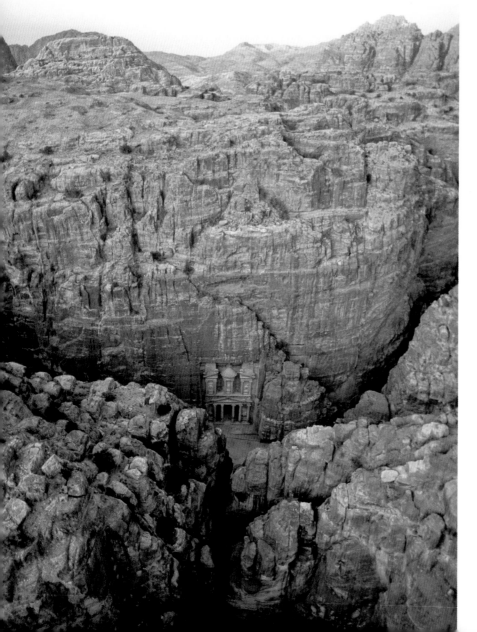

Weeping and silence

"How deserted lies the city… How like a widow is she… She who was queen among the provinces has now become a slave." So begins the Old Testament book of Lamentations – five long chapters in which the author (traditionally identified as Jeremiah) weeps over Jerusalem's fate. "All the splendour has departed from the Daughter of Zion. All her people groan as they search for bread… 'Is it nothing to you, all you who pass by?'" (Lamentations 1:6, 11–12).

Meanwhile in those distant refugee camps, the Babylonian officials – though in other respects treating the exiles reasonably – were taunting them: "Sing us one of the 'songs of Zion'!" But they refused: "How *can* we sing the songs of the LORD while in a foreign land?" (Psalm 137:3–4). Those deported (around 4,500 adult males with their families) had been the cream of the population, including the political leaders, the ruling families,

Left: View of Petra, the city that poet John Burgon described as the "rose-red city half as old as time". Petra was the impregnable stronghold of Israel's enemies, the Edomites, who rejoiced when Jerusalem fell (Psalm 137:7).

and many of the Temple's priests, officials, and musicians. So, they knew the notes they were meant to sing, but the songs simply would not come – their throats choked with grief.

Among them was a young priest, Ezekiel, who experienced a powerful call to be a prophet and to act out some bizarre parables: eating strange foods or lying on his side for forty days to indicate God's judgment on Jerusalem for the forty years of its rebellion.

Right: Medieval depiction of Hebrews weeping for Jerusalem.

Below: The Euphrates river (near Haditha in modern Iraq).

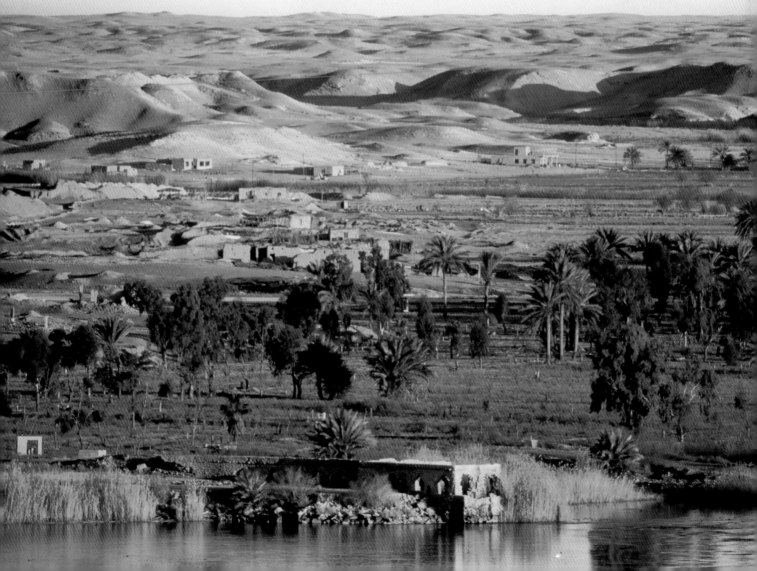

Hope in the desert

Both Jeremiah and Ezekiel were clear that this period of exile would last at least a generation. They held out no hope for an immediate return and encouraged the refugees to settle down. Yet both had profound words of hope for the long term. In Jeremiah, we read:

> The days are coming... when I will bring my people... back from captivity and restore them to the land... the city will be rebuilt on her ruins... He who scattered Israel will gather them (30:3, 18; 31:10).

Similarly, Ezekiel was given a dramatic vision of the nation of Israel being like a field of human bones. God then breathed on them, causing the bodies to re-assemble and then come back to life – a dramatic sign of resurrection power, symbolizing Israel's restoration to the Land.

These pictures and prophecies gave the people hope. Paradoxically, so did the prophets' stern words of judgment. It would have been easy for Jerusalem's exiles to abandon their belief in their unique God: all the evidence seemed to suggest that he was powerless. Far simpler to be absorbed into the culture of the surrounding nations: why hold out for something different? Yet this did not happen. Why? The answer lay in those words of judgment, which enabled them to see the tragedy of exile "not as the contradiction, but as the vindication of Israel's historic faith" (Bright, p. 349).

Thus Israel's faith was reborn. Just as the nation had been forged in the desert under Moses, so now – in the painful "desert" of exile – it was *re*-formed. Feeling the heat, purged and cleansed, the people found in their faith the seed of their renewal and a stream of hope. They might be in the desert, but they were not, so they believed, deserted.

"The desert and the parched land will be glad; the wilderness will rejoice and blossom" (Isaiah 35:1): such imagery was often used by the prophets to speak of Israel's restoration from exile.

The Returning Century (530–430 BC)

Empires come, but empires go. Throughout the Old Testament period, the power of Egypt was fairly constant, but to the north and east of the Land there were frequent changes: the Hittites (c. 1430 – c. 1180 BC) and the Arameans (c. 1100–911), followed by the Assyrians (911–605), the Babylonians (605–539), soon giving way to the Medes and Persians (539–331).

Changes in government

Intriguingly, Babylonian rule was brief. After the death of Nebuchadnezzar (in 562 BC), the Babylonian empire began to fall apart. There was a swift succession of kings (three in seven years), followed by Nabonidus (556–539 BC), who for ten years moved his capital away from Babylon. Meanwhile Cyrus II, a Persian, gained control over the former empire of the Medes and launched brilliant military campaigns – even destroying Sardis near the west coast of modern Turkey. Babylon was helpless. In the autumn of 539 BC Cyrus entered the city in triumph. He controlled all of western Asia up to the frontier with Egypt. For the Old Testament writers, however, the key thing was that Babylon, Israel's great enemy, had fallen.

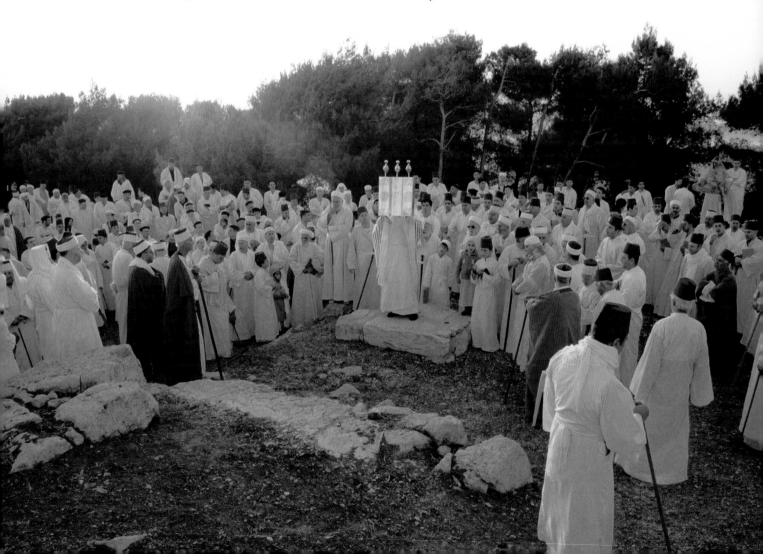

Moreover, in that first year of his reign, Cyrus issued a decree, allowing the exiles to return and to rebuild the Temple (see Ezra 1:2–4; 6:3–5). This was part of a wider policy allowing subject peoples throughout his empire – even if kept under firm official control – to have some cultural distinctives. Yet it was also a remarkable fulfilment of the words of Israel's prophets (see p. 56).

The initial return

The first group was led by a member of Judah's royal family, Sheshbazzar; another came soon afterwards under his nephew Zerubbabel. They seem to have tried to rebuild the Temple, but the project soon ground to a halt. The promised support from the Persian treasury may never have materialized and local residents (including the Samaritans to the north) resented the exiles' return. During those early years Cyrus's successor, Cambyses II, gained control of Egypt (in 525 BC) but was then succeeded by Darius (522 BC), who spent the next two years putting down various rebellions. During this volatile period, prophets such as Haggai and Zechariah urged that the work on the Temple be resumed. This alarmed the Persian authorities, who then double-checked their archives; however, Cyrus's edict was duly discovered, and reconfirmed by Darius.

The completed Temple was dedicated four years later (in March 515 BC). Some present burst into tears when they saw its meagre size – a shadow of its former self. Overall, this restoration to the Land was a disappointment. In particular Zerubbabel never became king, and the Davidic dynasty was never allowed to take charge. Instead Jerusalem may have come under the rule of officials in Samaria, with the Samaritans strongly opposing any substantial redevelopment in Jerusalem.

Above: The remains of Babylon's ancient ziggurat (*in the distance*) – a vast construction, possibly alluded to as the "tower of Babel" (Genesis 11).

Left: The Samaritans' annual Passover ceremony on Mount Gerizim. Now numbering around 750, they are descended from those who occupied Samaria after the exile of Israel's ten northern tribes (in 722 BC).

Below: A clay cylinder, inscribed in Babylonian cuneiform with Cyrus's account of his conquest of Babylon in 539 BC.

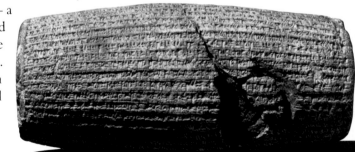

New walls, new community

As other groups of exiles returned, the number of residents in the Jerusalem area gradually increased, perhaps reaching 50,000 by the middle years of the fifth century. Even so, the conditions were such that they still felt like slaves in their own land (Nehemiah 9:36).

Then, around 445 BC, Nehemiah, a royal servant, bravely asked King Artaxerxes I (465–425 BC) for permission to return to Jerusalem in order to rebuild the walls destroyed over 130 years before. Despite fierce Samaritan opposition, the project was accomplished in fifty days – a remarkable team effort.

Around the same time, Ezra also returned – to establish the Jerusalem community on a stronger legal footing. He was an expert in Jewish Torah, and as a result of his guidance, though they had lost their political status, the people effectively gained a new identity – governed by their own distinctive law codes. Sabbath observance, circumcision, dietary rules – these aspects of community life that had begun to mark them out from their neighbours – were now enshrined in a new way at the heart of the community's life.

So people throughout the Land who wished to be identified with the Temple cult were now expected to live within the legal framework established by Ezra. Thus, a hundred years after that first return, a key transition had been effected: no longer an independent political nation, this was a people that was now defined by adherence to God's law.

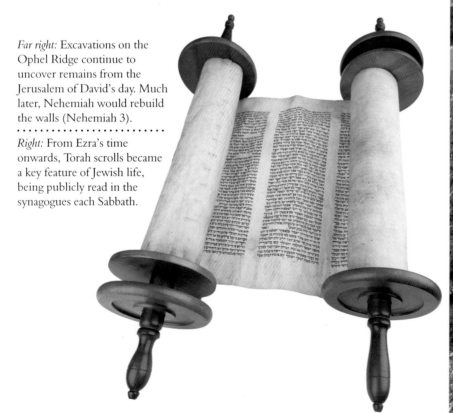

Far right: Excavations on the Ophel Ridge continue to uncover remains from the Jerusalem of David's day. Much later, Nehemiah would rebuild the walls (Nehemiah 3).

. .

Right: From Ezra's time onwards, Torah scrolls became a key feature of Jewish life, being publicly read in the synagogues each Sabbath.

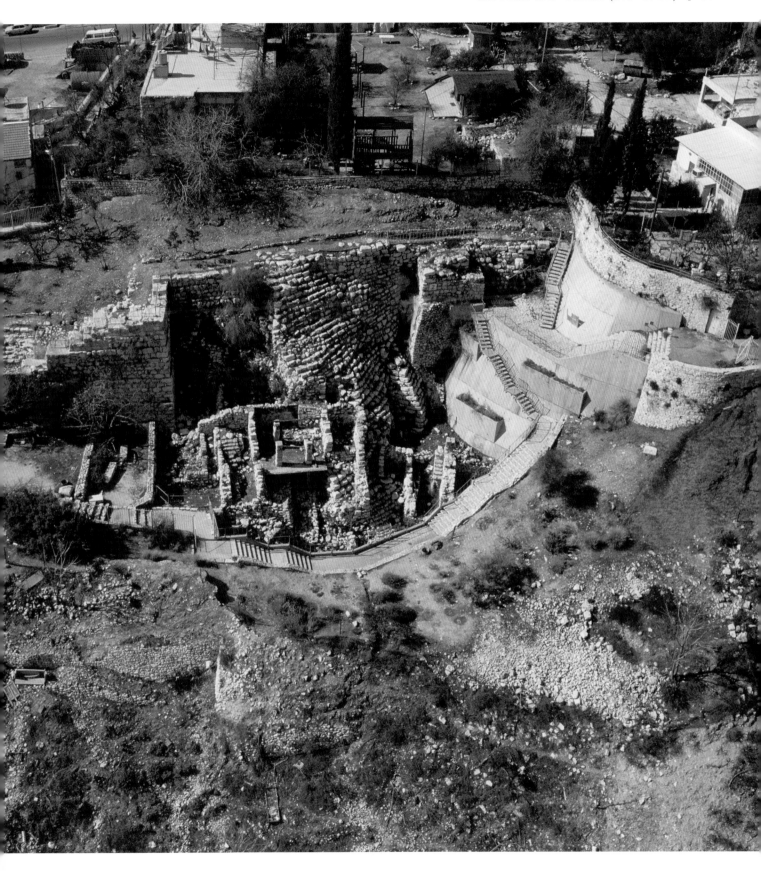

Greeks and Romans

Remarkably little is known about the Holy Land for the next 250 years. It was simply a small, insignificant part of the much larger empires that sprawled across the wider region of western Asia: the Persians, then the brief reign of Alexander the Great (336–323 BC), and then the era of his successors – first the Ptolemies (ruling from Egypt: 301–198 BC) and then the Seleucids (ruling from Syrian Antioch).

Within the Land there would have been a mix of people groups (initially all speaking Aramaic and then beginning to adopt Greek); many would have seen themselves simply as citizens within these various empires. Several Greek colonies were established (such as Scythopolis) which were thoroughly Greek (or "Hellenistic") from the outset and would have had a pervasive influence on the surrounding culture.

Set apart from these were both the Samaritans (initially centred around the city of Samaria, but who then relocated to Shechem after their revolt against Alexander) and the Jewish community (centred on Jerusalem). Effectively, this Jewish community would

have been a semi-autonomous enclave throughout this period – paying its imperial taxes, but otherwise allowed to govern itself according to its own laws (as codified back in the days of Ezra) and issuing tiny silver coins, marked "Judah". Some would have continued to use Hebrew, both in daily life and in worship. Overall, however, they seem to have been content to let the march of history simply pass them by.

. .

Below: The impressive theatre at Beth Shan (also known as Scythopolis), one of the Ten Cities of the Decapolis.

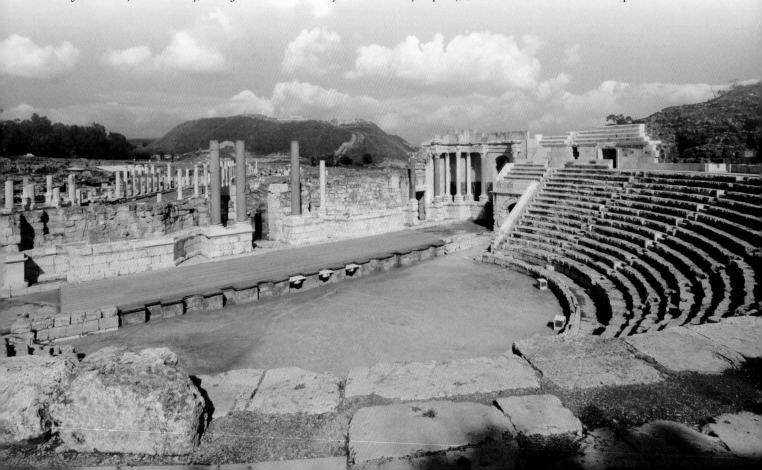

A rude awakening

These tranquil waters were all set to be disturbed, however, when in 198 BC Antiochus III (223–187) smashed the Egyptian army in a major battle in the extreme north of the Land – at Panium, near the source of the River Jordan. Initially this change of rule looked promising: Antiochus the Great remitted taxes for a season and allowed any Jewish refugees to return home to Jerusalem. Within a generation, however, things took a dramatic turn for the worse. Antiochus IV ("Epiphanes"), threatened by the rising power of Rome and hard pressed for cash, began imposing heavy burdens on his subjects and seeking revenue from various temples – including Jerusalem's. To encourage political unity he also promoted the worship of Zeus and, worse still, the worship of himself (as Zeus's human representative).

Some in Jerusalem were willing to go along with this. Joshua, brother of the legitimate high priest Onias III, bribed Antiochus for the post of high priest and promised to deliver his imperial policies. Renaming himself Jason, he set about imposing some Hellenistic features in the city – including a gymnasium for sporting enthusiasts. Then a rival (Menelaus) usurped him, and began selling some of the Temple's treasures. Jason responded by marching with 1,000 soldiers on Jerusalem and conducting a

Above: The fresh water springs of Panium (now Banias) flow into the Jordan. Centuries later, Herod Philip would rename the city Caesarea Philippi in honour of the pagan Roman emperor.
. .
Left: Hellenistic statuary inevitably challenged the Jews' monotheism and their ethical standards.

massacre. Antiochus, returning from a great victory in Egypt, promptly reinstalled Menelaus and plundered the Temple.

Two years later (in 167 BC) Antiochus sent a large force to build a garrison (the Acra) quite close to the Temple; worse still, he decreed the end of the Temple's sacrifices, forbade Sabbath observance and circumcision, and then (in December) set up an altar to Olympian Zeus within the Temple – on which pig's flesh was to be sacrificed. For practising Jews this was the last straw – a horrific and cruel insult, a blasphemous and arrogant act, indeed an "abomination that desolates" (Daniel 9:27, NRSV).

Resistance and dreams fulfilled

Despite savage persecution, Jewish resistance began to grow. A group called the Hasidim (the "loyal ones") led the way; then a man called Mattathias began some guerrilla warfare near Lydda. His third son, Judas (nicknamed Maccabeus, the "hammer"), took things much further – defeating two army forces sent down into Palestine by Antiochus. Admittedly, during that particular year (165 BC) Antiochus's chief concern was to ward off the Parthians on his eastern frontier. Even so, he despatched yet more troops. However, each time – in battles both at Emmaus and, one year later, to the south of Jerusalem – these troops proved no match for Judas. So, three years to the month since its desecration, Judas was able to ride triumphantly into Jerusalem and cleanse the Temple from its profanation. This Feast of Dedication (Hanukkah) was inevitably celebrated with great joy.

So began a hundred-year period (named the Hasmonean period after Judas's family dynasty) in which the Jewish community enjoyed some hard-won independence. Now at last, after 400 years, they could breathe the air of freedom and enjoy the land promised to their forefathers. Now, perhaps, it was fair to think that their exile was truly over.

Top: Vast statues of Zeus and other gods were an essential hallmark of pagan temples; by contrast, the Temple in Jerusalem for the God of Israel had none.

. .

Right: In response to the compromised stance of the high priests in Jerusalem, some devout Jews established an alternative "temple"-like community down by the Dead Sea at Qumran. Hoping for God's restoration of Israel, they may well have been inspired by prophetic texts such as: "prepare the way for the LORD; make straight in the desert a highway for our God" (Isaiah 40:3).

And finally some expansion became possible. Thus, although the vast majority of Jews who had moved to areas outside the Land (known as the Diaspora or "dispersion") continued living where they were, presumably a good number chose instead to return to the Land. This swelled the numbers of the Jewish population and allowed parts of the country to be "Judaized" – especially in Galilee and the area of the Decapolis (with its ten Hellenistic cities). Small groups of settlers, for example, established a Jewish presence in Nazareth…

Top: Jewish pottery from the Hasmonean period (165–67 BC).

Left: When the Qumran community was destroyed by the Romans in AD 72–73, precious manuscripts were hidden in the nearby caves, including this complete text of Isaiah (c. 100 BC). These Dead Sea Scrolls were only discovered in 1947.

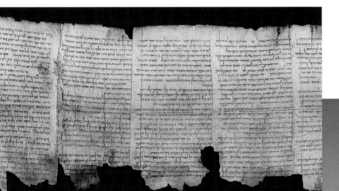

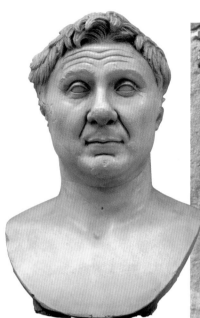

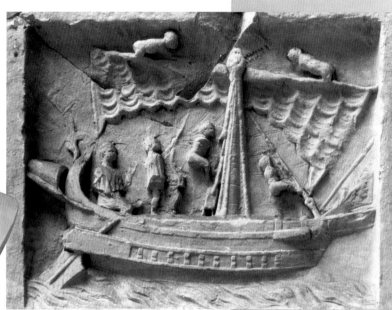

Hopes dashed

The dream, however, was about to be dashed. A new imperial power had been expanding from the west, building its navy and equipping its armies. Eventually it came to conquer. The Roman general, Pompey, came to the eastern Mediterranean in 67 BC and brought the whole area under Roman rule, now administered from Antioch within the province of Syria Palestina. In fact, he himself walked into the Temple; yet he did not actively desecrate it. Instead he was just puzzled at there being no statue of a god within its precincts, concluding that the Jews must be "a-theists".

For the Jewish population, however, even though the sacrilegious horrors of Antiochus IV were not being repeated, the arrival of this new empire came as a bitter blow. Better, perhaps, not to have dreamed of independence at all than to have those hopes – after a century of freedom – so cruelly dashed. Seeds of frustration, resistance, and rebellion were sown – seeds that would germinate in the generations to come.

Above left: Bust of Pompey (died 48 BC), who with Crassus and Julius Caesar extended the Roman empire further to the east.

. .

Above right: Detail of a Roman ship from a stone relief found in Pompeii, southern Italy.

. .

Right: The Samaritans' alternative temple on Mount Gerizim (built in the fourth century BC but destroyed by the Hasmoneans in 128 BC); much later (AD 484) the Byzantine Emperor Zeno would build an octagonal church within it.

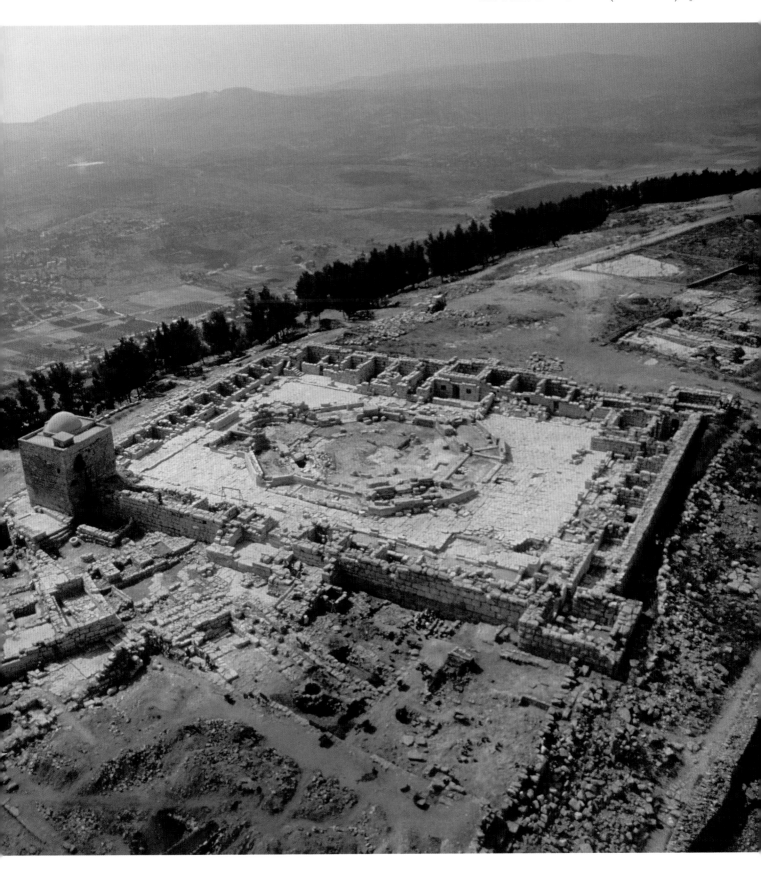

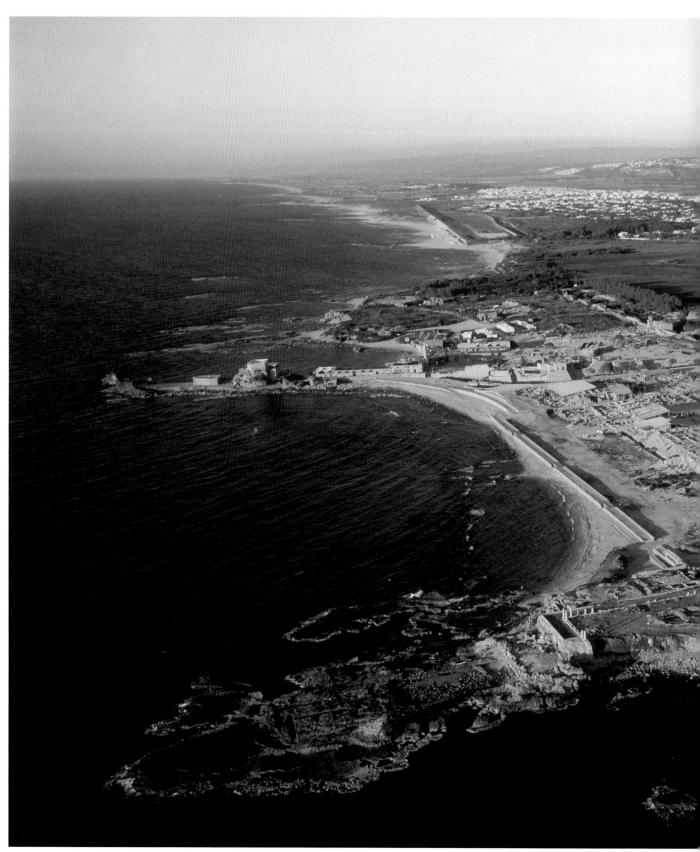

CITY IN THE SANDS: Herod's new capital, Caesarea Maritima

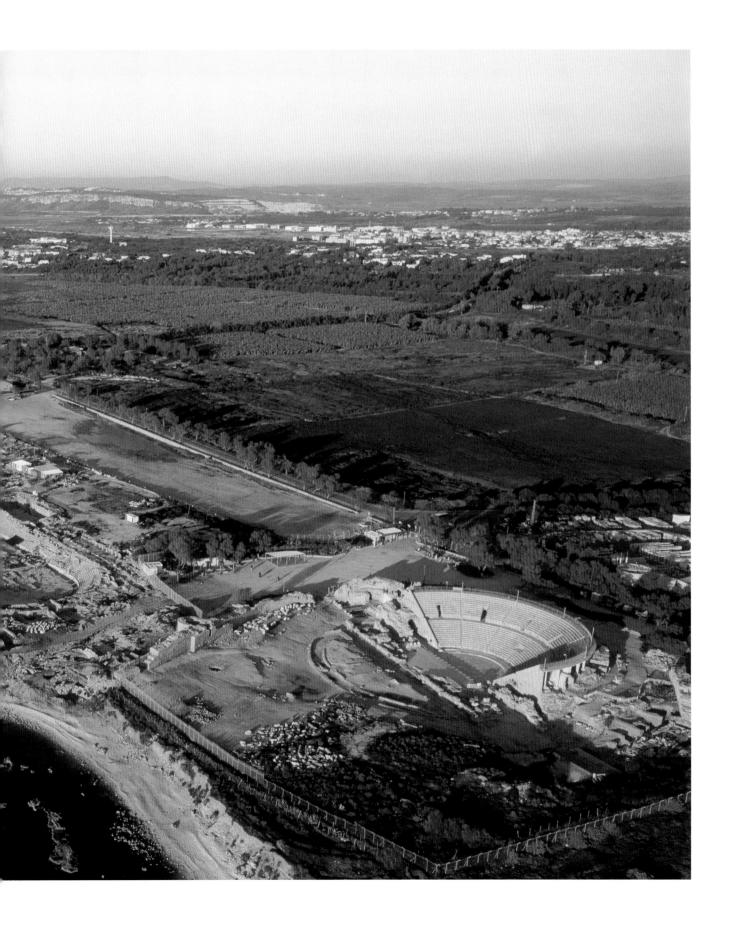

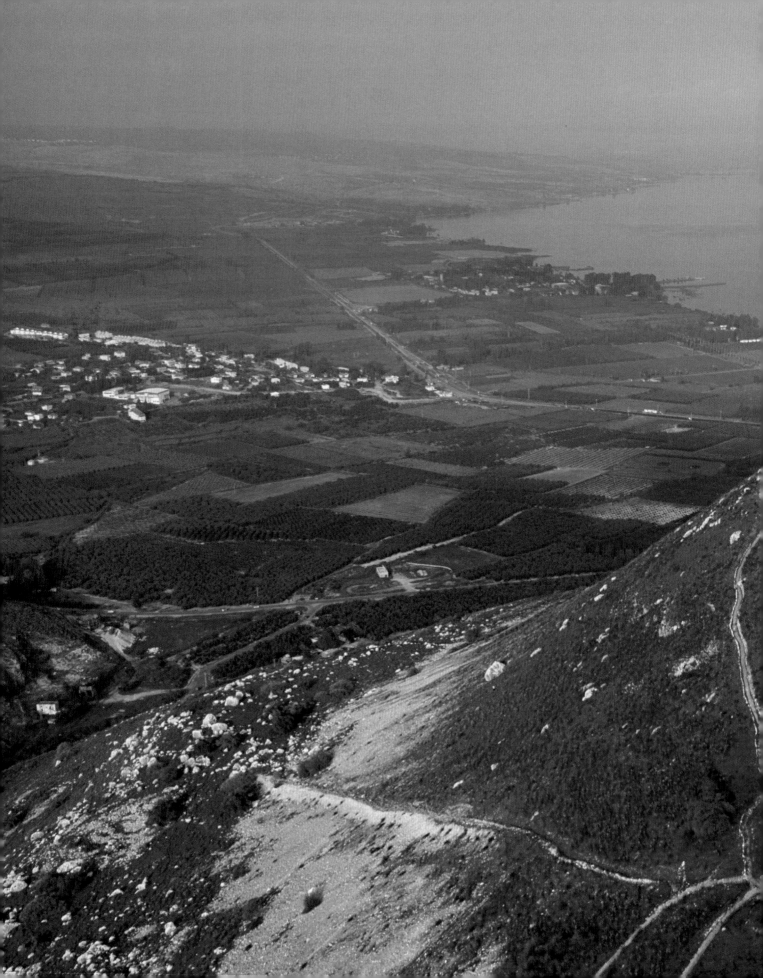

CHAPTER 4

THE CRUCIAL CENTURY
(40 BC – AD 70)

One old man, paranoid in his bunker,
issues death sentences to his subjects and even his own family.
One young general, seventy-five years later,
hacks down olive trees to build siege engines around a starving city.
And, between them, a young Jewish prophet from Galilee
is led outside the city, sentenced to death for rebellion against Rome…

Herod the Great

So we reach a crucial, pivotal century in the life of the Holy Land – a century which saw the Land transformed out of all recognition by magnificent buildings and the influence of Roman culture, but which, at its end, saw the destruction of those buildings by the armies of Rome as the Jewish people revolted against this invasive culture that was ruining their dreams of independence.

The century is best seen, perhaps, through focusing on three individuals – Herod the Great, Titus and, between these two, Jesus of Nazareth. Each of these, in their very different ways, would become key figures in the long history of the Holy Land.

We can note both their contrasts and their similarities. Herod was only half-Jewish, coming from Idumean stock, but made himself the "King of the Jews", bringing Roman values into Judaism. Titus was pure Roman and, after destroying Judaism's capital in AD 70, went on to become the Roman emperor – hailed as "lord" over the known world. Meanwhile, Jesus, a pure Jew, was crucified for claiming to be the "King of the Jews" but was then proclaimed by his followers as the Lord of the cosmos.

Herod (born c. 73 BC) was appointed procurator over Judea by Julius Caesar in 47 BC. Three years later, after some bitter fighting against a rival from the popular Hasmonean family, he emerged victorious. So began a long reign – effectively as a puppet-king on Rome's behalf. He was deeply unpopular and responded to this with fierce tactics, but also with a remarkable building campaign. The distinctive stones cut by Herod's builders now greet the modern visitor to the Holy Land at every corner. At the time they were designed to convey a clear signal – the Jews were now subjects within the Roman empire.

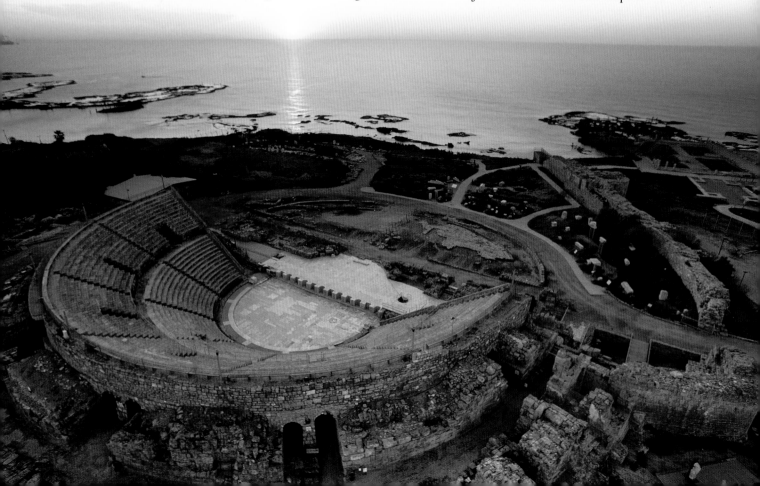

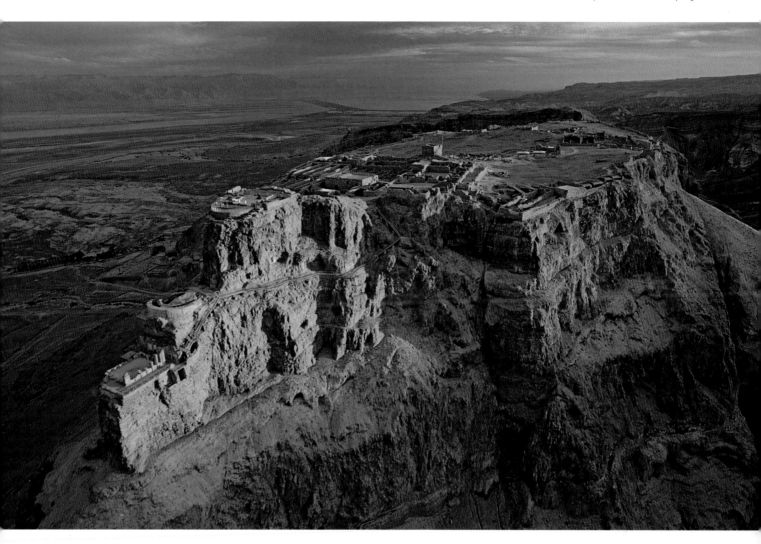

Buildings with a message

This is seen most powerfully in his building an entirely new harbour city – provocatively named Caesarea in honour of the Roman emperor ("Caesar"). He had already named Samaria as Sebaste (in honour of the "worshipful" emperor). Now in Caesarea he ensured there was a temple dedicated to the worship of the emperor Augustus.

Other distinctively Roman features in this seaside capital included a hippodrome and a theatre. People could not but be impressed: by Herod's bringing fresh water along an eleven-kilometre aqueduct; by his underground sewage system (which twice a day flushed out any waste by the tide); and by his using the recent discovery of concrete (poured down onto the seabed) to build a three-sided breakwater, thus providing Palestine at last with a safe harbour. Yet these gifts came with a message.

The same would be true when Herod began to rebuild Jerusalem's Temple in 19 BC. Again his plans were phenomenal. In order to expand the Temple's courtyard precincts, a vast platform was constructed. For this, massive stone ashlars would have to be cut, dressed, and then hoisted into position. Some visible today are vast, being over twelve metres in length and weighing over 80,000 kg; they would have been thiry metres above ground level at the time. First-century visitors to Jerusalem (such as

Above: Herod's secure palace (jutting out at the extreme northern point of Masada) was built on two levels – joined by an internal staircase.

Left: Stunning views over the Mediterranean greeted spectators in the back rows of Caesarea's state-of-the-art theatre.

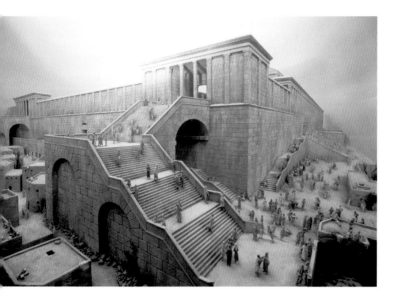

Jesus' disciples from rural Galilee) could not help but exclaim, "What magnificent stones!" (see Mark 13:1).

It was all hugely impressive. Yet religious Jews might well have wondered if Herod's reconstruction of their central shrine and national symbol, dedicated to the God of Israel, had been contaminated by this pagan king. And – given that there was a long-standing Jewish belief that the Temple would be given its most authentic rebuilding (after its destruction in 587 BC) by

. .

Herod's expanded precincts created a new, vast "Court of the Gentiles" – the area from which Jesus would later remove the money-changers (see Mark 11:15–17). There were several points of access to the Temple, including the impressive steps on its south-west corner (*left*). The Antonia fortress looked out towards the Temple and also to the area of Golgotha (*right*).

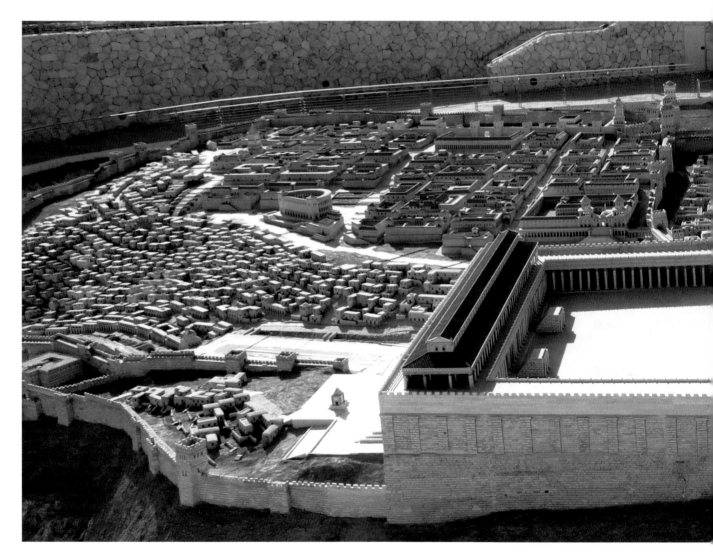

Israel's Messiah, her "anointed king" – was Herod also making an unpleasant political point? Namely, that *he* was the true fulfilment of this messianic hope, the true King of the Jews? To his subjects, of course, it felt more as if he was king *over* the Jews.

Intrigue and paranoia

Resistance against Herod continued, especially in Galilee where rebels eventually hid in the caves of Mount Arbel (see pp. 70–71) – only to be smoked out by Herod's soldiers. Herod became obsessed by people's opinion of him, and with the issue of his successor. As divisions within his family emerged, he had several of them murdered. He strategically married Mariamne (from the Hasmonean family) but then executed her too. Josephus describes Herod's increasing paranoia against his rivals:

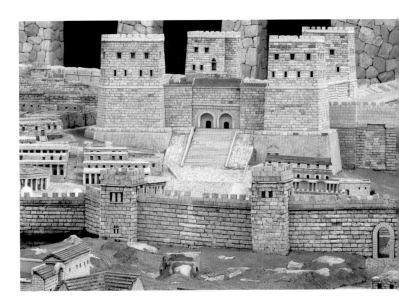

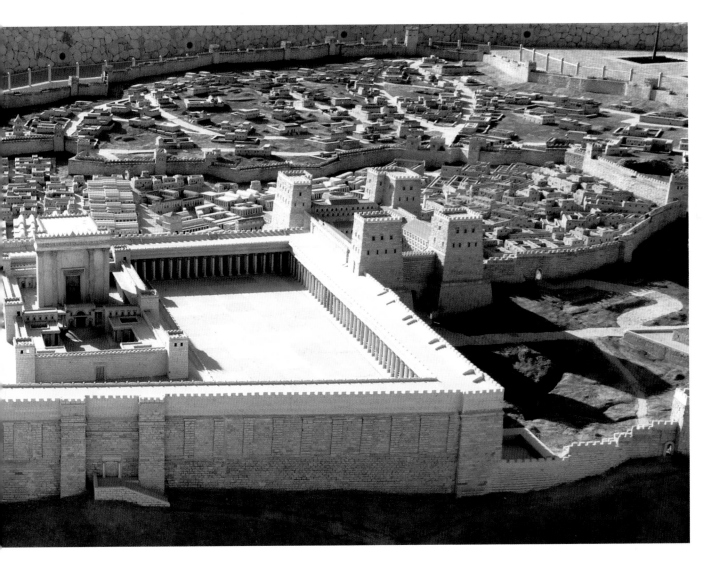

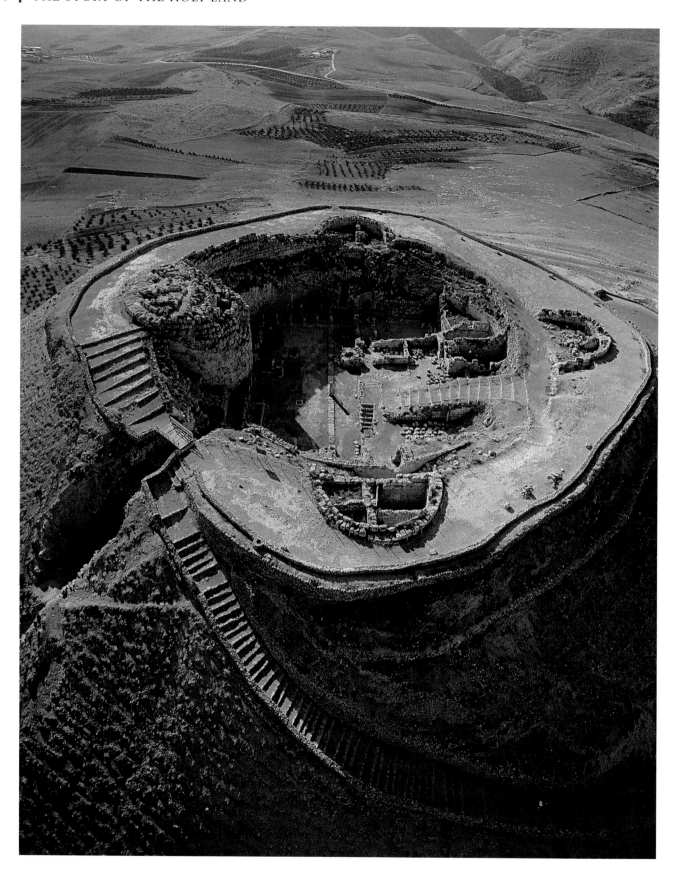

At the end of his days Herod could trust no one around him and required his personal body-guard to frisk all who came into his presence – even, and especially, the members of his own family (Josephus, *Antiq.* 18.25).

Herod was hated by everybody. When he eventually died (in March 4 BC) there were immediately major revolts, especially in Galilee, as the Jewish population tried to throw off the power of Rome. So throughout his reign Herod ensured he had some highly secure hideaways, such as his palatial rooms on the southern cliff of Masada (see p. 73) and his "bunker fort" (the Herodium) on the edge of the desert, five kilometres south-east of Bethlehem. Built up from a natural hill, its cone provided a secure last bastion in the event of attack.

In the end Herod died in his winter palace in Jericho from natural causes (described in ghoulish terms by Josephus: *Antiq.* 17.6–8). Foreseeing his death, however, Herod attempted one last act of brutality. He imprisoned a large number of leading Jewish officials and gave orders (which mercifully were not carried out) that they should all be murdered on the day of his own death – in the hope that any joy among the Jews on hearing news of his death would be mingled with tears of sorrow.

Left: The living quarters within the conical dome of the Herodium, near Bethlehem; Herod's own tomb has recently been found halfway down its slopes.

Below: Herod's winter palace (*middle right*), located to the south of Jericho's oasis.

Jesus of Nazareth

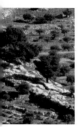

In the final years of the reign of Herod, as he retreated to his hill-top bunker just below Bethlehem, a poor Jewish boy was born in the village on the western horizon. Not much of a threat to Herod's powerful rule, one might think. Yet a few months later, Herod's soldiers were despatched into tiny Bethlehem to kill any boy under the age of two. The life of this tiny infant had to be nipped in the bud.

Why was Herod reacting in this way? Some strange rumours, first put about by ignorant shepherds, might have reached his ears. Yet otherwise the child's birth might well have escaped Herod's attention – had it not been for some bizarre visitors from Arabia, who flooded Jerusalem with their questions, looking out for a child recently born as the "king of the Jews". Such a rival was not to be tolerated – certainly not one born in the same village as Israel's great hero from the past, King David. So the soldiers were sent, but to no avail. The child they were seeking had been whisked away to Egypt.

Below: The fields below Bethlehem (halfway between the village and the Herodium). The events described in Luke 2 (with shepherds being told of Jesus' birth) probably took place in August – the one time of year when sheep would be allowed to wander into the recently harvested agrarian "fields".

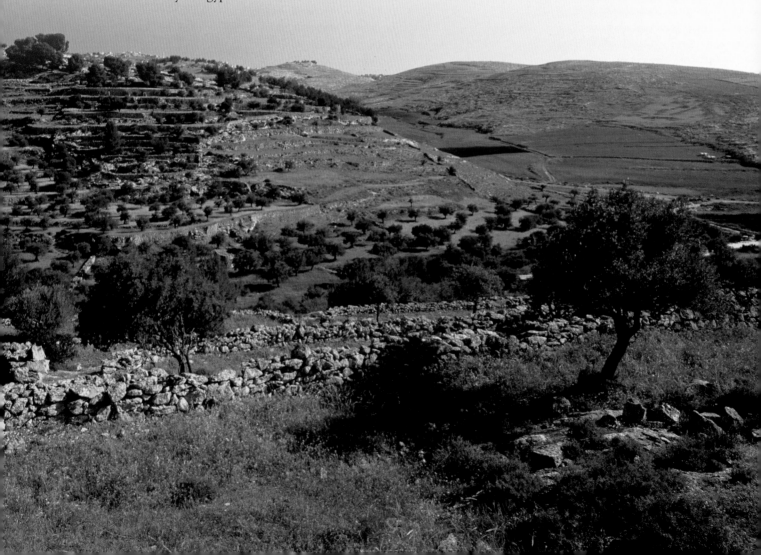

A humble home

So begins the story of Jesus of Nazareth who, despite these inauspicious beginnings, may have changed the history of the Holy Land more than any one other individual. After Herod's death, Jesus' mother Mary returns with her husband Joseph to Nazareth, the village in Galilee where she had been raised. And, as far as we know, here Jesus remains – except for some Passover visits to Jerusalem – for the next thirty years. Nazareth had a population of only a few hundred and was very much off the beaten track, being surrounded by hills – a perfect place to be out of the limelight. So one might well ask, as did one of Jesus' first followers, "Can anything good come out of Nazareth?" (John 1:46, NRSV).

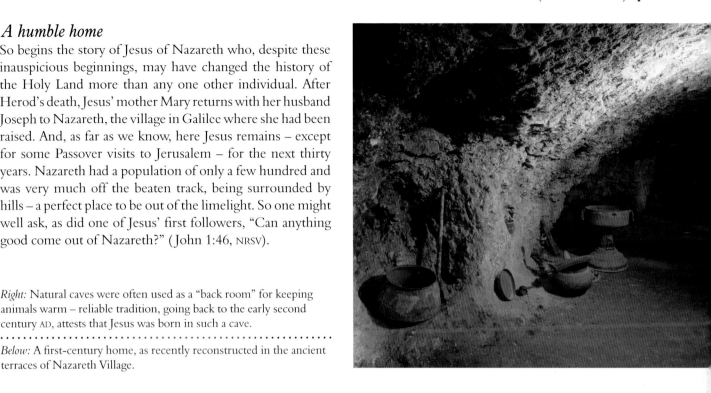

Right: Natural caves were often used as a "back room" for keeping animals warm – reliable tradition, going back to the early second century AD, attests that Jesus was born in such a cave.

Below: A first-century home, as recently reconstructed in the ancient terraces of Nazareth Village.

Humble origins, a rustic upbringing, a backwater village, effective obscurity – these are hardly the expected raw materials for a life which, arguably, would change the history of the world. Yet, sometime just before AD 30, Jesus moves to Capernaum – a larger town on the shores of Lake Galilee and, more importantly, on the main road from the Mediterranean to Damascus – and launches a ministry which in time would become truly international.

A messiah in Galilee?

The area around the lake (also known at the time as Lake Gennesaret or the Sea of Tiberias) can look idyllic and calm on a fresh spring morning. In Jesus' day it would have been bustling with activity – with more than ten harbours plying the fishing trade, and with the year-round harvesting of fruits and vegetables in the fertile Plain of Gennesaret. It was also an area of seething conflict. Galilean Jews had to pay heavy taxes;

Below: The white limestone synagogue at Capernaum stands out from the small houses nearby, which would have been built from black basalt rock. The probable site of Simon Peter's home has recently been covered by an octagonal church.

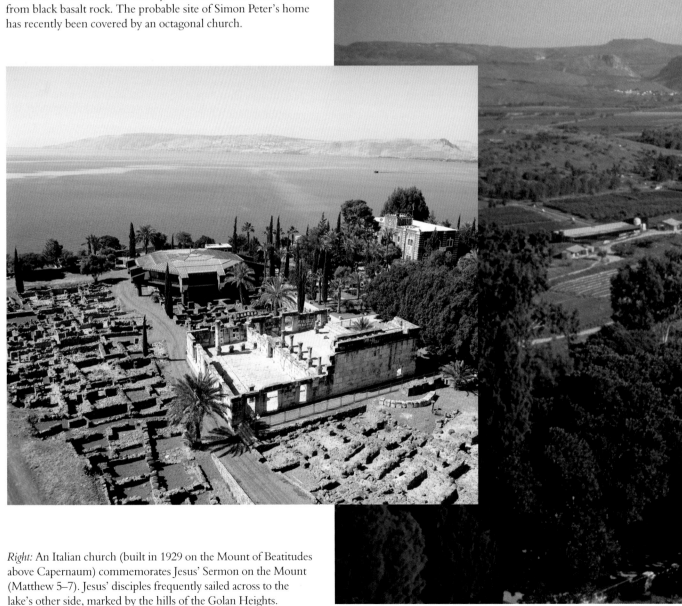

Right: An Italian church (built in 1929 on the Mount of Beatitudes above Capernaum) commemorates Jesus' Sermon on the Mount (Matthew 5–7). Jesus' disciples frequently sailed across to the lake's other side, marked by the hills of the Golan Heights.

they also had to watch the galling sight of their despised ruler (Herod Antipas, Herod's son) building a Roman city on the lakeside in honour of the hated emperor Tiberius (AD 14–37) – built, worse still, over a Jewish graveyard. Josephus, the Jewish historian, records how Galilean Jews were born to be "fighters from the cradle" (*War* 3.3). Galilee was a hotbed of unrest and fervent nationalism. It would only take a spark for the whole thing to go up in flames.

It was in this far-from-peaceful setting that Jesus began his three-year public ministry: "the kingdom of God has come near!" (Mark 1:15). No wonder people flocked to him. His fame spread outside the Land into Syria and Lebanon and attracted some raised eyebrows from the religious hierarchy in Jerusalem. This was precisely the message Jewish nationalists had been waiting to hear for centuries – now, at last, Israel's God was about to resume his rightful place as king! Soon

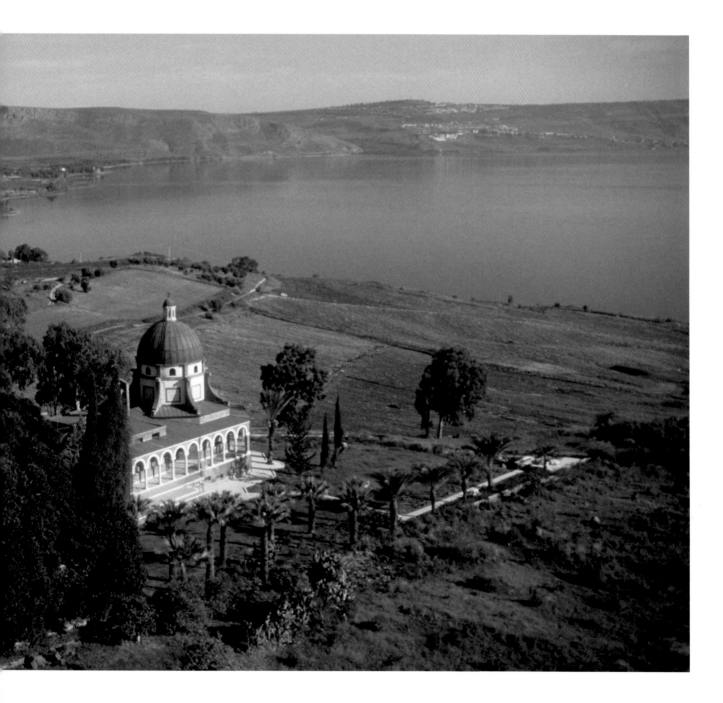

Roman domination would come crashing down before Yahweh, the true Lord of the world – and before his appointed ruler, Israel's long-awaited Messiah.

Yet, strangely and disappointingly, Jesus did not seem to share this anti-Roman sentiment. "Blessed are the peacemakers," he proclaimed. "The meek shall inherit the land…" (Matthew 5:5, 9; Psalm 37:11). So the crowds might have loved the awesome signs of God's kingdom – as seen in Jesus' powerful encounters overcoming diseases, demon possession, and even death – but they became increasingly puzzled and disillusioned with his unusual messianic agenda. Was he really the Messiah? If he was, then he was decidedly *not* fulfilling the role they had been hoping for! At one point, for example, after he had fed 5,000 people with five loaves and two fishes, they were so amazed that they tried to make him king, but Jesus quietly slipped away into the mountains to pray. His agenda was clearly not theirs.

Far right: A nineteenth-century tinted photo of the Mount of Olives: in Jesus' day the Roman road from Jericho came down straight past the enclosed Garden of Gethsemane (*centre*).

............................

Right: Fishermen on Lake Galilee. In 1986 a first-century boat was discovered not far from Magdala, a major centre for preserving fish with salt.

............................

Below: A natural amphitheatre near Capernaum – almost certainly where Jesus taught the Parable of the Sower from a boat (Mark 4:1).

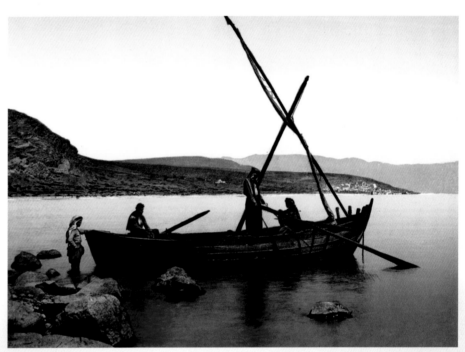

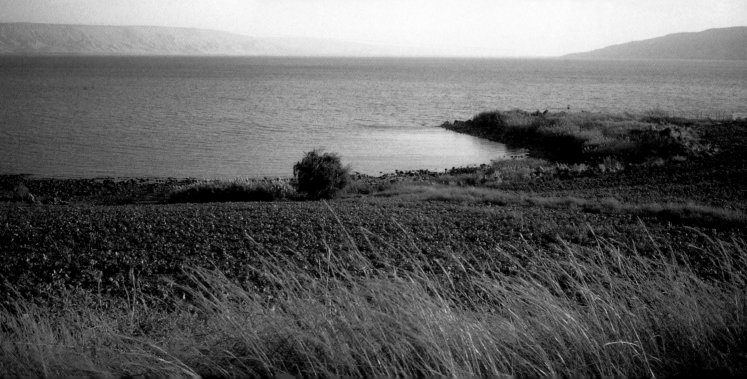

Journey to Jerusalem

Then, one March, he set out for the annual visit to Jerusalem for Passover. This was to be his last visit. The Galilean pilgrims travelled down via Jericho and then up through the Judean desert towards their Holy City. Jesus had been in this desert before – at the outset of his ministry, when his steely resolve to follow God's will had been tested in prayer and deeply established in his heart. Now, however, was the definitive moment of testing. He knew that, once he walked over the crest of the Mount of Olives and entered the city, matters would come to a head.

For here in Jerusalem he could no longer hide his messianic claims. He would enter the city on a donkey (fulfilling an Old Testament prophecy about Jerusalem's true king), but would the city recognize him as their king? He would display his authority and judgment over the Temple, but would people realize who it truly was who was now present in that "holy place"? He would teach in the Temple courts – using parables about tenants in a vineyard killing the owner's son and about unruly subjects rejecting their duly appointed king – but how would they respond?

Jesus enters the city. Predictably, his fellow-Galileans give him a victor's welcome, but in the midst of the celebrations he bursts into tears, weeping over the city for not knowing the "hour of its visitation": the city – both its religious leaders and its secular political authorities – would reject this supposed Galilean messianic pretender. In their eyes his provocative actions might, alarmingly, rouse the rabble's aspirations to fever pitch, and, worse still, his messianic claims were evidently ludicrous and

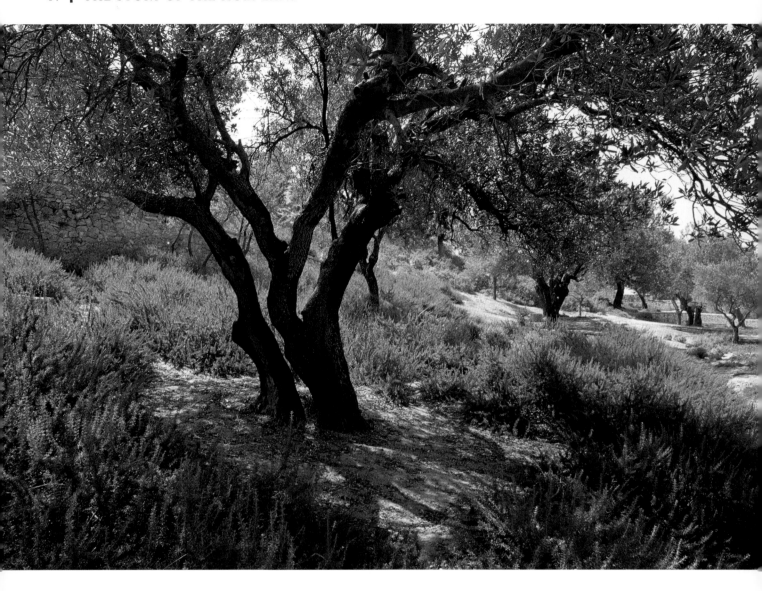

even blasphemous. He had to go. "Better that one man die for the people", quipped Caiaphas the high priest, "than that the whole nation perish!" (see John 11:50).

The story of Jesus' last hours before his death has been preserved in detail in the Passion narratives of the four Gospels (Matthew, Mark, Luke, and John): his last supper with his disciples; his walking up the Kidron Valley towards the secluded olive garden of Gethsemane, where he was arrested; his being led back into the city to be tried before Caiaphas and the Jewish council (the Sanhedrin); his appearance before the Roman procurator, Pontius Pilate; and, finally, his being led out to be crucified between two thieves just outside the city walls.

His story continues

With that, the story of Jesus of Nazareth should have ended. Anyone who ended up dead on a Roman cross was clearly a failed Messiah. No matter how impressive his moral teaching or spiritual power had been in Galilee, clearly he had failed miserably in Jerusalem. As such, he should by rights never have even entered our history books.

..

Above: Among olive trees such as these, Jesus prayed in Gethsemane under the Passover full moon, waiting into the early hours for the moment of his arrest.

Yet he has. And the reason – according to each of the Gospel writers and to the Christian community that now comprises his followers – is that his story, simply put, did *not* end there. Three days later, they claim, his burial tomb was empty and he began a series of appearances in Jerusalem and Galilee that convinced even his sceptical followers that God had indeed raised him from the dead.

If true, then Jesus' resurrection, of course, has a right to be considered as the most momentous event that has ever taken place in the Holy Land and indeed as the true centre, pivotal and crucial, to its age-long story.

Left: Jesus was crucified at the "place of the skull" (Golgotha in Aramaic, Calvary in Latin). This cliff-face, located north of the Damascus Gate near the Garden Tomb, resembles a skull. The traditional site is now marked by the Church of the Holy Sepulchre (see pp. 100–107).

Below: A first-century tomb, together with its rolling-stone.

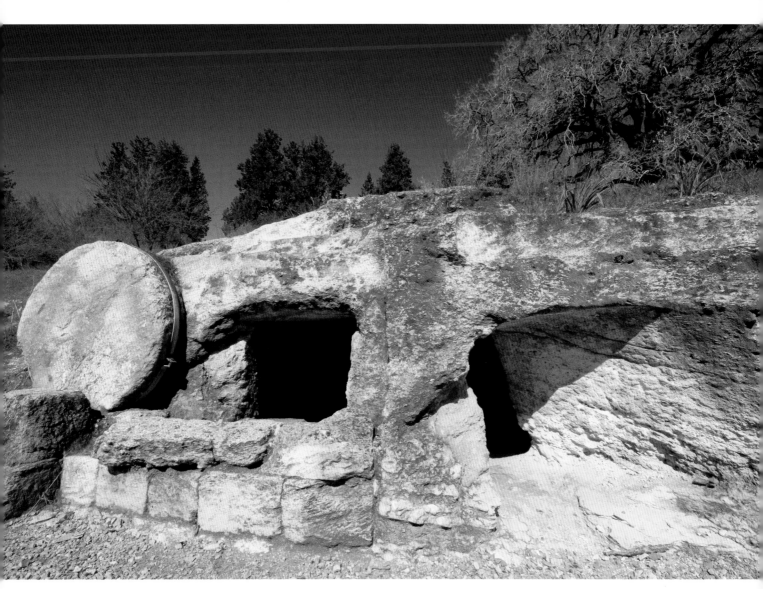

The Early Church and the Fall of Jerusalem

The next forty years are among the most well documented in the long saga of the Holy Land: the early days of the Christian church are described in the Acts of the Apostles (written by Luke in Rome c. AD 60–62); meanwhile, for events in the wider Jewish population, which culminated in the destruction of Jerusalem, we have the Jewish historian Josephus (writing in Rome c. AD 85–90). Both knew that these were critical days for the Holy Land – days of ever-mounting tension between the Jews and Romans – but they viewed the situation from different angles.

Luke and Paul: farewell to Jerusalem

Luke was not Jewish and only visited Palestine once (AD 57–59) – when he accompanied Paul, a former Jewish rabbi, who was going up to Jerusalem for the international festival of Pentecost.

Paul was a controversial figure, and his visit to the Holy City proved to be short-lived. Born in Tarsus, he had been sent by his parents (possibly Jewish refugees from Galilee, taken prisoner after a Jewish uprising) to complete his education in Jerusalem, studying Torah with Rabbi Gamaliel. However, after what he would later describe as a dramatic encounter with the risen Jesus while journeying to Damascus, Paul became one of the chief leaders of the young Christian movement. Much of his time would be spent outside the Land (building up Christian congregations in Antioch, Asia

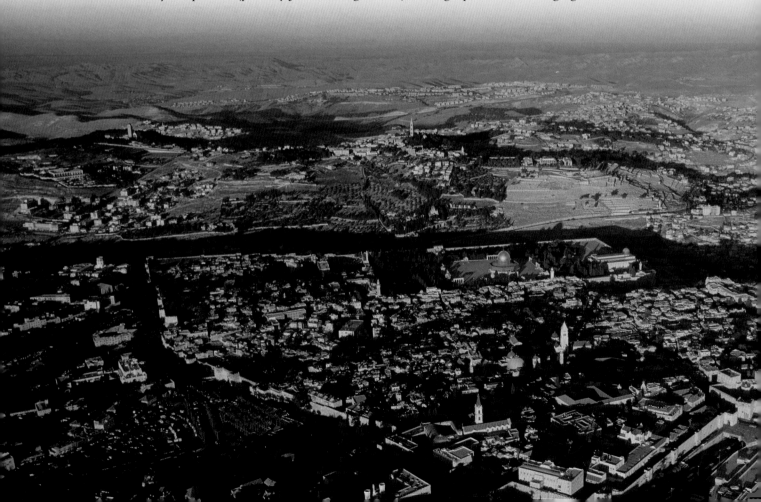

and the tensions between the Jewish nationalists and the Roman authorities are almost tangible. The local population is deeply suspicious of this new messianic movement – not least because it seems to have a far too relaxed attitude towards Gentiles (who are joining the movement without being circumcised). So, when Paul goes into the Temple, he is falsely accused of illegally taking some of his Gentile converts into the inner courts, strictly reserved only for Jews. A riot ensues, and Paul's life is only spared due to the speedy arrival of Roman soldiers; Paul then gives a brave speech, testifying to Jesus, on the steps of the Antonia fortress (see p. 75). A few days later, after various attempts on his life, he is whisked away during the night (by no fewer than 476 Roman infantry and cavalry!) down to the provincial capital, Caesarea – and imprisoned there for two years, before being sent to Rome to have his case heard by Emperor Nero.

Luke, one of those Gentile companions, survives to tell the tale. Yet that Jerusalem visit, as seen in his writings, evidently leaves its mark. He spends the next two years in Palestine, doing the research work which will result in both his Gospel and its sequel, the book of Acts. Both books tell of key journeys up to Jerusalem (by Jesus and Paul) which led to the city's rejecting them; and the second volume shows how the centre of gravity for the young Christian movement, after its initial launch within Jerusalem, gradually moved away – first through Samaria and Caesarea (Acts 8–10), then far away from the Land, eventually reaching Rome (seen by Luke as symbolic of "the ends of the earth"). By the end of Acts, Jerusalem has truly been left behind – in more ways than one.

Minor, and Greece), but every few years he would return to Jerusalem.

This time (in May AD 57), however, his visit is more climactic: he is bringing a large gift of money, intended to convey the love of his predominantly Gentile churches for the poor Jewish Christians in Jerusalem (led by Jesus' younger brother, James). The atmosphere in Jerusalem is very strained, however,

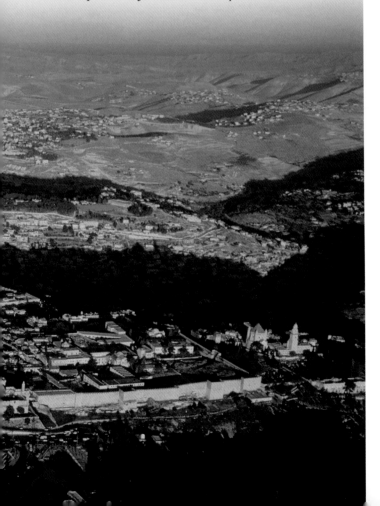

Top: An ossuary box (for storing human bones), possibly that of James (Jesus' brother), martyred for his Christian faith in AD 62.

. .

Left: Between AD 30 and 70 Jerusalem expanded to the north, with the new "third wall" probably running along the line of the later Turkish walls (*lower left*).

. .

Right: A stone plaque warning Gentile visitors to the Temple not to go any further into the Court of Israel on pain of death.

Josephus: the final days

This mounting tension, as rebellion against Rome became more and more likely, soon meant that others too would leave Jerusalem behind. Within ten years of Paul's departure, the struggling, isolated Christian community in Jerusalem sensed that the city's end was nigh and migrated northwards, taking refuge in Pella, a city in the Decapolis. Jesus had explicitly predicted the destruction of the Temple ("Not one stone here will be left on another", Mark 13:2) and advised his followers in those calamitous days to "flee to the mountains" (Matthew 24:16). Those days, his followers decided, had now come.

The Roman army under Vespasian eventually besieged Jerusalem in AD 67. There had been several flashpoints long before then. In AD 35, a revolt against Rome by the Samaritans was put down savagely by Pontius Pilate; then Emperor Caligula tried, in AD 39, to install a statue of himself in the Temple (only averted because Caligula died first). There were horrific massacres in Jerusalem in AD 49 (the year in which the Christian leaders hosted an "apostolic conference" in the city to discuss Gentile membership within the church); and throughout the 50s and 60s there was continuous in-fighting between rival warring factions. The final trigger was quite small – some provocative anti-Jewish acts in Caesarea – but, after so much escalating tension and years of waiting, little was needed to spark the conflagration.

Right: Gamla, besieged by the Romans in AD 67; its name derives from its distinctive shape (like a "camel").

Below: Pella, in the hills of Trans-Jordan near Lake Galilee – the new home for Jerusalem's Christians, fleeing the Roman siege.

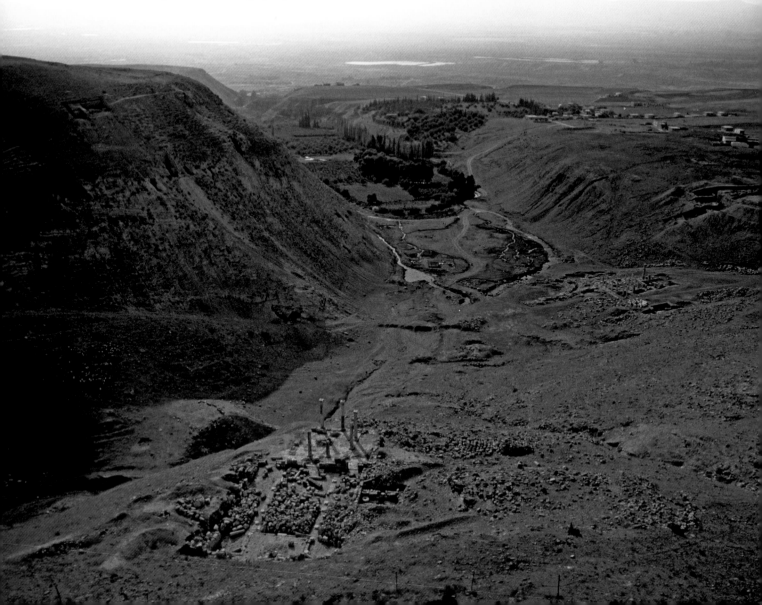

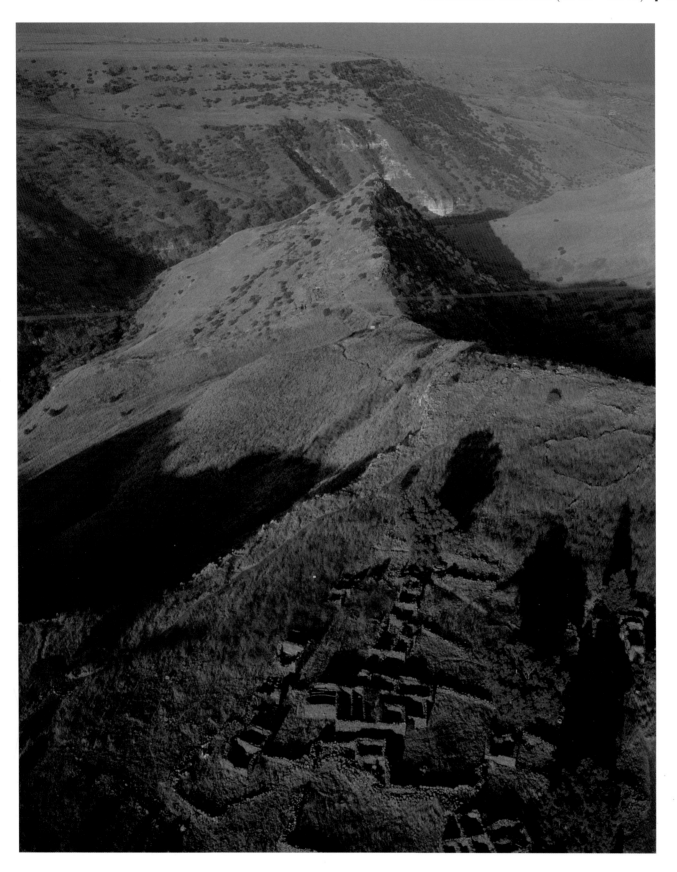

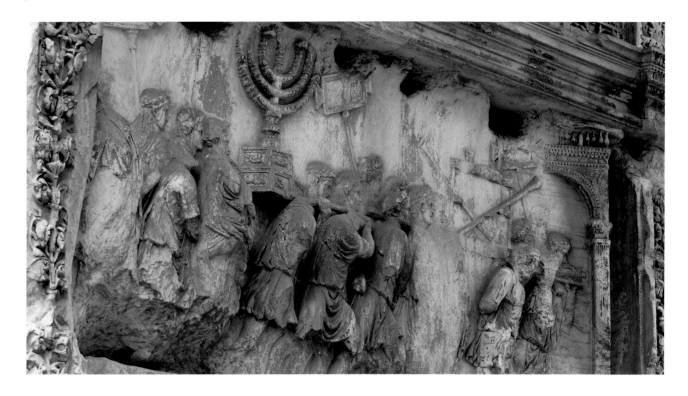

Above: Titus' triumphal arch in Rome, commemorating his destruction of Jerusalem: note the Temple's seven-branched candlestick (or Menorah).

Right: View northwards across Masada, showing the massive Roman ramp built in AD 73 to overthrow the last Jewish Zealots.

Below: Vespasian, who launched Jerusalem's siege.

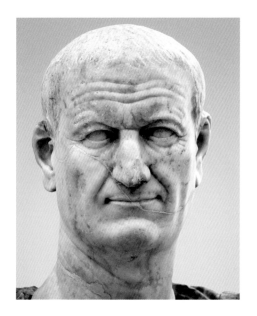

Josephus himself was an enterprising young man, immediately put in charge of the Jewish resistance movement in Galilee. Later he would describe from first-hand experience some of the horrific early events of the revolt: the siege of the hill-top city of Gamla, and the sea battles on Lake Galilee which left its waters red with blood.

However, at a critical point – and after surviving a mutual suicide pact – Josephus went over to the Roman side. He was taken into Vespasian's confidence – helped, no doubt, by his canny prediction that Vespasian would become emperor (which came true when Vespasian left for Rome in AD 69). The task of finally destroying Jerusalem was thus left to Vespasian's son, Titus.

Josephus describes in graphic detail those awful final days of the siege in the summer months of AD 70: the inhabitants' hunger and even cannibalism, the internecine warfare between the different Jewish factions. Eventually in the late summer, the Temple was stormed, its stones thrown down, and all the houses nearby burnt to the ground. After a crucial hundred years in the story of the Holy Land, Herod's scarcely completed Temple was in ruins; Jesus' prophetic words had proven true; and the brutal might of Rome, under Titus, had triumphed.

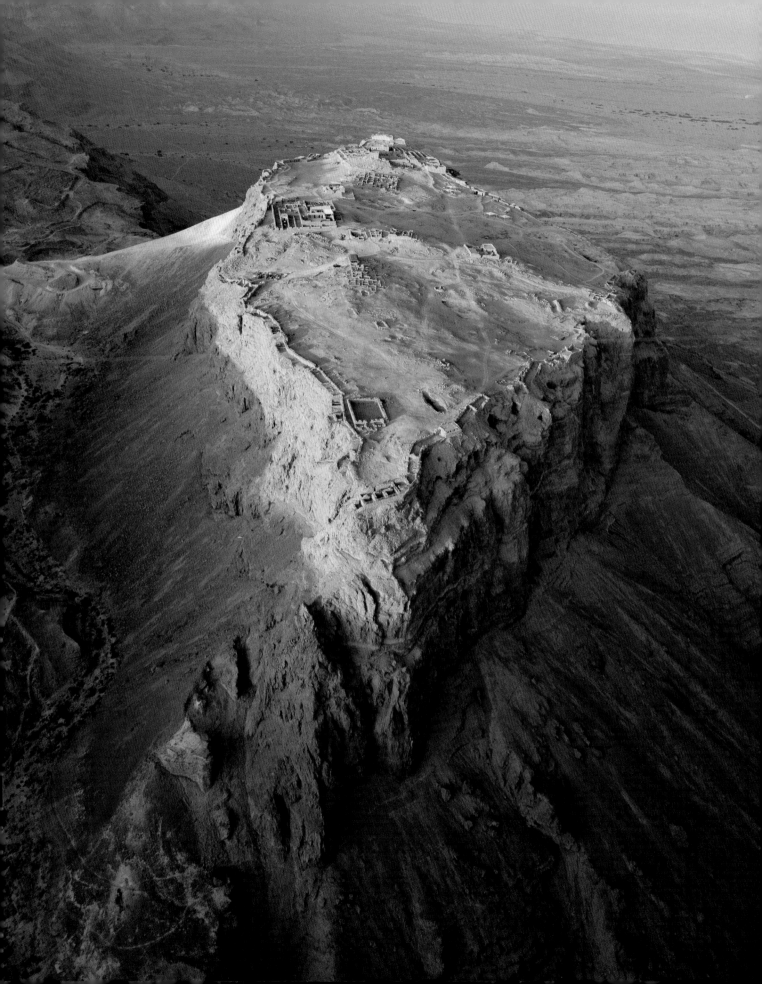

CITY IN FLAMES: The Destruction of Jerusalem

CHAPTER 5

ROMANS AND BYZANTINES
(AD 70–630)

A scholar pores over his parchments in a seaside library;
an elderly British woman issues orders to Jerusalem's builders;
a monk sits alone in his desert cave for six days a week;
and pilgrims process into Jerusalem after midnight by candlelight.
Four distinctive scenes from the next era in the Land
– that of the Byzantine Christians.

The Aftermath

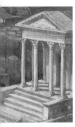

From a Roman perspective, Jerusalem's destruction seemed final. Yet sixty years later, history repeated itself. Although some in the Jewish community adapted to a Temple-less world, many found this intolerable. Led by a man called Simon ben Kosiba, they rose up against Rome yet again – in what is now called the Second Jewish Revolt (AD 132–35).

Simon was a dazzling leader. His name was soon changed in popular parlance to "bar Khochba" ("son of a star", in line with a prophecy in Numbers 24:17); and a famous rabbi, called Akiba, even declared that he was the long-awaited Messiah. Expectations ran high – with a new coinage being minted to celebrate the "first" and "second" years of this regained independence. In the third year, however, they met their match in the Roman emperor Hadrian (AD 117–138).

A definitive response

Hadrian besieged the city and, once victorious, decided that Jerusalem must be totally destroyed. No seeds of hope were to be left in Jewish hearts. So he marked out an "exclusion zone" for several kilometres around it, forbidding any Jews to catch sight of their Holy City. He set up an army camp and laid out the surrounding small town on a completely new grid plan. Worse still, he renamed this new town after his own family and the gods on Rome's Capitoline Hill: "Aelia Capitolina". Thus from AD 135, Jerusalem, both in name and in reality, was no more – obliterated (or so Hadrian hoped) from memory.

Right: Mount Sion (*foreground*), the area where Christians gathered after AD 135, now lay outside the walls of Aelia Capitolina (though it had been within the Upper City in Jesus' day).

. .

Bottom: Artist's depiction of the pagan temple and open forum, built by Hadrian over the site of Jesus' tomb in the redesigned city of Aelia Capitolina.

. .

Below: Coins minted in Jerusalem to mark the Second Jewish Revolt.

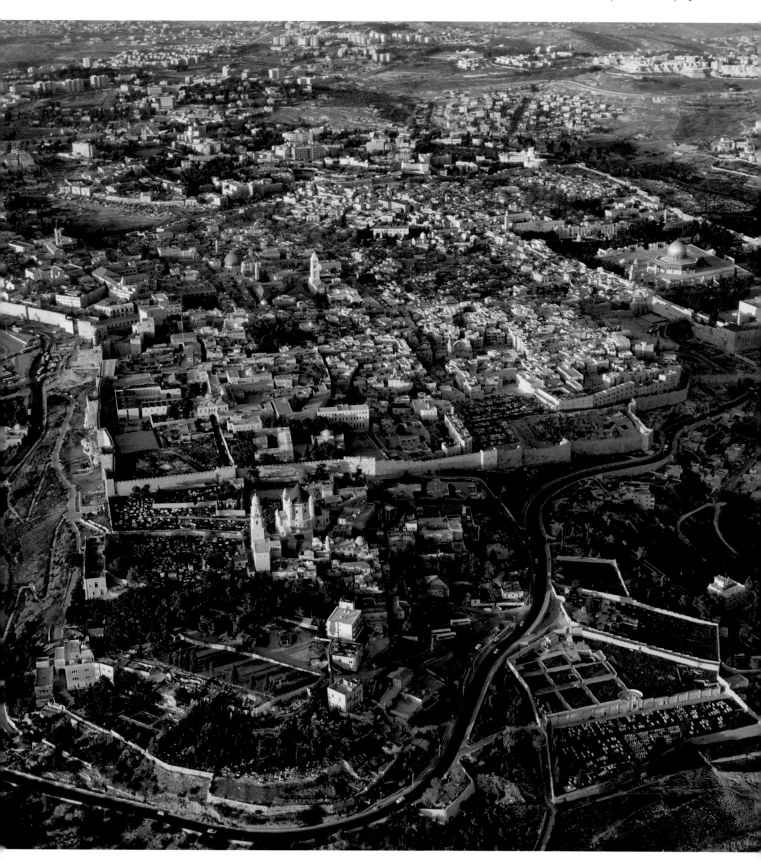

The Jewish community had to adjust. Back around AD 85 there had been an important gathering in Jamnia where the Pharisaic movement had come to the fore. Now, after 135, this Pharisaic or "Rabbinic" Judaism became even stronger, re-establishing Jewish identity on the foundation of studying Torah within synagogues.

Meanwhile, Judaism's geographical centre moved to cities in the north, such as Sepphoris and Tiberias. These (originally pagan) cities now became vibrant centres for Jewish life and scholarship. Thus around 200, a collection of Jewish traditions (the Mishnah) was produced in Sepphoris, to be followed several centuries later by the Palestinian Talmud produced in Tiberias. For the next 1,500 years or more, the key Jewish presence in the Land would be here around Lake Galilee.

Comparative poverty

However, Jews and Christians were a small minority within the population of what the Romans termed Syria Palaestina. After the ravages of both 70 and 135, new people groups, including army veterans and Roman colonists, moved into the area. Fortunately, there were few military threats from the East during this period, but the province as a whole would economically have been quite poor.

Below: Signs of pagan culture – a theatre in ancient Tiberias.

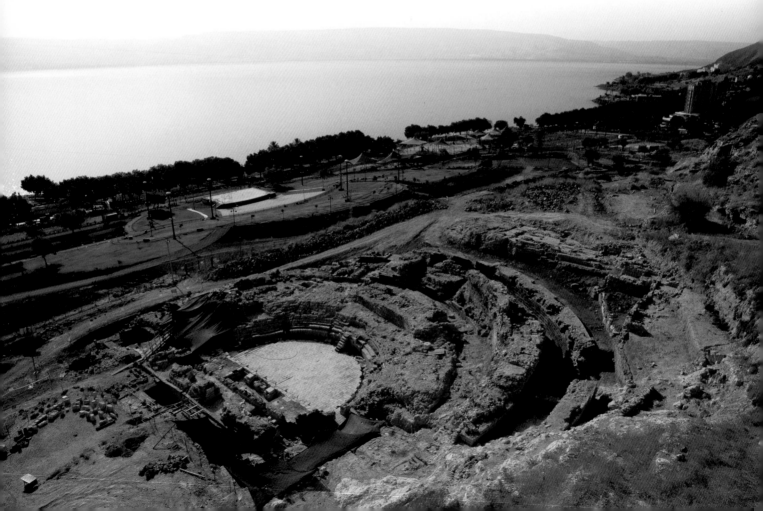

The only exception was the provincial capital, Caesarea Maritima. Some rabbis had sensed the implicit contrast – even rivalry – between Jerusalem, the religious city in the hills, and Caesarea, the worldly city on the Mediterranean. Now that Jerusalem was no more, Caesarea naturally came into its own.

And it was here that the Christian church began to put down some firm roots. Already by 200 its bishops were recognized as the "metropolitans", with jurisdiction over all of Palestine. There was an important Christian library here, set up by a prolific scholar called Origen (d. 253/54). Yet the Christian community would also take its share of the intense persecutions instigated by the imperial authorities. Eusebius, soon to become Caesarea's bishop, would write an entire book (*The Martyrs of Palestine*) listing the atrocities his contemporaries suffered during the eight-year persecution instigated in 303 by Emperor Diocletian.

Thus, at the dawn of the fourth century, the prospects for Palestine as a whole – and the Christian community in particular – looked bleak. Few could have guessed what would happen next…

Left: A small gate (part of a larger "triple gate") built by Hadrian, now just to the left of the Damascus Gate.

Bottom: The small cave-church, used from at least the third century to commemorate Mary's home in Nazareth; now under the Basilica of the Annunciation.

Below: The theatre and other buildings in Sepphoris, a major city in ancient Galilee (just 7 km from Nazareth).

The Constantinian Century (AD 310–410)

In AD 325 everything suddenly changed. Jerusalem had a dramatic face-lift, brought about by the arrival in the East of a new emperor – Constantine.

In 305 the Roman emperors Diocletian (in the East) and Maximian (in the West) had abdicated in favour of their chosen successors, Galerius and Constantius. The next year, Constantius died (during a military campaign in northern Britain), which led to a major power struggle. Eventually Constantius's son Constantine (married to Helena, a British woman) would emerge victorious in the West. During his campaign, on the night before a decisive battle at the Milvian Bridge, he saw a cross in the sky and heard the words *"in hoc signo, vince"* ("in this sign, conquer").

..

Below: Emperor Constantine and his mother, Helena, jointly holding the wood of the cross.

As a result, when Constantine won and began to rule the western half of the empire, persecution of Christians (now perhaps 15 per cent of the empire's population) came to a halt. Instead he tried to harness their energies for his own purposes. So when he defeated his rival, Licinius, at the battle of Adrianople (in 324), the eastern half of the empire – including Palestine – now found itself under a single emperor who actively espoused the Christian cause.

A strategic vision

The following July Palestine's bishops (including Eusebius of Caesarea and Macarius from Jerusalem) were invited to a splendid conference hosted by Constantine in Nicea – not far from the new imperial capital, the "New Rome" built on the site of a small Greek colony called Byzantium (now renamed Constantinople). Surrounded by the pomp of the imperial court, they could chat with the emperor – dreaming dreams about the untapped potential of a possible "Christian Palestine".

For, 300 years before, this province had witnessed the life of a unique man whom these bishops now worshipped as the Son of God and Lord of the cosmos – a person who had lived uniquely in Palestine. What could be more fitting, then, than that Constantine, elevated to ruling most of the known world, should honour the places associated with this King of Kings? There was also something appropriate about a Roman emperor vindicating in public someone who had been crucified on a Roman cross. So began what has been called Constantine's "Holy Land Plan": the building of Christian basilicas (or royal buildings) on a range of sites associated with the life of Jesus Christ as recorded in the Gospels – which, for Constantine, also provided his subjects with powerful and uniting symbols of his own magnificent reign.

..

Right: View from the entrance of the Tomb of Christ within the Church of the Holy Sepulchre (known to Eastern Christians appropriately as the Church of the Resurrection).

A unique archaeological find

The first priority was to recover from oblivion the site of Jesus' death and resurrection. Constantine's excavators knocked down a pagan shrine that had been placed over the likely spot during Hadrian's re-ordering of the city in AD 135. This was risky. What if the local Christian memory was wrong? What if there was now nothing to find?

Yet there was! Eusebius describes in extended and gushing terms that amazing moment when suddenly the workmen discovered "contrary to all expectation, the venerable and hallowed monument of our Saviour's Resurrection". After "lying buried in darkness, it again emerged to light", thus offering a striking parallel to what had happened 300 years previously to Jesus' own body: burial followed by resurrection (*Life of Constantine* 3.25). This risky archaeological excavation – almost unique in the ancient world – had found its buried treasure.

The excavators found other tombs nearby, confirming that this had been a Jewish graveyard in the first century. However, they identified one as Jesus' (presumably because it matched the Gospels' detailed accounts) and proceeded to cut into the natural rock all around it, enabling it to become a self-standing structure. Worshippers could walk all around Jesus' tomb, and it could be incorporated as the central feature under a large dome (known as the "Anastasis" or "Resurrection", completed about twenty years later). Meanwhile, to its east they constructed a courtyard and vast basilica (known as the "Martyrium" or "Witness", eventually dedicated in September 335).

Eusebius describes in great detail how, soon after the tomb's discovery, Helena, the queen mother, visited. She commissioned two further basilicas, one the Church of the Nativity in Bethlehem, the other the "Eleona" (or "Olive" church) on the Mount of Olives. Significantly, however, he does not mention what we expect – the discovery of the wood of the cross. By the end of the fourth century, rumours and legends were rife all around the empire – that Helena, by miraculous means, had identified some wood found in the excavations as the true cross. Quite possibly Eusebius was aware of this story, but kept silent because he was sceptical about the likely authenticity of any wood found in the debris. For him, the focus was on the tomb, which had all the hallmarks of being the genuine article.

Jerusalem: back at the centre

Jerusalem was now once more back on the map, and visitors flocked in. In 333 a man from Bordeaux wrote a brief travelogue of his journey; and there is a fulsome diary account from an energetic Spanish nun, Egeria (visiting around 384). Some came and stayed, establishing monastic communities on the Mount of Olives or in Bethlehem.

..

Right: View south-westwards over the Church of the Holy Sepulchre, showing the extent of Constantine's original church – from the large dome (*centre*) to the narrow street or passageway (*bottom left*). Note too the minaret of the Mosque of Omar and the tower of the Lutheran Church of the Redeemer (*middle, to the left*).

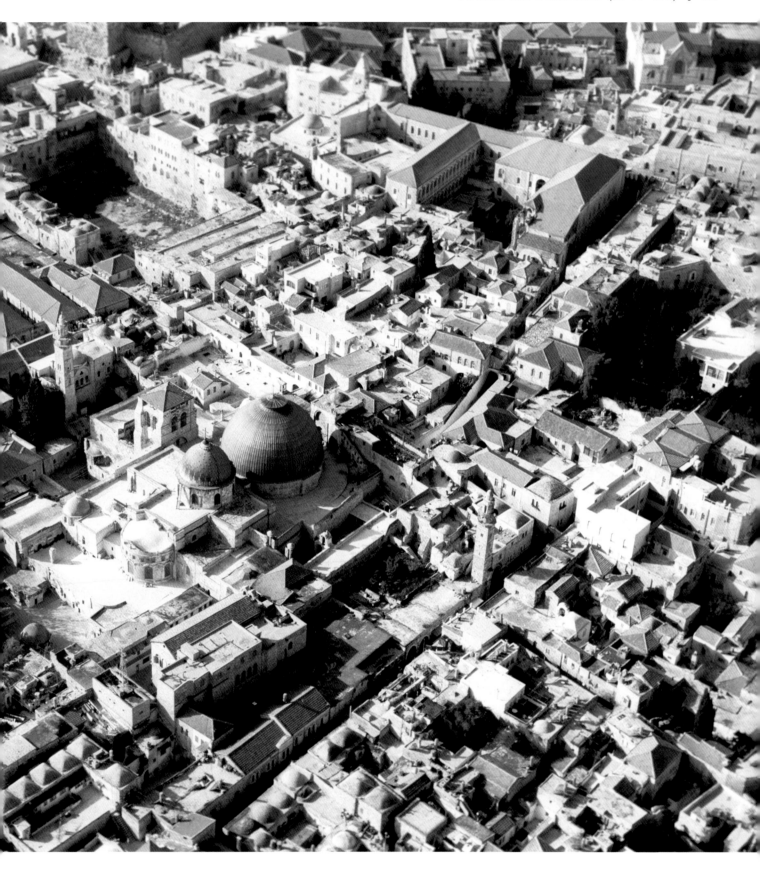

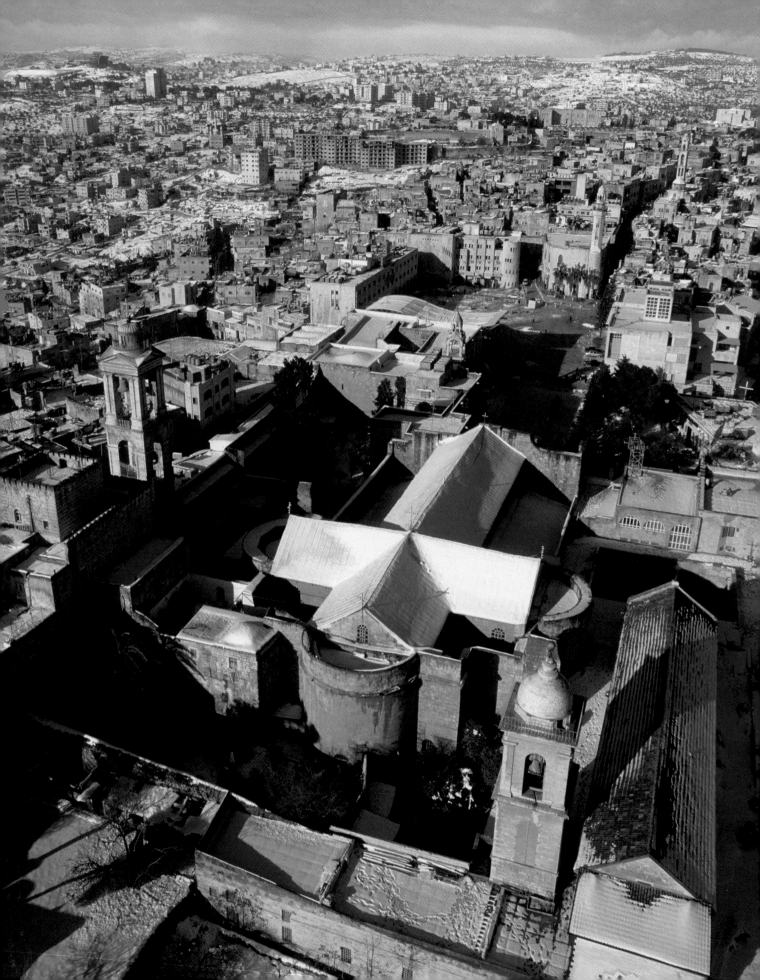

All this had massive repercussions for the Christian congregation within Jerusalem. Up till now it had been quite small. In his earlier *Church History* (c. 290), Eusebius says the Christians in Jerusalem kept a list of their bishops, held some important archives, and treasured a chair that they claimed had been used by James, their first "bishop". Now, however, they found themselves at the epicentre of a new Christian world. Aelia Capitolina was no more; Jerusalem had been reborn – causing Eusebius to compare it to the "New Jerusalem" prophesied in Revelation 21–22.

Things developed yet further under the colourful personality of Cyril (bishop of Jerusalem from 348). In giving his baptism classes that year he developed further this theme of Jerusalem's "pre-eminence". This was the city of the cross and the resurrection; where the Eucharist was instituted, and which was the supreme focus of the incarnation. "Others only hear, but here we can see and touch." He described with pride how the "wood of the cross" had spread from Jerusalem to "all the world" (*Catechetical Lectures* 14:26; 13:22; 10:19).

Cyril's enthusiasm for Jerusalem is evident in his development of "Holy Week" – an eight-day festival from Palm Sunday to Easter Day in which Jesus' last

Above: The Church of the Nativity, redesigned by Emperor Justinian (527–565). Mosaic flooring from Constantine's earlier basilica can be seen by visitors below the trap-doors (*bottom left*).

Left: A rare view of Bethlehem in snow, looking westwards over the Church of the Nativity towards Manger Square.

Below: The Armenian Chapel of St Helena (below ground level within the Church of the Holy Sepulchre), commemorating her discovery of the "wood of the cross" in this or nearby cisterns.

movements were remembered in sequence and in their original locations – with processions out to Bethany, candle-lit prayers in Gethsemane, and night-time vigils in the area around Golgotha. Celebrating Holy Week in Cyril's Jerusalem would have been exhausting – but also deeply moving and inspiring.

And when people returned to their native lands, they naturally asked their local clergy if this could now be implemented at home. So, within the first hundred years after Constantine, the whole shape of the Christian year (from Advent and Christmas to Easter and Pentecost) spread around the Mediterranean – another of Jerusalem's legacies to the wider world.

This whole pattern has been repeated ever since, as Christian visitors to the Holy Land come from all over the world to celebrate the story of Jesus either in, or very close to, the actual locations where those events first occurred. Those belonging to historic denominations – Orthodox, Catholic, Armenians, Copts or Ethiopians – use liturgical forms, which are often almost unchanged since Cyril's time. And, even if they speak different languages or have different traditions, there is something uniquely powerful for them all in proclaiming together in Jerusalem that message which was first heard just outside the city's walls on the first Easter Day: "He is not here; he is risen!"

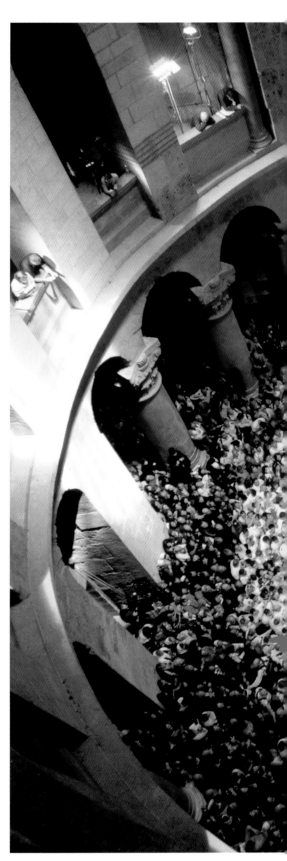

Right: "Christos anestee!" (Greek for "Christ is risen"): the long-awaited moment on Holy Saturday when the Greek patriarch reveals the Holy Fire at the entrance to the Tomb of Christ.

. .

Far right: View from the Rotunda (first completed in the AD 340s) in the Church of the Holy Sepulchre: worshippers crowd round the *aedicule* (built above the Tomb of Christ), awaiting the appearance of the Holy Fire, a dramatic symbol of Jesus' resurrection.

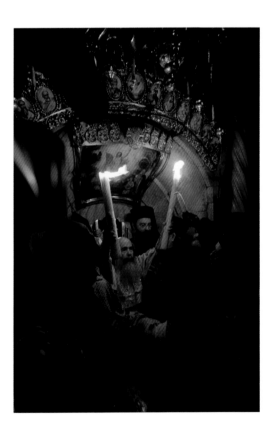

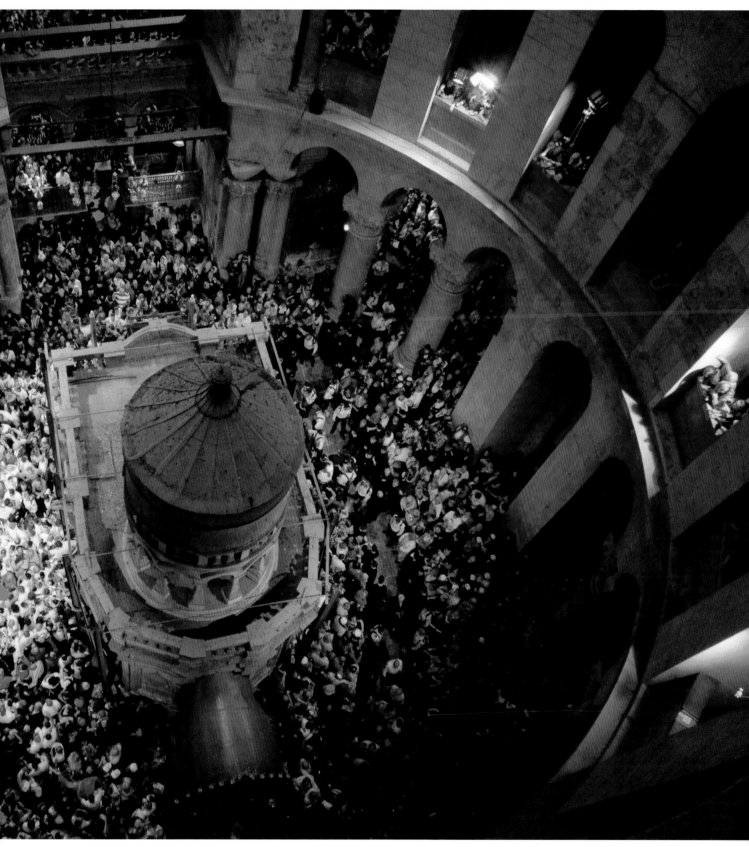

The Rule of Byzantium

Constantine never visited the Holy Land (though he spoke on his deathbed of having wished to be baptized in the River Jordan). However, his keen interest in the Land left a lasting legacy – for the next three centuries, through to the arrival of Islam (in AD 638), and indeed beyond.

Jerusalem experienced a resurgence, becoming an international centre for the worldwide Church. Its population was swollen with new Christian residents, mostly Greek-speaking, but with a sizeable minority from outside the Byzantine empire – from Syria, for example, and Armenia (the first nation to have adopted the Christian faith as its official religion, in 301).

A building spree

Construction developed apace, with new streets and houses. After the Church of the Holy Sepulchre was completed, further basilicas appeared – one outside the city on the hill of Mount Sion (commemorating the events of Pentecost and marking the site where the Christian community had worshipped during the

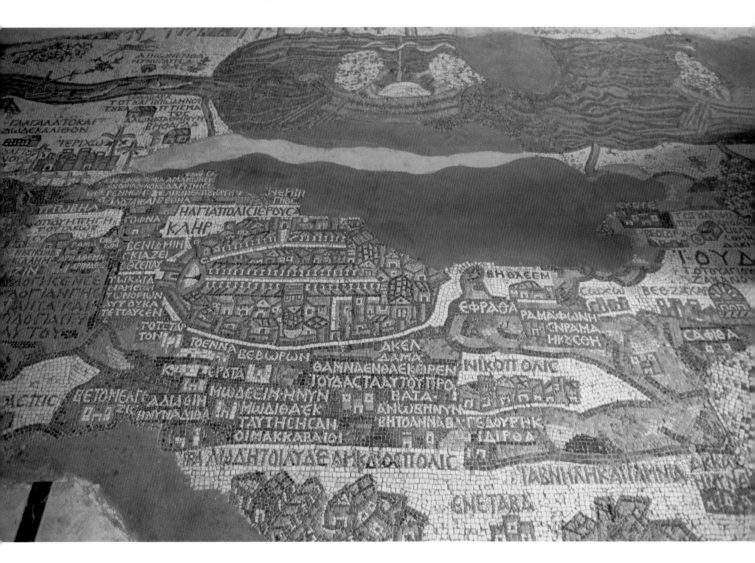

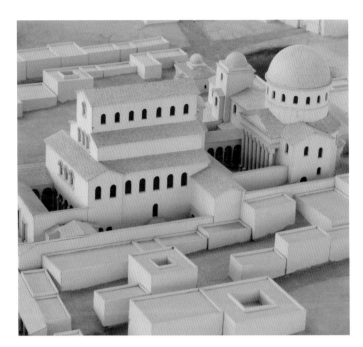

days of "Aelia"); the other just inside the walls (the "New" church dedicated to the Virgin Mary).

The phenomenon of a Christian Jerusalem proved especially attractive to women. In addition to Helena and Egeria (already mentioned) we learn of other keen female visitors (such as Paula and Eustochium, both friends of Jerome, a monk in Bethlehem) and of nuns living on the Mount of Olives (near the new "graceful church" in Gethsemane), who joined in the city's liturgical celebrations.

Far left: A large floor mosaic within a sixth-century church in Madaba, Jordan, depicting Byzantine Palestine.

Below: Balsa-wood model of Byzantine Jerusalem, looking southwards from the area of the modern Damascus Gate along the Cardo Maximus towards Constantine's Church of the Holy Sepulchre (*detailed above*).

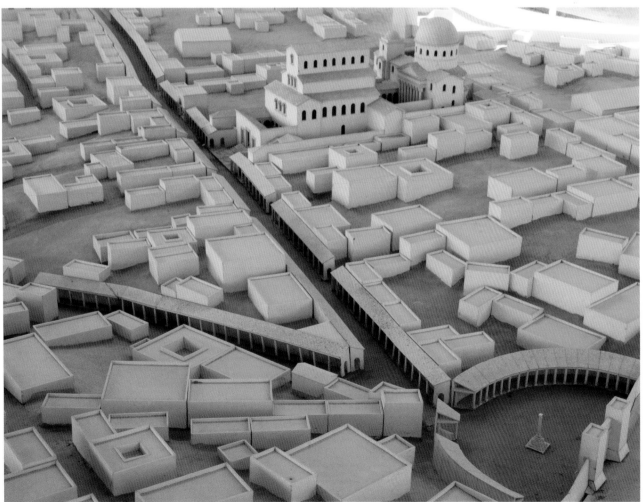

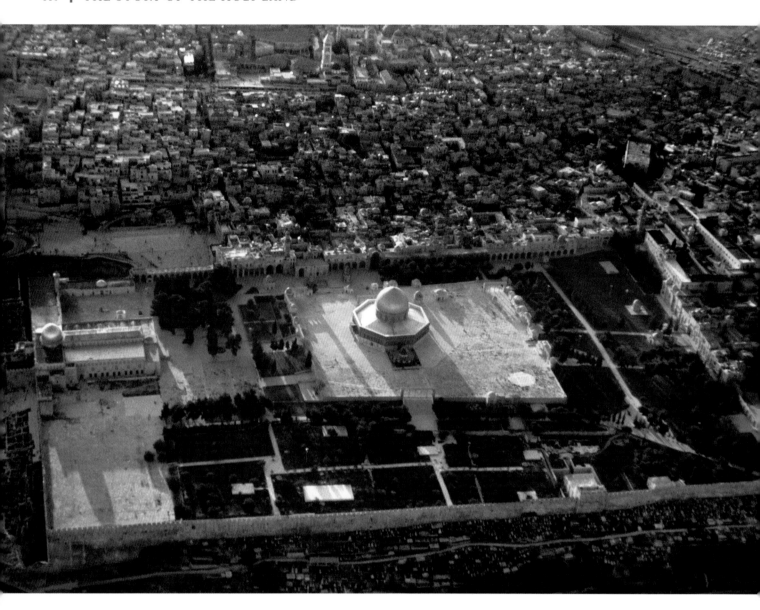

Some women also gave generously from their independent means to fund this building spree. Poemenia funded the construction of a small octagonal building on the very summit of the Mount of Olives. This "Imbomon" commemorated the moment of Jesus' ascension, which previously had been remembered in Constantine's Eleona church, built over a cave fifty metres to the south. However, pilgrims had found this "cave of the ascension" an unhelpful contradiction in terms, and so were very grateful when Poemenia's small building was left suitably open to the sky – something far easier for their imaginations!

Similarly, in the fifth century, further building projects were funded by the Empress Eudocia (wife of Theodosius II), who first visited Jerusalem in 438 and eventually died there in 460. Due to her patronage, the city's walls were completed and foundations were laid for yet another basilica – this time to commemorate the first Christian martyr, Stephen, who had died somewhere outside the city walls (quite probably, as they reasoned, in the area north of the Damascus Gate).

Above: The vast area of Herod's Temple platform, which Byzantine Christians deliberately left undeveloped – as a witness to Jesus' predictions of the Temple's destruction.

Pilgrims demand sites

There were also developments outside Jerusalem: Christian pilgrims inevitably wanted to visit Galilee. Although the population in this area was predominantly Jewish, Count Joseph had petitioned Constantine for permission to build some small churches and had been successful, despite some local opposition, in both Nazareth and Capernaum (where small groups of Jewish Christians may have lived since the first century).

Other Gospel sites were soon identified, such as Cana (commemorating Jesus' attendance at a wedding feast), Mount Tabor (as the scene of Jesus' transfiguration), and Heptapegon (or "seven springs"). The last of these (now in Arabic known as Tabgha) was by the lakeside, just before pilgrims reached Capernaum. A range of Gospel episodes could be commemorated here – Jesus' Sermon on the Mount, his encounters with his fishermen disciples, and the miraculous feeding of the 5,000.

Right: Five pillars from the main north–south street (Cardo Maximus) in Byzantine Jerusalem.

Below: Floor mosaic in the sixth-century synagogue at Beit Alpha, depicting (*foreground*) Abraham's sacrifice of Isaac (Genesis 22).

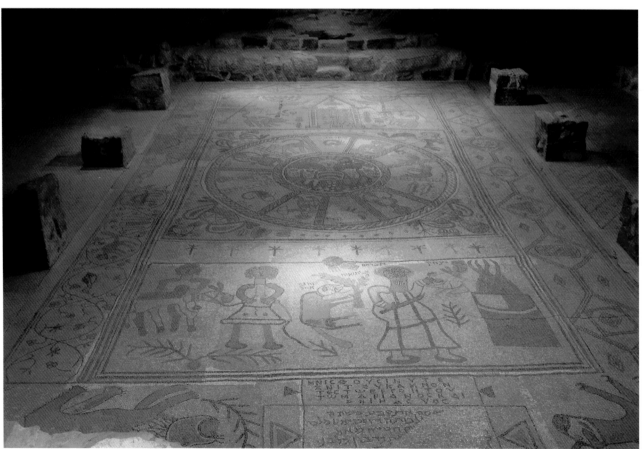

Many of these sites may well not have been identified correctly in line with biblical evidence. The feeding of the 5,000, for example, is described by the Gospel writers as being in a "remote, desert place" – presumably some considerable distance from both Capernaum and Bethsaida (and thus probably on the far, north-eastern side of the lake). These mistaken identifications, however, were the effects of some basic practicalities. Pilgrims, then as now, tended to prefer specific places (not vague locations and mere possibilities); some of the original sites were also hard to pin down and certainly off the beaten trail. Thus, for example, the site of Jesus' transfiguration (as Eusebius correctly suggested) may well have been in the far north of the country – in the foothills below Mount Hermon – but it was far more convenient for Bishop Cyril, a few years later, to opt categorically for Mount Tabor, close to Nazareth.

The pilgrims' appetite for identifying Gospel sites caused a multitude of sites to be selected during this early Byzantine period, all of which, even if chosen for sensible reasons, have little claim to strict authenticity. By contrast, those sites that were identified *before* the coming of Constantine (such as the places of Jesus' birth and burial, his home in Nazareth, and Peter's home in Capernaum) are more likely to be authentic. Moreover, the well at Sychar (where Jesus sat talking to a Samaritan woman, recounted in John 4) can be identified with certainty: wells simply do not move. Here at least the Christian visitor knows that "X marks the spot"!

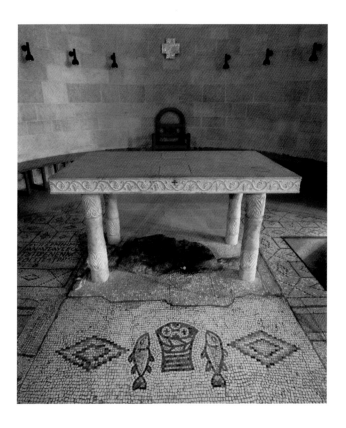

Above: Fifth-century mosaic of the loaves and fishes, preserved within the modern Benedictine church at Tabgha, commemorating Jesus' feeding of the 5,000.

Below: View south-eastwards across the top of Mount Tabor, with its modern Italian church commemorating Jesus' transfiguration.

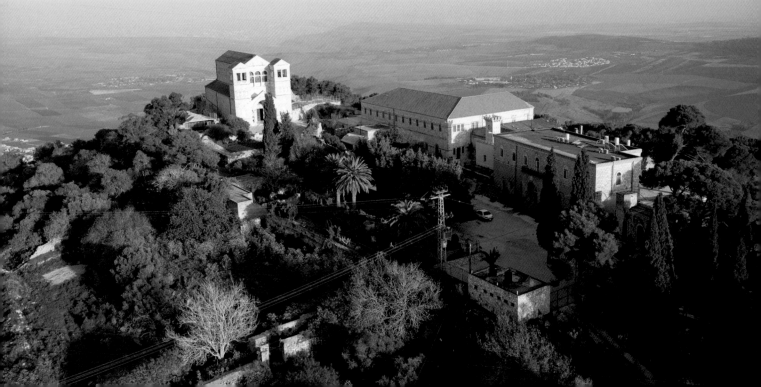

"The desert a city"

This newfound Christian interest in the Land affected it in other ways. Better roads and accommodation units for pilgrims were required; and the trade in relics began to blossom (often in slightly bizarre ways) as people wanted to take home precious keepsakes of their visit (archaeologists have turned up many small jars, designed for those taking back some olive oil or even soil).

There was also the magnetic lure of the desert. Following in the steps of Anthony, who had first gone out into the Egyptian desert as a hermit around 280, a veritable stream of Christians sought the solitude of the Judean desert – used by Jesus for prayer.

The first known Palestinian monk was Chariton, who founded a small desert community around 330; others followed in later generations (such as Euthymius, Sabas, and Theodosius). The monastery associated with St Sabas (Mar Saba) has continued to this day (see pp. 94–95). During the peak period (in the sixth century), there may have been up to 30,000 monks in the desert to the east of Jerusalem and Bethlehem. In a memorable phrase, the desert itself thus "became a city".

There were two basic types of monastic community: in one (the *coenobium*, developed by Pachomius, 292–346)

the monks lived together in a small fort-like building; the other arrangement (the *laura*, Greek for "lane") had the monks living in cave-cells, spread along a track or lane, and coming together on Sundays for worship and a common meal. There was also the attractive possibility of joining in the liturgical celebrations at Christmas and Easter in the nearby cities of the incarnation (Bethlehem and Jerusalem) on the western horizon.

Sometimes these desert fathers got caught up in the ecclesiastical politics they had hoped to escape. There was much consternation in their ranks when Bishop Juvenal of Jerusalem, attending the council at Chalcedon (451) to discuss the "two natures" of Christ, sided with the Orthodox rather than with those who argued for "one nature", such as the Egyptians. So the desert monks were not as impressed as Juvenal had hoped they would be when he returned to Jerusalem – despite his having

Above: Since the fifth century the monastery of St George of Koziba has clung to the side of the steep Wadi Qelt in the Judean desert, 2 km west of Jericho.

secured Jerusalem's status as the fifth "patriarchate" in the Byzantine church.

Overall, the fifth and sixth centuries were calm and prosperous days in the Land. The chief unrest was caused by the Samaritans, who rebelled against Byzantine rule four times (in 484, 500, 529, and 555). This long period of comparative peace, however, would come to a sudden end early in the seventh century, when the rulers in Constantinople had to yield to two (very different) peoples who would come into Palestine from the East – first the Persians, and then the Muslims. For the monks in the desert and those living in Jerusalem, those halcyon days, in which they sensed that Christ himself ruled over his Land, were soon to be a thing of the past.

Above: Sunset over a Byzantine church in Shivta, a city deep in the Negev desert (40 km south-west of Beersheba) first populated by the Nabataeans.

Right: View within the Church of the Holy Sepulchre of the Rotunda (restored in 2000) set high above the *aedicule* (restored in 1810), which covers the Tomb of Christ.

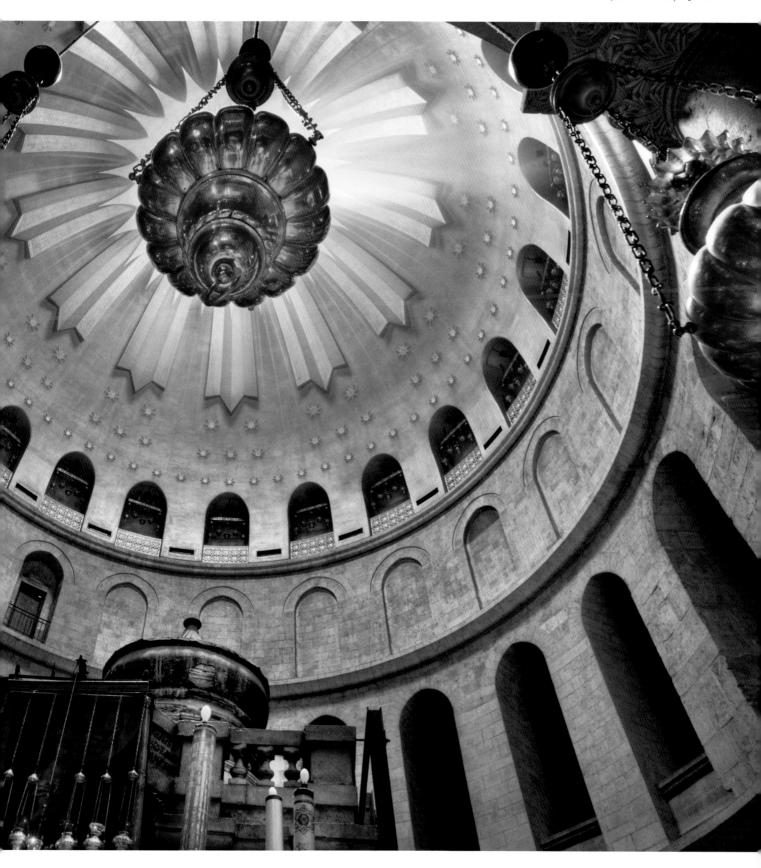

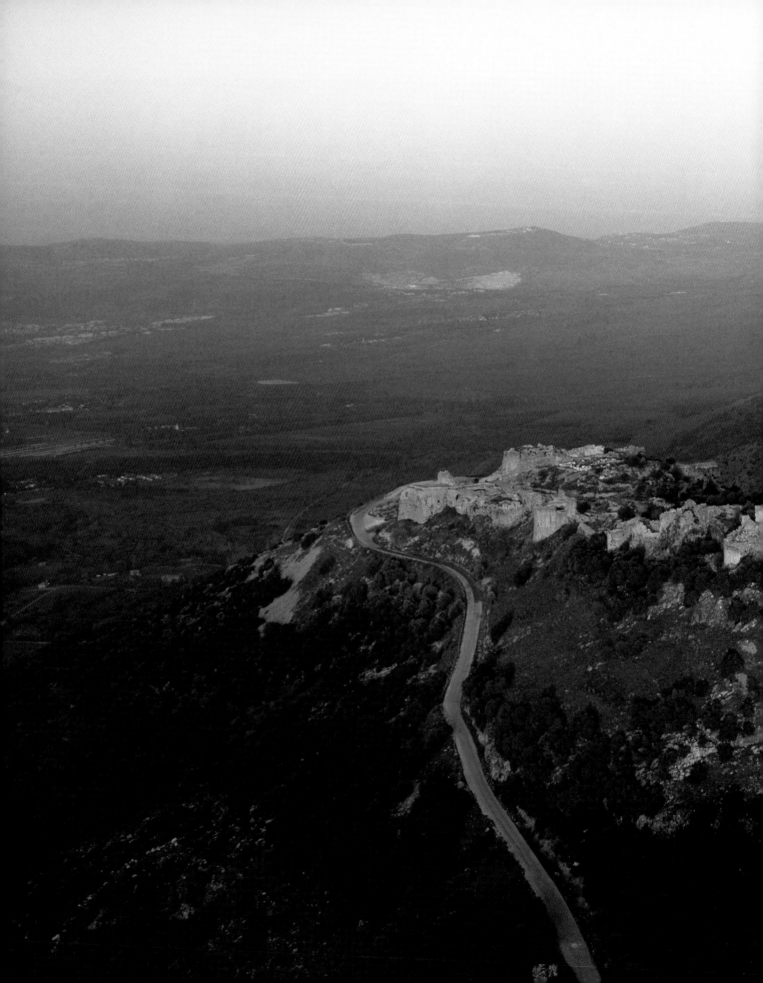

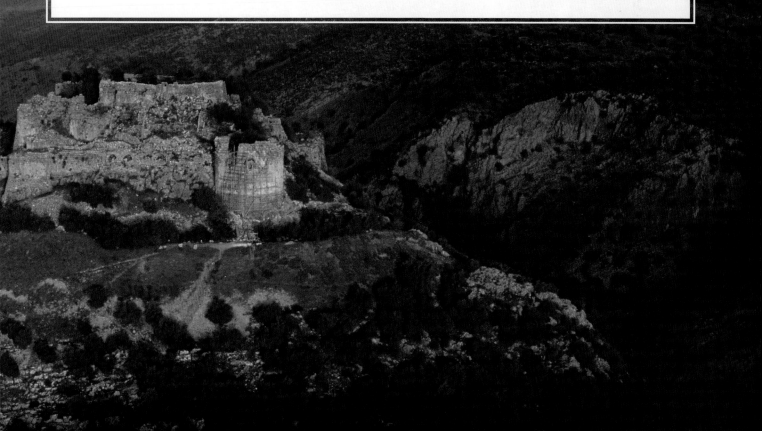

CHAPTER 6

MUSLIMS AND CRUSADERS
(AD 630–1291)

A conqueror enters the Holy City on a camel; another, at the end of a fierce day's fighting, entertains his defeated foe in his tent and offers him ice-cold sherbet; a woman leads some jubilee celebrations, fifty years after a bloodbath; men stage a last-ditch stand in a harbour, before fleeing to a few waiting ships…

The Arrival of Islam

The year AD 614 is still remembered. After an uneasy truce between Byzantium and the expanding Sassanid empire, King Chosroes II unleashed his Persian troops into Palestine. This was the first of two very different invasions: the one twenty years later by the forces of Islam was peaceful; this one by the Persians was savage.

Persian butchery

The effect was cataclysmic: a twenty-day siege of Jerusalem, followed by its capitulation; monasteries and churches destroyed; monks butchered to death and pilgrims sent fleeing; relics captured and removed to the Persian capital, Ctesiphon. Just about the only building that was spared was the Church of the Nativity in Bethlehem – only because the Persian soldiers were impressed by the Persian headdress of the Magi (depicted in the murals over its entrance). The soldiers were marauding hordes from the East and cared little for the long history of the Land.

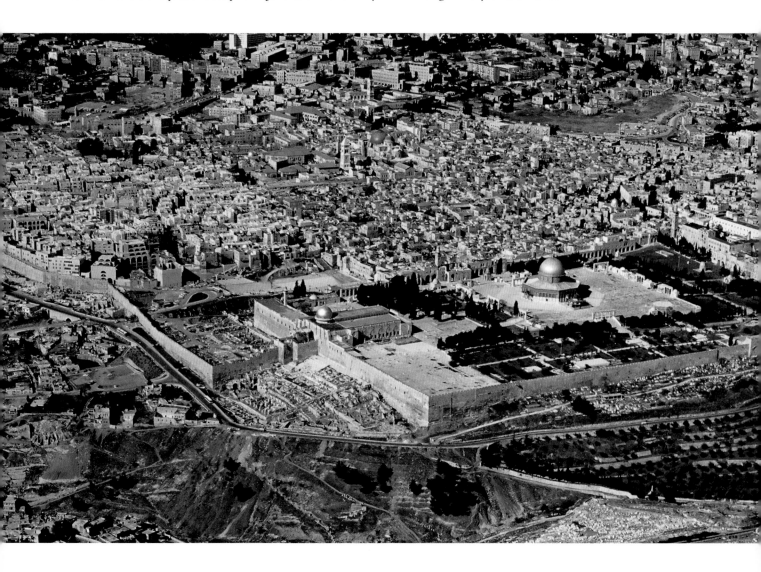

The Byzantine emperor, Heraclius, fought back in a long campaign and eventually (in 628) succeeded in bringing back to Jerusalem the captured relic of the "true cross". There was much rejoicing on that day (its anniversary, 14 September, is still a major festival in Jerusalem), but it was destined to be short-lived. Over that eastern horizon there loomed a second, more powerful, force. It would come far more quietly than the Persians, but when it came, it would stay: the new creed of Islam.

Below: The former Temple Mount, known in Islam as the Haram esh-Sharif ("the noble sanctuary"), with the silver-domed Al-Aqsa Mosque at its southern end and the golden-domed Dome of the Rock at its centre.

A second invasion

Mohammed's powerful ministry as a prophet had been developing in Arabia, first in Medina and then, from 622, in Mecca. By March 635 his followers, who were mostly nomadic tribes, had come north and besieged Damascus. During the following year, they brought the whole of Palestine under their control – except for the large urban cities of Jerusalem and Caesarea. Eventually, in 638, Jerusalem capitulated – with Caliph Omar demanding to ride into the city on a camel and in a cloak of camel hair. The aged Christian patriarch, Sophronius, persuaded him to change his clothing for this triumphant entry, and then did some necessary negotiations with the new conqueror; but within a few weeks he had died – his heart broken, so it was said, at witnessing Jerusalem's capture for the second time within twenty-five years.

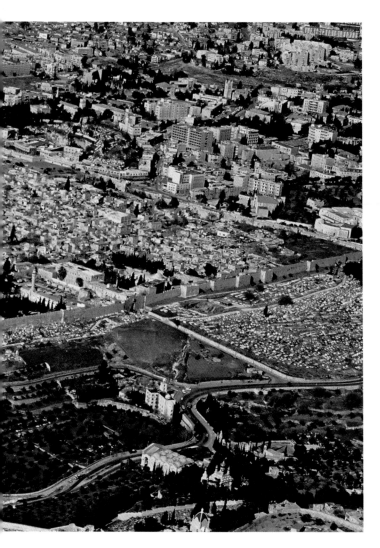

According to some early traditions, Caliph Omar deliberately refused Sophronius's offer of praying within the Church of the Holy Sepulchre – on the grounds that his followers would demand to be able to pray in any place where he, their leader, had prayed. Instead, he prayed to its south (where a mosque bearing his name still stands to this day, see pp. 102–103).

Above: The Dome of the Rock at twilight, with the Mount of Olives in the background.

A third "holy city"

Omar does not seem to have started a major building project in Jerusalem. Indeed, scholars now suggest that Omar and those caliphs who succeeded him were not particularly interested in the potential religious significance of Jerusalem. True, Mohammed had initially named Jerusalem as the first *qiblah* (or direction for prayer), but after thirteen years, in 623/24, this was abandoned in favour of Mecca. An Islamic devotion to Jerusalem seems instead to have developed a hundred years later (from after 725), when extended eulogies were written in honour of the city. These state that "one prayer in Jerusalem is worth a thousand elsewhere" and reveal the Islamic belief that the city will play a central role in the events of the end times.

This new focus on Jerusalem's sanctity came about, no doubt, as Muslims began to respond to the two hugely impressive buildings constructed on the site of the former Jewish Temple: the Dome of the Rock (completed in 691 on the orders of 'Abd al-Malik) and the Al-Aqsa Mosque (started soon after his death in 705).

Above: Ornate Islamic decoration within the Dome of the Rock.

Right: The rock (or *sakhra*) under the Dome is the highest point of the former Temple Mount, thus quite possibly marking the site of the Holy of Holies in Solomon's Temple.

Below: Interior of the Al-Aqsa Mosque, looking southwards.

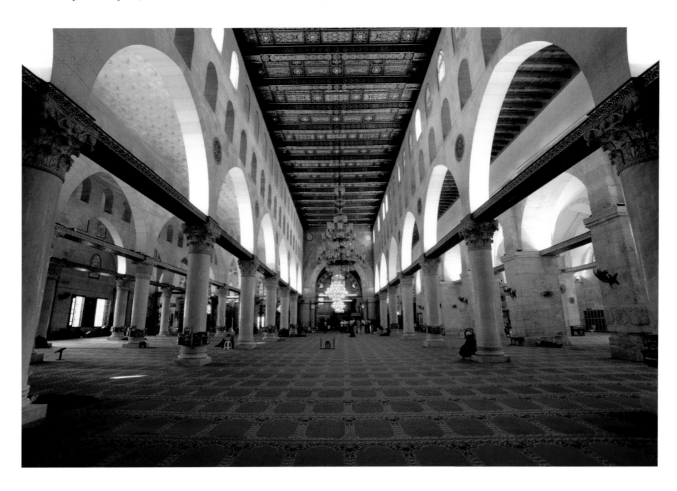

The Byzantine Christians, focusing instead on a different hill to the west (the site of Jesus' resurrection), had deliberately left this large area undeveloped – a dramatic endorsement of Jesus' predictions about the Temple's imminent destruction. Malik took advantage of this obvious blank space within Jerusalem's city plan. The Temple Mount (and the residential area immediately to the south) became the ideal place to develop a distinctively Islamic enclave within the city. And the contrast between the two nearby hills sent out a clear political message: if Christianity thought it had eclipsed Judaism, then Islam had now eclipsed Christianity.

The Dome of the Rock was built, according to tradition, over the rock (or *sakhra*) where Abraham had attempted to sacrifice his son Isaac on Mount Moriah. Meanwhile, *Al-Aqsa* is an Arabic reference to the

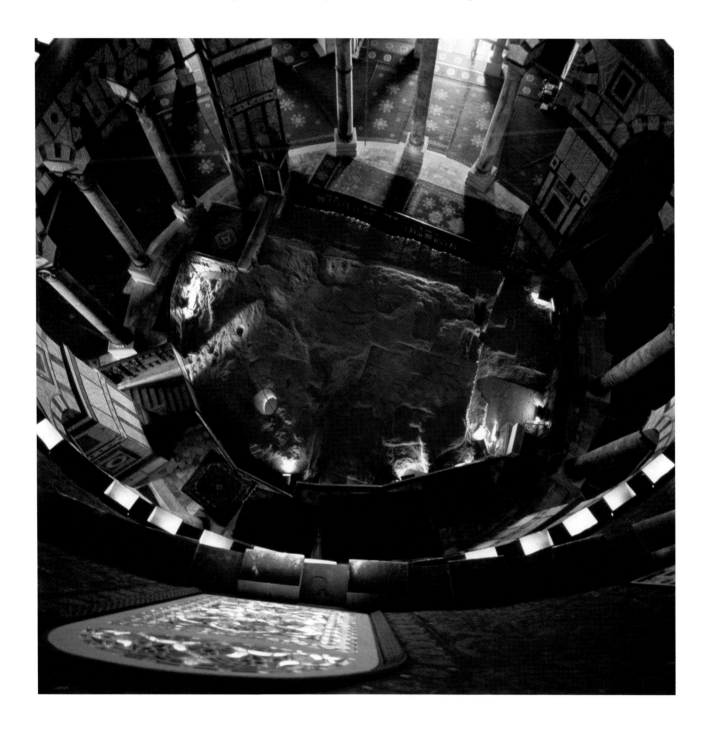

"furthest mosque", a phrase from a sura in the Qu'ran, which speaks of Mohammed's famous night journey into heaven. With these associations, the two shrines have a revered status within Islam. The whole area of the former Temple Mount is known as *Haram esh-Sharif* (the "noble sanctuary") and, although Mecca remains the direction for Muslim prayer, this sanctuary has now served for more than 1,300 years as the third most holy site within Islam (after Mecca and then Medina). No wonder Jerusalem itself is simply referred to in Arabic as "the holy" (*al Quds*).

A simmering tension

Many of the Muslim population were still nomadic tribespeople; thus only one Muslim city (Ramla) was built in Palestine throughout the next four centuries. Moreover, Muslim rule was exercised by those quite distant from the Land: the Umayyid Dynasty (based in Damascus: 661–750) followed by the Abassids (based in Baghdad). Then, from the 870s, Palestine's control became a matter of dispute between Egyptian and Turcoman authorities. During the next 200 years the area was thus, once again, but a pawn in the wider politics of the region – with lots of upheaval.

By the eleventh century the population seems to have dropped by around 30 per cent, when compared with the Byzantine era. Quite probably, Muslims had never been in the majority – what with a continuing Samaritan minority, large Jewish cities in Galilee, and Christians being numerous in rural areas and in Jerusalem. Some estimate that during this period there may have been only twenty mosques in

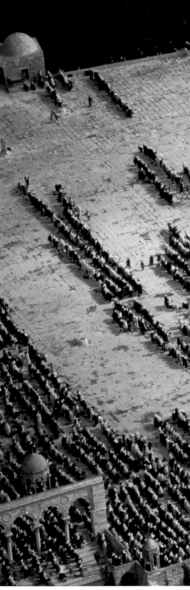

Palestine, compared with over sixty churches; and in 1093 a Muslim visitor would complain that "the country belongs to the Christians, because they work its soil, nurture its monasteries and maintain its churches".

Top left: Pages from a fourteenth-century copy of the Qu'ran.

Bottom left: A Muslim in the Haram, praying towards Mecca.

Below: Until recent restrictions, Friday prayers would attract thousands of Muslim worshippers.

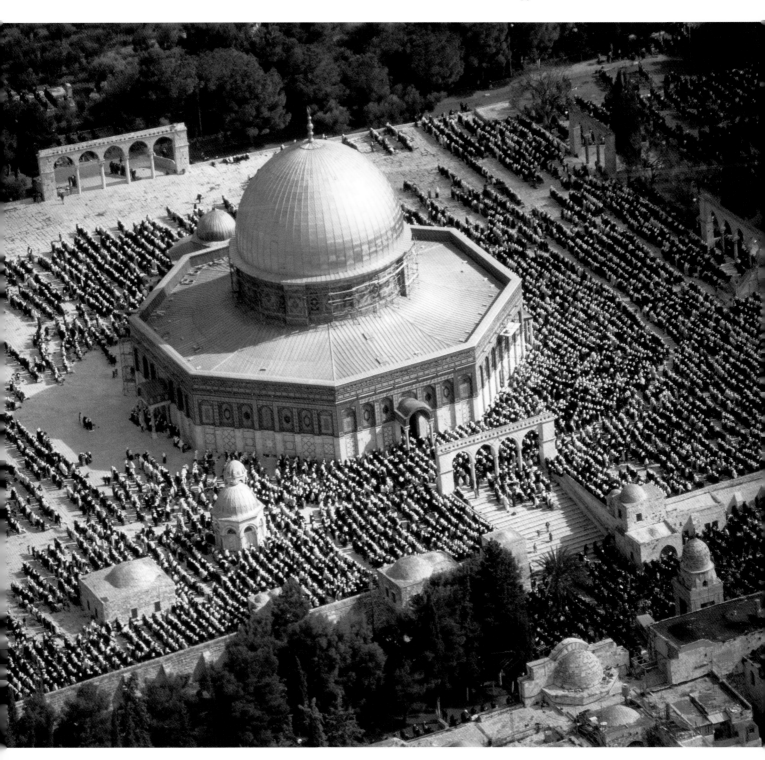

Both Jews and Christians, as "people of the book", were accorded the status of *dhimmi* (or "protected people"); but this meant increased taxes and accepting Muslim rule. Much of the time there was peaceful co-existence and cooperation – especially when it came to trade – but matters took an ugly turn in 1009.

Back in 937 and 966 there had been some arson attacks on the Church of the Holy Sepulchre but now a caliph in Egypt (called Al-Hakim) ordered his troops to destroy it completely: "make its sky equal to its ground". They totally destroyed the buildings. The vast Martyrium basilica was reduced to rubble; the small *aedicule* surrounding Christ's tomb was smashed; and the

dome above it came crashing down, burying the tomb in the debris. One of the most magnificent churches in Christendom, which had been standing for nearly 700 years, was obliterated in a matter of days.

Christians all round the world were appalled at this barbaric act: the place that commemorated the very centrepiece of their faith had been desecrated. A modest rebuild was made possible during the reign of the Byzantine emperor, Constantine IX Monomachus; but due to lack of funds this was a paltry affair. A better-resourced response was surely called for – some concerted effort.

And so the idea gradually developed among Christians in western Europe that perhaps now it was their turn to play a part in the story of the Holy Land. Thus Palestine would experience yet another invasion from outside – this time a violent one, coming not from the East, but rather from the far, far West.

..

Below: The small mosque, commemorating Jesus' Ascension on the peak of the Mount of Olives. The Crusaders had rebuilt along the lines of the fourth-century Imbomon church (see p. 110), leaving the central structure open to the sky: Saladin added the roof.

The Crusading Century (AD 1099–1184)

So we come to the era of the Crusades – an episode in the Holy Land's long story that still provokes strong reactions and has left a lasting legacy. The memory of the Crusades lives on and on – fostering embarrassment among some, but resentment among others, and a fear that Western interest in the Land ever since may be in danger of only repeating past mistakes.

Bloodbath in Jerusalem

Whatever the multiple reasons (economic, political, or spiritual) that caused the Crusaders to leave their European homelands, the effect on the Holy Land was dramatic. The forces of the First Crusade reached the shores of Palestine in May 1099. The citizens of Ramla fled as the soldiers pressed onwards towards Jerusalem. Their first sighting of the Holy City (7 July) would have been as they marched over the crest of a hill a few kilometres to its north-west (which they soon labelled as the "Mount of Joy"). And so began a six-week siege of Jerusalem, with a population inside its walls numbering around 20,000 (consisting of both Muslims and Eastern Christians).

Right: Christ the *Panto-krator* ("the All-Creating One"), as set within the dome over the Greek *Catholicon* section of the Church of the Holy Sepulchre. Despite the Greek-styled decoration, this entire structure was the work of the Crusaders (rededicated in 1149).

. .

Below: The Crusader remains on the Mount of Joy, looking towards the Mount of Olives (identifiable now in the extreme distance by its three towers) some 10 km to the south-east.

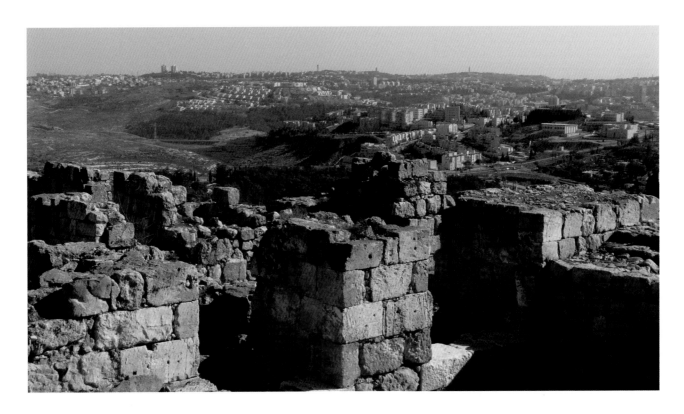

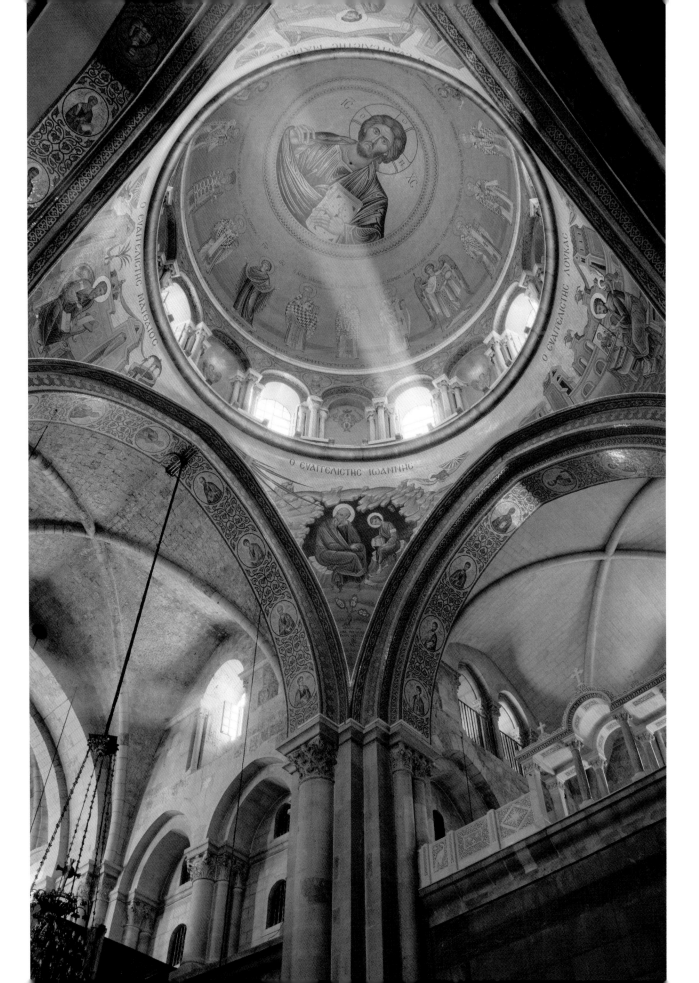

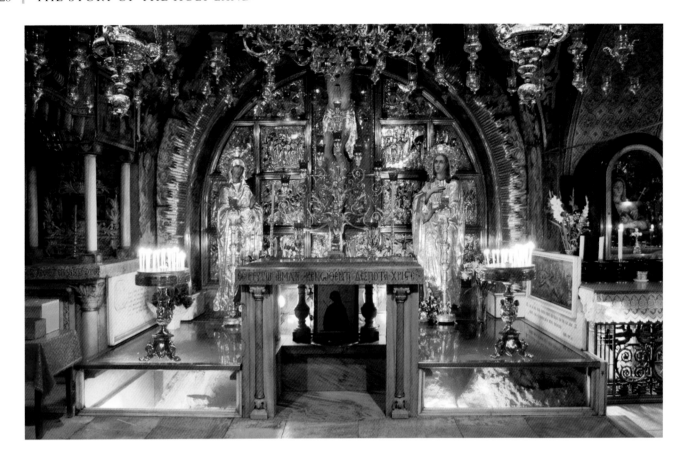

Eventually, in the afternoon of 15 July, the Crusaders successfully breached the city walls and poured through the narrow streets, killing all in sight, determined to reach the Church of the Holy Sepulchre. As they entered, triumphant, they sang a historic Christian anthem (dating back to the second century) known as the *Te Deum* ("We give thanks to you, O God…"). Yet it had been nothing short of a bloodbath.

Coastal forts and inland castles

So began the eighty-eight-year span of the Latin Kingdom, ruled over the years by eight "kings of Jerusalem" (five of whom were called Baldwin) and one distinctive queen, Melisende.

For some years prior to 1099 the area of greater Syria had become (as one scholar describes it) "one vast war zone" – with almost every town having its own Muslim ruler. The newly arrived Crusaders took full advantage of this internecine warfare, soon securing control over the coastal trading cities of Caesarea, Haifa, Acre and, a little bit later, of Tyre, Sidon, and Beirut. Inland, however, things were less straightforward.

On the positive side, they soon discovered that their initial policy of massacring all the inhabitants was neither necessary nor practicable. Many of the inhabitants were Orthodox Christians anyway; and the Crusaders simply did not have enough personnel to settle the Land entirely with their own Frankish people. A *modus vivendi* had to be found. So, after the initial banditry, they treated the local peasantry well and allowed the local patterns of trade and commerce to continue. Meanwhile, they mainly populated the cities and began building a series of castles throughout the Levant, including Belvoir (completed in 1168) and Nimrod.

Building projects galore

They also set about building some fine churches in their distinctive Western style. Their first priority, of course, was to improve the Holy Sepulchre. They built a small church at the east of the tomb (now known as the *Catholicon*). Meanwhile, in 1104 the estranged wife of Baldwin I (1100–1118) was placed in a nearby convent, and the convent's chapel was later replaced with a new Romanesque basilica, dedicated to St Anne. Similar

Left: Greek Orthodox chapel of Golgotha (or Calvary), located above the outcrop of rock (illuminated under the glass) which rises up some 6 m above ground level within the Church of the Holy Sepulchre.

......................................

Below: The Romanesque church of St Anne (built by the Crusaders: 1131–38), situated just beyond the Byzantine ruins over the pool of Bethesda (mentioned in John 5:2).

reconstruction took place over the site on Mount Sion associated with the Last Supper (the *Coenaculum* or "Cenacle"). Then, around 1160, the Armenian Christians built their own cathedral, dedicated to St James.

A key figure in this building enterprise was the colourful Queen Melisende, who ruled Jerusalem as Queen Consort (1131–1143) and then during the regency of her son, Baldwin III (1143–1153). Her husband, King Fulk, was a great castle builder; but Melisende too had an eye for important projects. She had a demandingly high taste for the artistic – at least, so we can presume from the top quality work seen in the "Psalter of Melisende" (commissioned for her by her husband as a

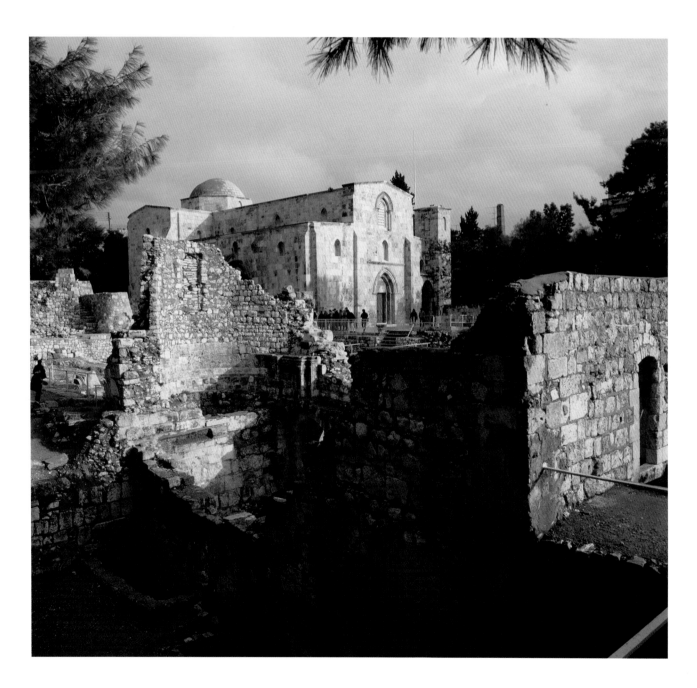

token of affection after some indiscretions); and she ensured the Jerusalem area was well endowed with new Christian buildings.

She commissioned the building of a convent for St Lazarus at Bethany and ensured that the Muslim Dome of the Rock was reconsecrated for Christian worship (to be known as the *Templum Domini* or the "Temple of the Lord"). She was also integrally involved with the ceremonies for the rededication of the Church of the Holy Sepulchre, held on the fiftieth anniversary of the Crusaders' first arrival (15 July 1149).

The Crusader builders were also busy outside Jerusalem: small churches were built in Caesarea, Lydda, and Hebron (where they stumbled on what they understood to be the relics of Abraham and the other patriarchs); and a large cathedral – complete with three apses and seven bays – was constructed in Nazareth. New capitals were crafted for the columns of the Church of John the Baptist in Sebastiye (ancient Samaria). And King Amalric (1163–1174), working in harmony with both the Byzantine emperor and Bethlehem's local bishop, produced a stunning renovation of the Church of the Nativity in Bethlehem; this combined both Eastern and Western styles in a way that is unique in the Holy Land.

Top right: Benedictine worship in the church built (in an area now known as Abu Ghosh) by the Crusaders and decorated with frescos (c. 1170) to commemorate the Risen Christ's appearance at Emmaus (Luke 24:13–35).

Bottom right: The Cenacle on Mount Sion, rebuilt by the Franciscans in 1335 with distinctively Gothic arches, to be an "Upper Room" within which to commemorate Jesus' Last Supper.

Below: The unadorned interior of the Church of St Anne.

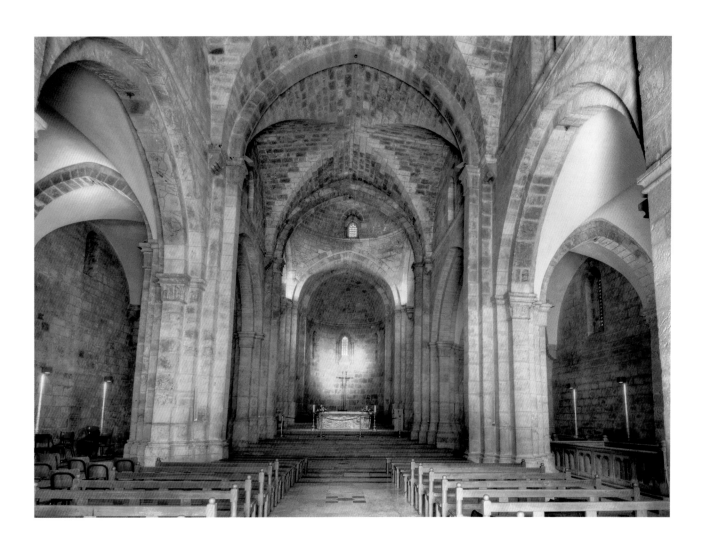

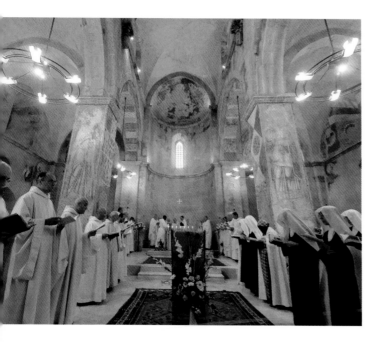

Praying and watching

During this century, a good number of monastic communities from western Europe were established in the Holy Land. They too helped in these building projects: the Benedictines built on Mount Tabor; the Hospitallers at Abu Ghosh; and the Carmelites (not surprisingly!) on Mount Carmel. Meanwhile the Franciscan community won the privilege of becoming the "Custodians of the Holy Land", taking a special responsibility (continued to this day) for ensuring that the Gospel sites were kept as appropriate places for prayer.

Yet quiet places of prayer would soon be hard to find. In 1169 Nur al-Din, the sultan of Damascus, brought Egypt under firm Muslim control. He was succeeded in 1174 by his vizier, a fine soldier called Saladin (or Salah-eddin). The Latin Kingdom had been watching, waiting anxiously for the Muslims' eventual response; now it was surrounded, and its days were numbered.

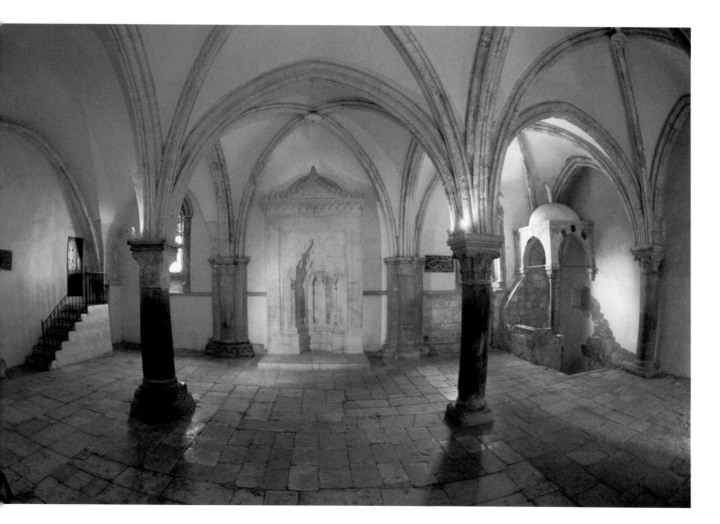

Saladin and the End of the Crusades

Saturday 4 July 1187: this would prove to be a key day in the story of the Holy Land. Saladin was marching an army of around 30,000 men on a campaign through Galilee, en route to the important castle at Tiberias.

Meanwhile the Crusader troops, with their military headquarters in Acre, were active in the region – under the command of their recently crowned king, Guy of Lusignan. An ongoing "war of attrition" between the two sides was about to have its first direct engagement.

Bottom right: The Golden Gate, blocked up in the Middle Ages to prevent any messianic pretenders entering Jerusalem.

Below: The so-called "Horns of Hattin" (3 km to the west of Tiberias), high above the Arbel Pass and Lake Galilee.

Charging down the hill

Enticed by Saladin away from their overnight quarters and water supplies, Guy's troops moved eastwards, marching up towards the Horns of Hattin peak, above Tiberias. The Crusaders were sweating profusely in their chain mail, desperately needing water. Parched and exhausted, they came over the crest of the hill, and in so doing they could see the Muslim forces on the slopes below. It was now or never.

Guy ordered his expert cavalry to charge down the hill at the enemy forces. Off they went, gathering pace, and then, at the critical moment, Saladin's soldiers, instead of aiming fire, simply parted to either side – leaving the Crusaders' horses to gallop down the hillside towards Tiberias.

With the Crusaders' chief weapon now effectively removed, Saladin's famous bowmen rapidly mopped up the operation. Guy was captured and, later that evening, was offered an ice-cool sherbet in Saladin's army tent – a mocking gesture from a Middle Eastern warlord to a western European, as a subtle reminder that water is key to military success.

The last resorts

This crushing defeat effectively spelled the end of the Crusader project in the Holy Land. Eleven weeks later, Saladin's forces besieged Jerusalem. With 60,000 people crammed behind its walls, Balian of Ibelin sought for peace terms using some strong "bargaining" tactics (threatening to destroy the Dome of the Rock and to massacre the city's Muslim minority). It was eventually agreed that, after forty days, those Crusaders who could find enough money to pay their individual ransom price would be set free; the remainder (about 15,000 in the end) would be taken captive. In this way, the Dome of the Rock, described by one contemporary Muslim commentator as the "jewel of the signet ring of Islam", was duly restored to its original Muslim ownership.

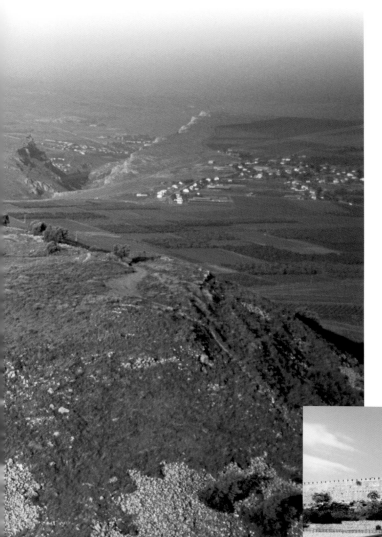

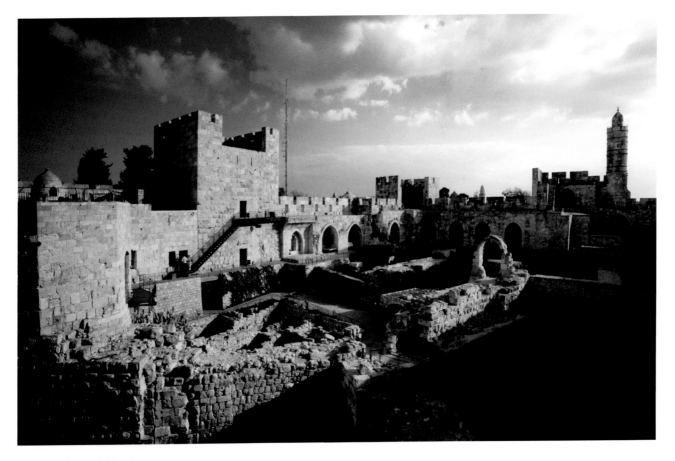

Saladin was soon on his way. In August he had beaten the Crusaders in Acre, but not in Tyre. Now in November, Tyre continued to hold out; and when he engaged with the Crusader troops encamped outside Acre, it ended in a stalemate. The next spring Saladin would hear rumours of yet another Crusade from western Europe: apparently Frederick Barbarossa was leading over 200,000 troops through Asia Minor en route for the Holy Land. And on 8 June, Richard the Lionheart arrived from England, sailing into Acre with twenty-five galleys.

Things looked promising for the Crusaders: by 1191 Richard, with Philip II of France, had regained Acre, along with Tyre and Jaffa; and in 1193 Saladin died. Frederick, however, drowned in an accident in the River Cydnus in Cilicia and his demoralized troops effectively evaporated. For the next hundred years, the Crusading movement was effectively reduced to its few last resorts along the coast. Control of Jerusalem would never be regained.

Above: The so-called "Citadel of David", originally the site of the palace of Herod the Great but, much later, of a Crusader fortress.

Right: The Crusaders' main entrance to the Church of the Holy Sepulchre (from the south).

Left: Franciscans in the chapel over Calvary, celebrating the daily "Way of the Cross".

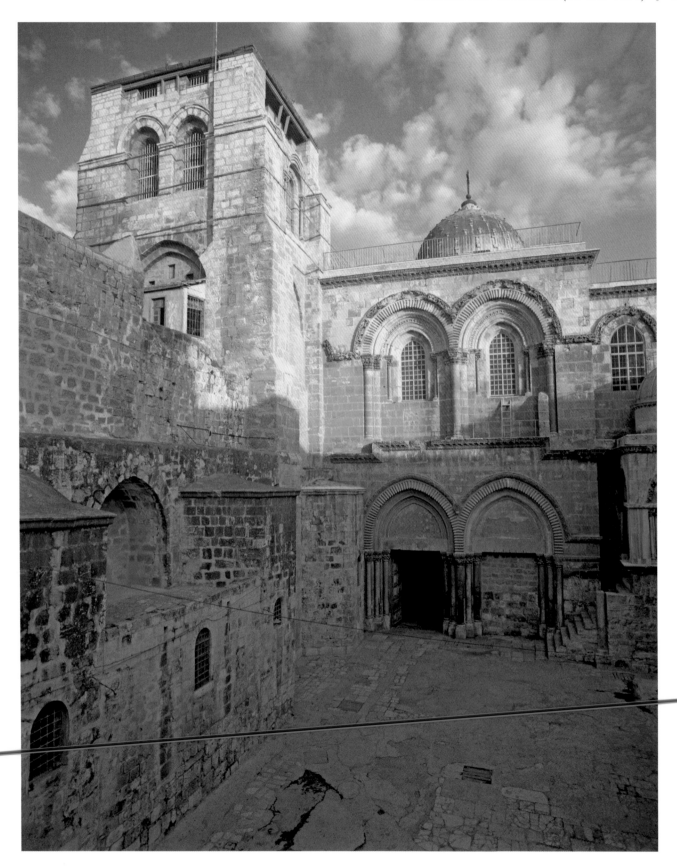

Frederick II concluded a treaty in 1229 with the Sultan, allowing Christian access to Jerusalem, Bethlehem, Lydda, and Nazareth. Twenty years later, Louis IX had some success in invading Egypt and rebuilding Acre, Caesarea, and Jaffa. There continued to be a small number of Frankish settlements in some rural areas. Overall, however, Crusader presence was very weak. As a sign of the times, the Greek patriarch of Jerusalem during this period normally lived in Acre, while the Latin "kings of Jerusalem" were based even further away – in Cyprus. The Latin Kingdom was just a coastal enclave clinging to the fringes of the Land.

The final departure

Around 1260 yet another threat hung over the region: the possibility of a Mongol invasion from the Far East. Fortunately for Palestine the new emerging power of the Mamluk regime in Egypt (under Sultan Baybars: 1260–1277) kept them at bay. Yet Baybars was also very successful against the Crusaders, destroying the scarcely finished cathedral in Nazareth in 1263 and seizing a good number of Crusader strongholds, ruining their maritime trade. Year by year, the Crusaders' meagre territory was being chipped away.

Eventually, in 1291, their final bastion within the Holy Land was lost forever: after months of fierce fighting, Acre fell to the Mamluk forces on 28 May. Although the Crusading movement would find other projects, its original goal – to re-establish a Christian Holy Land – had come to an inglorious end. So the Crusaders left the shores of Palestine behind them, but, in another sense, the shadow cast by their visit has never left.

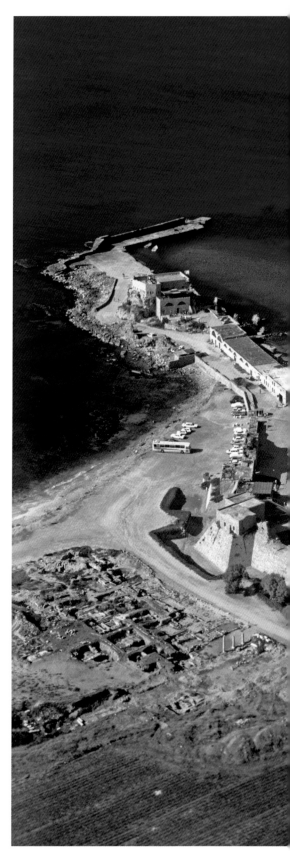

Right: The Crusader walls at Caesarea (with the submerged lines of Herod's harbour in the extreme distance).

Below: Crosses engraved by Crusader soldiers and pilgrims on the stone walls going down to the chapel of St Helena, beneath the Church of the Holy Sepulchre.

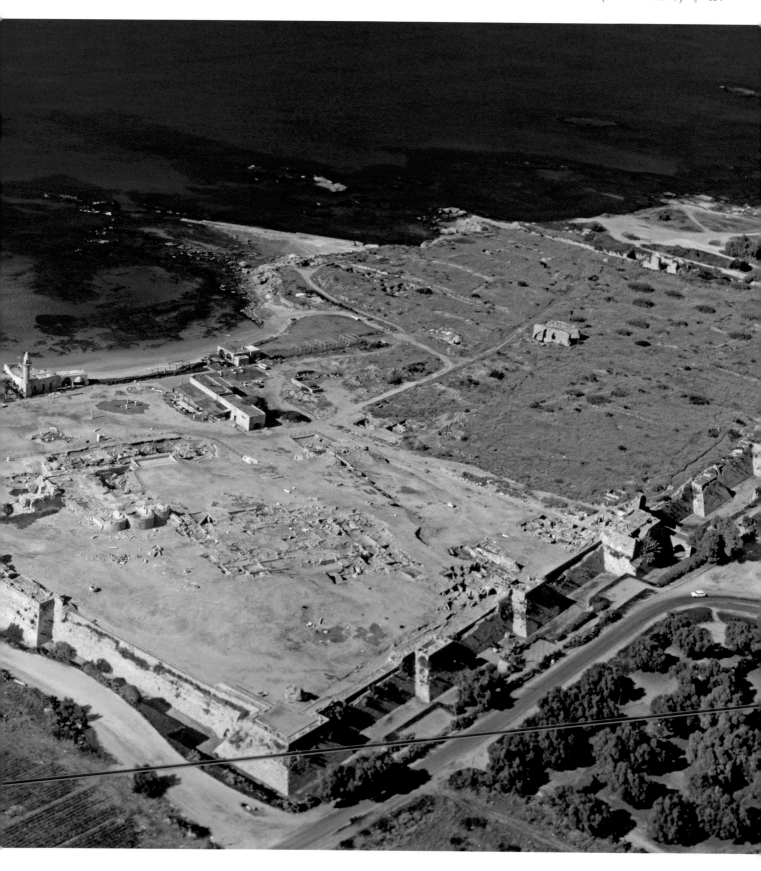

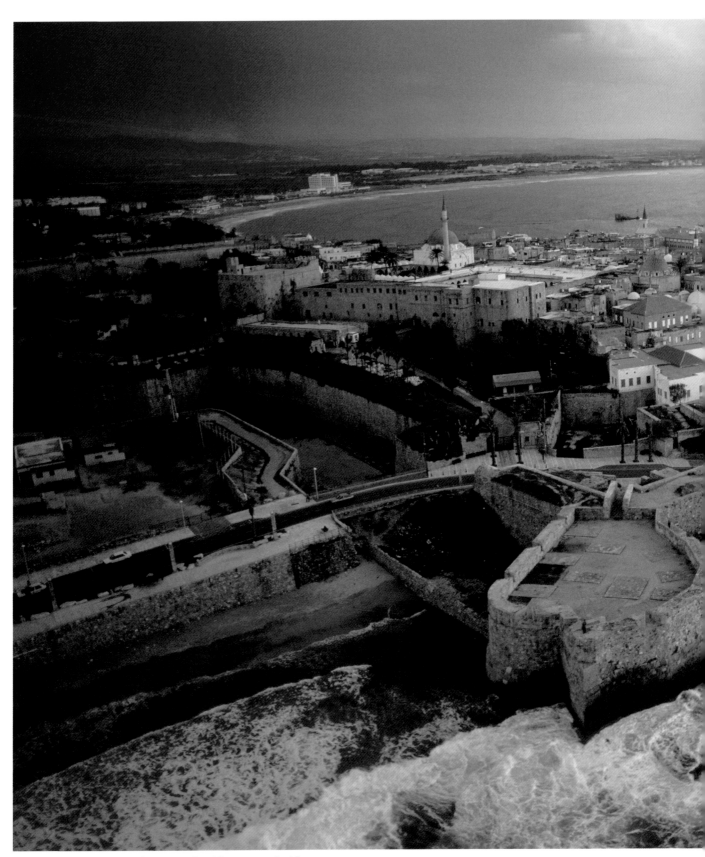

CITY OF REFUGE: Acre, the Crusaders' last stronghold

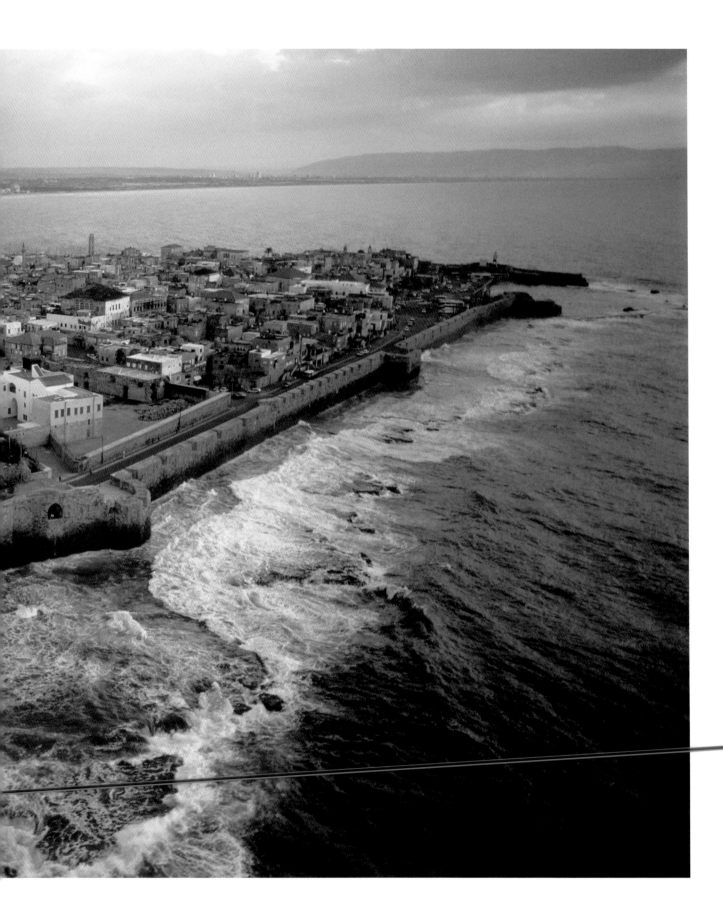

David Roberts April 1st 1839

CHAPTER 7

OTTOMANS AND WESTERNERS
(AD 1291–1948)

A British man, fresh from a year with Arab tribes in their desert campaigns;
a Jewish businessman encouraging his fellow Jews to build homes outside
Jerusalem's walls; swarms of Russian Orthodox pilgrims, or Muslims from
various countries, coming to Jerusalem to pray.
All these – some as tourists, some as long-term residents, some motivated
by religious reasons, others by economics or politics –
are about to converge on the Holy Land, which will find itself
a bubbling melting-pot of nationalities, religions, and personalities.
After more than five centuries of relative calm,
the Land is heading once more into turbulent waters…

The Mamluks and Ottomans

After the Crusaders withdrew in 1291, the Holy Land became comparatively peaceful – first under Mamluk control from Egypt and then, over two centuries later, under Ottoman control from Constantinople (from then on known as Istanbul). More than five centuries went by without any major invasion or catastrophe. With hindsight, of course, this seems to have been an extended lull before a major storm.

The Holy Land was stable because the contentious "front-lines" between the Islamic world and its neighbours (whether to the east or west) no longer ran through Palestine. In particular, the line with Christian Europe was now drawn further to the west – in Cyprus or, later, the Balkans and Malta. No one was contending for the Holy Land, politically.

The only major political event came in 1517. After a century of increasing power (in which they seized Constantinople in 1453 and Athens in 1460), the Ottoman Turks wrestled power from the Mamluks, taking Egypt and all the lands of the eastern Mediterranean.

"Protected people"

For the Holy Land, this meant very little: control was still clearly in Muslim hands – albeit the rulers now lived much further away and administered matters through local bureaucrats. For Jerusalem, however, it led to the rebuilding of the city's broken-down walls during the reign of Suleiman the Magnificent (1520–1566). Jerusalem's residents would be secure from attack for many centuries to come.

Throughout these five centuries, then, Islamic rule was a given. Both Jewish and Christian residents had to accept this reality. They lived within the status quo and settled down – albeit as *dimmis* or "protected people" with an inferior political status – to live peaceably in the Land whose history meant so much to them.

There was a thriving Jewish population in the Galilee region. Both Tiberias and Safed were considered to be Jewish "holy cities" (along with Jerusalem and Hebron). The great Jewish philosopher and Torah scholar, Maimonides, asked for his body to be brought to Tiberias from Egypt after his death (in 1204); and from the sixteenth century Safed became the leading centre for a form of Jewish mysticism known as Kabbalah.

Right: A bird's eye view of Jerusalem's Old City with the Mount of Olives to the east (*left*). Its Muslim Quarter is to the north, the Christian and Armenian Quarters to the west (*right middle and top*), and the Jewish Quarter to the south-east.

Below: Traditional dress, as worn by Ottoman officials.

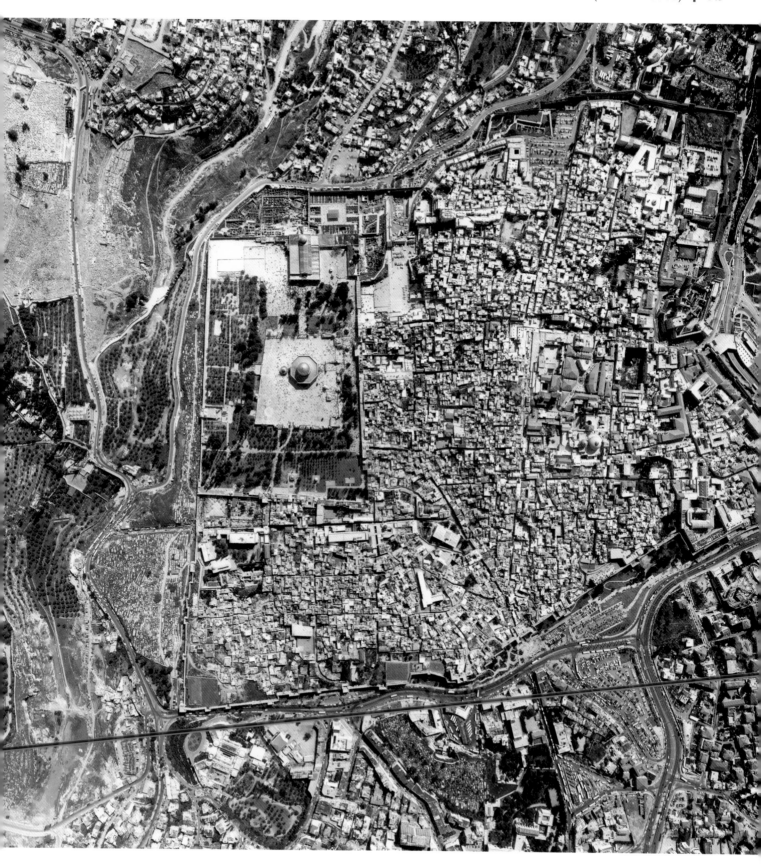

Meanwhile there were Christian villages and towns dotted around the Land. Tracing their origins back to the Orthodox Christians living in the Land prior to the arrival of Islam, these Christians, though naturally using Arabic for their everyday existence, continued to use the Byzantine Greek liturgy for their worship. Many also lived in or near Jerusalem, with representatives from other "Eastern" branches of the Christian family – Armenians, Syrians, Copts, and Ethiopians.

They were joined by "Western" Christians (in communion with the pope in Rome) – predominantly "Latin (or Roman) Catholics" and "Greek Catholics" (also known as Maronites). A trickle of pilgrims still visited from the West (though very few from the new Protestant denominations brought about by the Reformation); and the historic Gospel sites were preserved by the Franciscans. By and large, however, the Muslim authorities discouraged any major redevelopment of those sites. For

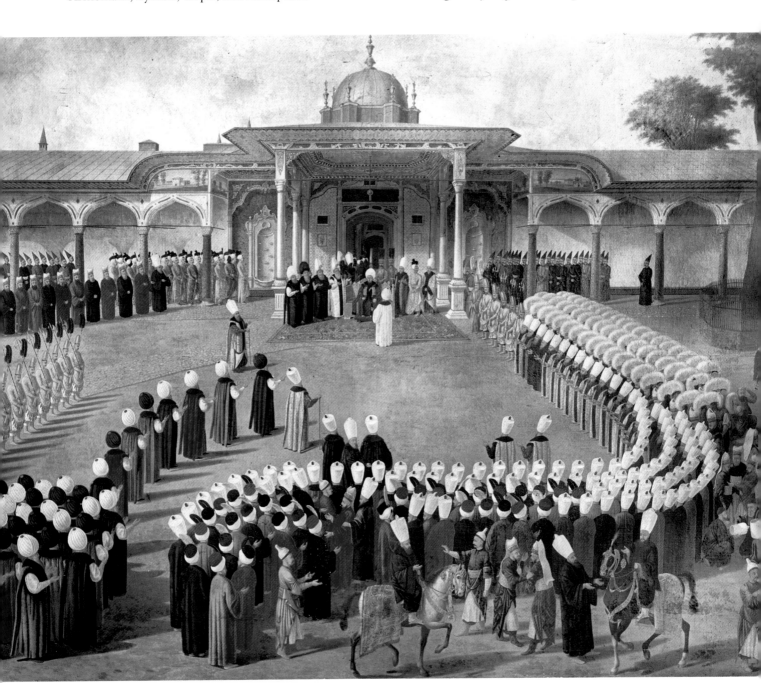

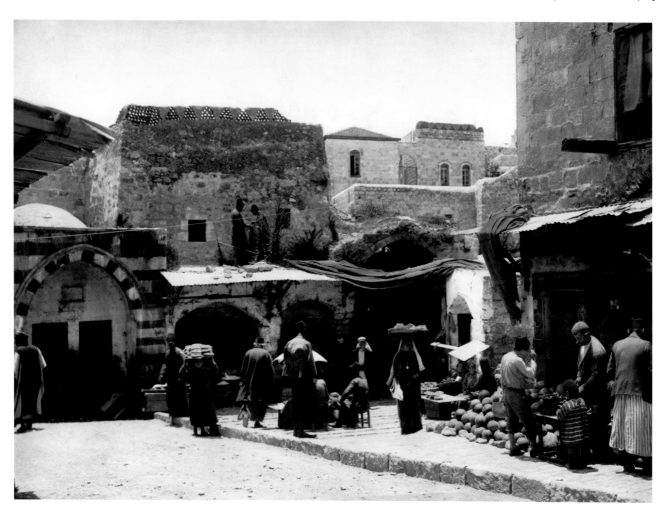

example, the Franciscans succeeded in buying back the ruins of Nazareth's cathedral in 1620, but it was not till 1730 that they could attempt a modest rebuilding.

As time goes by...

During all these centuries of Ottoman rule no new cities were built. Patterns of urban and rural life were simply passed on unchanged to each succeeding generation, and traditions became deeply embedded. So, when western Europeans started to return to the Land in the early nineteenth century, they found it quaint: time seemed to have stood still for centuries. Suddenly, however, that time clock would start ticking – faster and yet faster. The timeless idyll of the Holy Land's pre-modern world was about to be shattered.

Above: A daily market scene from Ottoman Jerusalem, just inside the Damascus Gate (taken in March 1914).

Left: The Holy Land was under the control of the Ottomans, based far away in Istanbul. Here Sultan Selim III receives guests in Istanbul's Topkapi Palace.

The Returning Century (AD 1820–1917)

This atmosphere was rudely disturbed in the nineteenth century. From Napoleon's brief visit in 1799 right up to the grand entrance into Jerusalem of Kaiser Wilhelm II of Germany in 1898, people in the West became ever more fascinated with the Holy Land – for reasons both religious and political.

From around 1820 the Holy Land suddenly received a myriad of conflicting interest groups: archaeologists or historians, with their eyes on the past; religious idealists inspired by "prophetic" hope, with their eyes on the future; many refugees or settlers, simply focused on surviving in the present – of living peaceably in a place they longed to call their home.

Jerusalem itself would be transformed. In 1800 it was but a "provincial town of little consequence", but by 1900 it had become a "growing cultural and spiritual centre, attracting people from all over the world" (Ben Arieh, p. 400). Yet all this expansion came at a cost and meant there was an increased probability of eventual conflict and collision.

The stream of visitors: Jews and Christians

Travel to the East was made considerably easier in the 1830s when the Egyptian pasha, Muhammed Ali, who had briefly seized control over Palestine from the Ottomans, began to pursue a more pro-European approach. The visitors came flooding in – some to visit only briefly, others to stay.

They included a number of Jews wishing to live in Jerusalem; thus the Jewish population in the Old City rose from around 2,250 in 1800 to around 11,000 in 1870. Meanwhile, the British government gained the pasha's permission to build the first Protestant church in the Middle East as a chapel for their consulate: Christ Church was eventually consecrated in 1849.

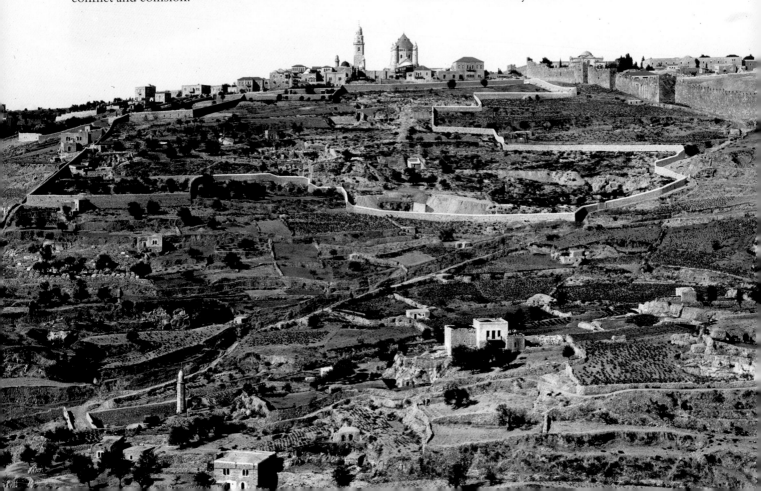

Not surprisingly, Christian missionaries arrived too. In the early 1800s a spate of missionary organizations had been launched (primarily in Britain). Some of these had an express focus on working among Jewish people. In Jerusalem they founded a school and a key mission hospital, which did excellent work bringing medical care, but the response from the Jewish population was disappointing. Increasingly, then, some of the missionary organizations focused instead on extending a warm welcome to the local Christians in the historic denominations (especially the Greek Orthodox), inviting them to join their new congregations with their more modern forms of Protestant worship.

Seizing these new opportunities, in 1841 the British and Prussian governments came up with a clever scheme: a joint Anglican–Lutheran bishopric within Jerusalem. The first bishop, himself of Jewish background, was Samuel Alexander; he arrived in 1842 but died three years later. The second bishop, a Lutheran, was Samuel Gobat, who worked in Jerusalem until his death in 1879.

Above: View north-eastwards towards the Temple Mount (c. 1900); the spring of Robinson's arch (identified by him in 1838) was almost invisible under vegetation, but today stands high above the excavated street level of the city in the first century.

Left: View westwards over the City of David towards the Upper City of Jesus' day (Mount Sion), with the new Dormition Abbey (c. 1910).

Below: View northwards up the Kidron Valley, between the Ophel Ridge and the Arabic village of Silwan (*right*).

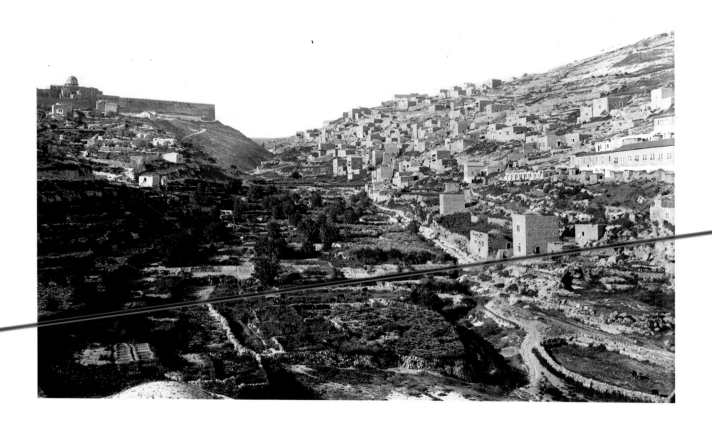

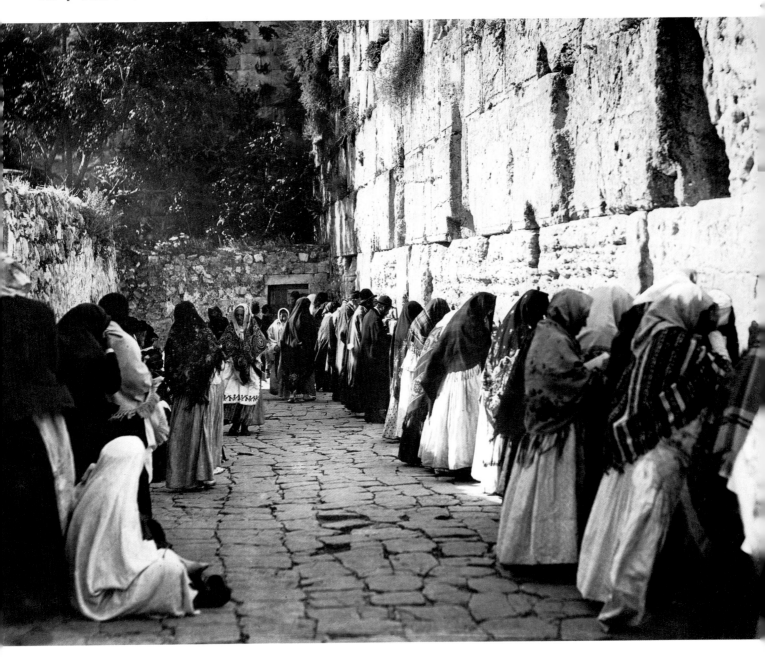

Similarly, in 1847 the pope established a Latin patriarch in Jerusalem and the Russian Orthodox established a delegation in the city. All the great Western powers were developing their political interests in the region, often by making these ecclesiastical appointments. There were exceptions: the French government made no appointments (no doubt influenced by the anti-Church nature of the French Revolution in 1792); and the American Presbyterian missionaries focused their attention on Beirut.

Above: Jewish men and women praying at the Western Wall. Note how the Herodian stones (supporting the Temple Mount platform) were only a few metres away from residents' homes.

Right: View north-eastwards from Mount Sion towards the Temple Mount (*left*) and to the Lower City, with the Mount of Olives beyond.

Tourists and artists

Then there were the tourists. Many wrote illuminating accounts of their travels; artists sent back evocative images (see one of David Roberts' famous paintings, pp. 140–41). These first ever images of the Holy Land made a lasting impression on readers of the Bible – previously reliant on their own imagination to see the biblical landscape.

Many, however, insisted on coming to see for themselves. In 1869 an enterprising British Baptist, called Thomas Cook, initiated tours to Egypt and Palestine, which, during the next five years, would bring to the Holy Land 450 visitors, and over 12,000 in the next eighteen. The company's reputation was such that in 1882 Queen Victoria's son, Albert (the Prince of Wales, later Edward VII), who himself had visited the Holy Land in 1862, now required that his two sons travel to Jerusalem only under the safe auspices of Thomas Cook's travel agency. Jerusalem was now very much part of the young gentleman's "grand tour".

There were other famous visitors: for example, the British Army general Charles Gordon in 1883 (who argued strongly that Jesus' crucifixion had taken place in "Jeremiah's Grotto" to the north of the Old City); and the American author Mark Twain, who wrote up an account of his visit in *The Innocents Abroad* (1869). As his readers soon discovered from his acerbic wit, he was not impressed; Jerusalem was "mournful, dreary and lifeless"; it was full of "rags, wretchedness, poverty and dirt".

Above: Early archaeological work done on the slopes of Mount Sion revealed these well-preserved steps from the first century (quite possibly used by Jesus and his disciples as they went down to the Kidron Valley and Gethsemane after the Last Supper).

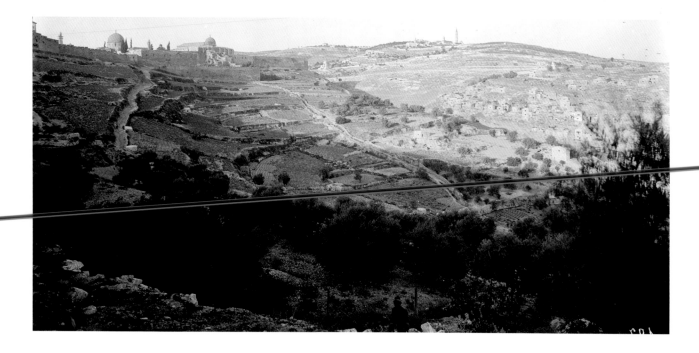

Bible lovers and diggers

Bible scholars and archaeologists also turned up. One of the first, Professor Edward Robinson (from Union Seminary in New York), was also not greatly impressed. After his visit in 1838 he concluded that many of the so-called Gospel sites were historically inaccurate: their identification was based on erroneous traditions or, worse still, "pious fraud".

In 1848 an architect called James Fergusson, wondering if the Crusaders had built the Church of the Holy Sepulchre in the wrong place, suggested Calvary might be under the Muslim Dome of the Rock (opened up to non-Muslim visitors from the 1850s). Perhaps *that* building was originally Constantine's basilica built over Christ's tomb? Fergusson's bizarre suggestion was only possible because he himself had never visited Jerusalem! Nevertheless, he set up the Palestine Exploration Fund (PEF), which through its *Quarterly Statement* would become one of the key channels for publishing archaeological discoveries.

Fergusson's pet theory was dismissed immediately by Charles Warren – ironically sent out by the PEF in 1867 to investigate the Temple Mount area. Other key archaeological work in Jerusalem included excavations on Mount Sion (in 1874 and 1894); the discovery of the Pool of Bethesda (in 1888); and Charles Wilson's detailed "mapping" survey of the city (from 1869 onwards).

Right: The Armenian Quarter of the Old City, with new developments along the Jaffa Road visible in the distance (*top left*).
...
Below: View north-westwards from the walls near the Damascus Gate (April 1911), showing the extensive late nineteenth century developments, including the Notre Dame Centre (*top left*).

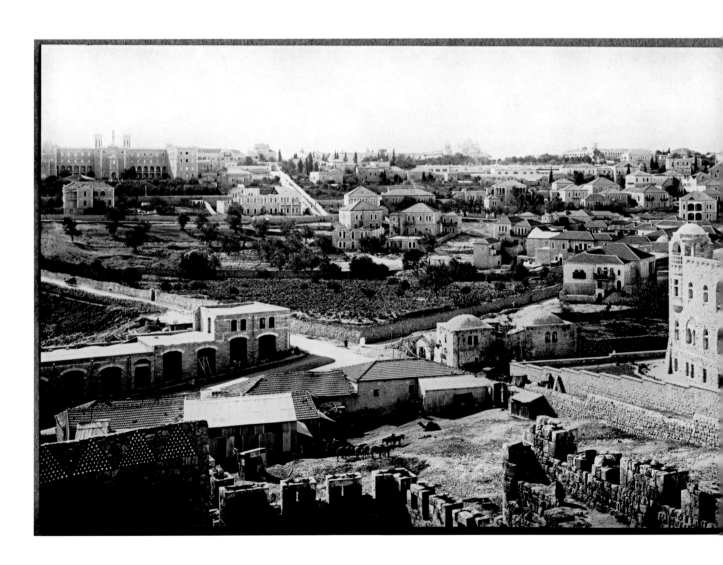

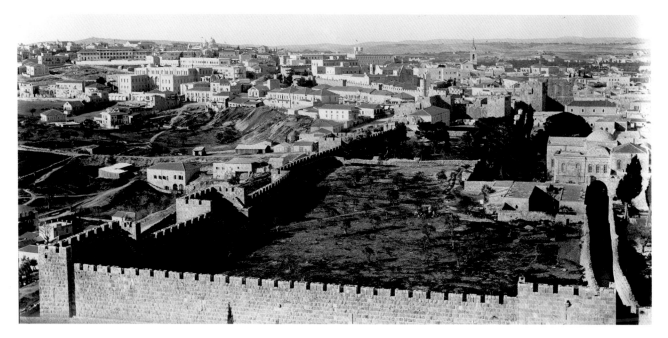

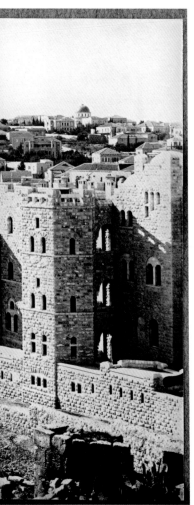

Cramped conditions

Inevitably the Old City became ever more populated. The total number of residents increased from around 9,000 in 1800 to around 27,000 in 1870 (with Christians constituting roughly a third). Then there were the numerous pilgrims. The Christian communities were busy with their respective buildings: St Anne's (refurbished by the French in 1860); the Austrian Hospice (also in 1860); the Ecce Homo Convent (1868); the expanded accommodation near St Saviour's for Latin pilgrims (1870); and the grand New Hotel (built by the Greek Orthodox inside the Jaffa Gate in the 1880s). Some definite improvements were made: public toilets were installed in 1868 and further openings were made in the city walls – the Dung Gate (1853), Herod's Gate (1875), and the New Gate (1890). Yet something had to give.

So Moses Montefiore, a leading Jewish philanthropist, encouraged his fellow Jews to live outside the city (his almshouses were ready for occupation from 1857); and soon countless buildings appeared, especially on the north-west side of the city. In this area, either side of the Jaffa Road, there were soon (by 1879) no fewer than nine Jewish neighbourhoods. There was also a vast compound for Russian Orthodox pilgrims with its cathedral (built 1860–64); the Ethiopian church (1887); and Notre Dame (built by French Assumptionists from 1885 to 1904). Meanwhile there was a string of developments going due northwards from the Damascus Gate, including the Garden Tomb compound (owned from 1895 by a British trust, after the discovery of the tomb there in 1867); the Anglican Cathedral of St George (consecrated in 1898); and the French Dominican compound of the École Biblique, including the rebuilt Church of St Stephen (dedicated in 1900 on the outline of the fifth-century basilica: see p. 110).

Entering and ruling

From 1880 onwards the pace of change was increasingly rapid. There was also a growing sense that Ottoman rule over this vastly expanded city, with the evident competing interests of its various minorities, might be too weak to handle this volatile situation. How long would the "sick man on the Bosphorus" (as Ottoman rule was commonly described) survive?

So perhaps there was something symbolic when, at the end of the century, Kaiser Wilhelm attended the consecration of the Lutheran Church of the Redeemer. For a completely new opening in the wall had to be created (adjacent to the old Jaffa Gate) to allow his carriage procession to enter the Old City. Western powers – and Western religious groupings – were all eager to get inside Jerusalem and bring it under *their* control. But who would be the first to succeed in breaching its walls? And, once they succeeded, would they share that prize with anyone else?

Right: The tower of the Lutheran Church of the Redeemer, under construction in preparation for the church's dedication on Reformation Day, 31 October 1898.

Below: Kaiser Wilhelm II (German emperor: 1888–1918) entering Jerusalem in 1898.

Below: Preliminary excavations on the site of Constantine's Eleona church (p. 110) on the Mount of Olives, prior to the construction of the Pater Noster Church (never completed due to World War I).

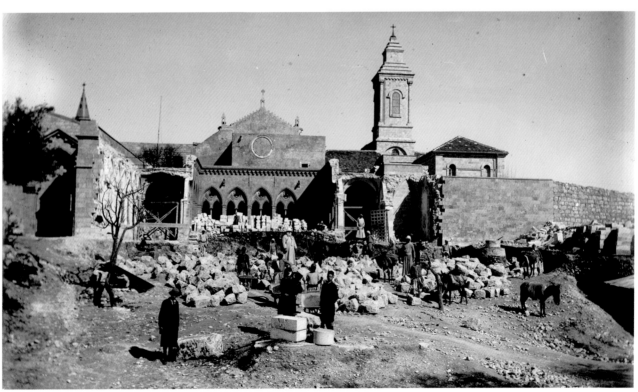

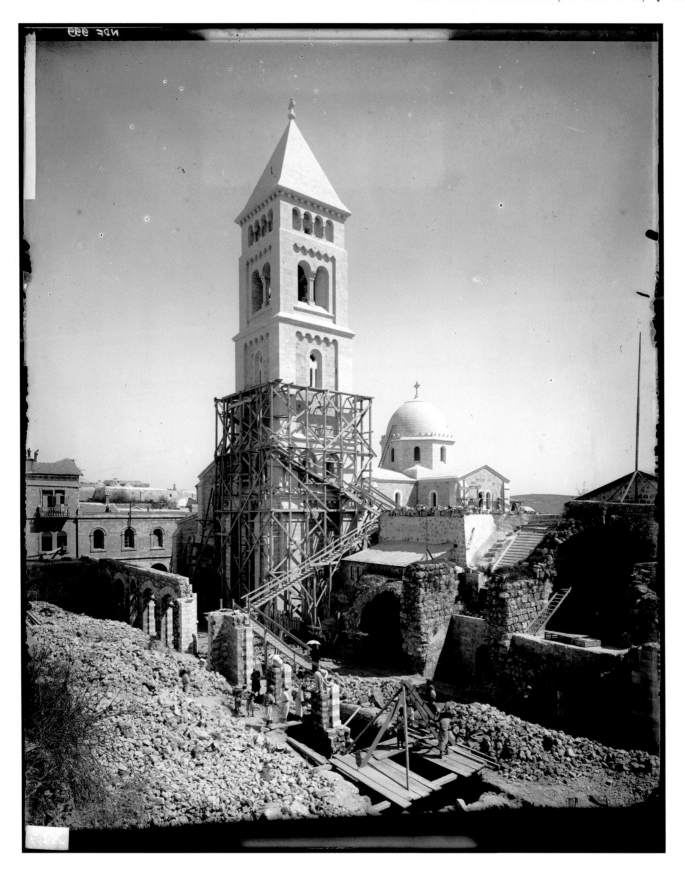

The British Mandate

Within twenty years a different European power – Britain – came through that new Jaffa Gate to announce its rule over Jerusalem. It was a warm sunny day in December 1917 when General Allenby, commander of the British forces, marched into the city and presided over a ceremony on the steps of the citadel. Among his entourage was T. E. Lawrence ("Lawrence of Arabia"), who had worked tirelessly alongside the Arab tribes in previous years, encouraging them to support Britain and the Allied forces. He had high hopes of what the British presence in Palestine might achieve and described that day in Jerusalem as the "supreme moment of the war".

A new foreign power

So exactly 400 years of Ottoman rule in Palestine came to a quiet and reasonably uncontested end. During that long period of Muslim rule, Jews and Christians –

Right: Pilgrims outside the Church of the Holy Sepulchre.

Below: General Allenby reading the proclamation of the British Mandate (11 December 1917).

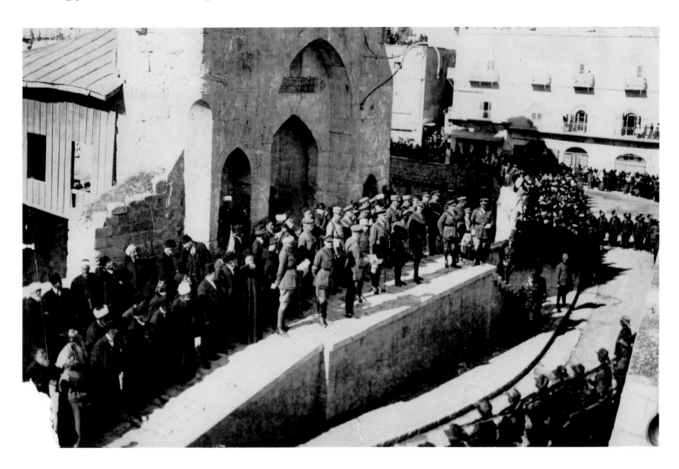

whether viewed as individuals or as a collective group – had effectively accepted that they had no political power. During the nineteenth century, however, both parties had begun to express their keen interest in the future of the Land and would have wondered, when Muslim rule came to an end, who would pick up the baton. In the first instance, it went to the Christians, but in due course it would go to the Jewish people.

Once again, however, the Holy Land was just a pawn in the wider world of geopolitics. The ministers of Kaiser Wilhelm in Germany had persuaded the Ottomans to join their side in World War I. When they lost, the prize went to the victors. After the Treaty of Versailles in 1919, the French gained a mandate over the Lebanon area, the British over Palestine.

Above: The German "Graf Zeppelin" airship over Jerusalem (11 April 1931).

Inevitable tensions

Yet how sustainable was this rule, imposed from several thousand kilometres away to the west? During the course of the twentieth century the tide would turn sharply against such vast imperial claims – with local nationalisms becoming the norm. Here in Palestine it could not be long before the local, indigenous people – whether newly arrived or resident for centuries – would demand their own sovereignty. When viewed in this light, the years of the British Mandate (1920–1948) were a temporary stopgap, delaying the inevitable clash between the Jewish and Arabic peoples, both living in the Land.

Bottom right: The "little town of Bethlehem" (late 1920s), with the tower near the Church of the Nativity in the middle distance and the Herodium on the skyline (see p. 76).

Below: Christian clergy outside the Church of the Nativity in Bethlehem (c. 1930).

By 1920 the demography of Palestine had changed dramatically, compared to fifty years before. The United Nations reported that the overall population had risen to just over 700,000; of these around 76,000 were Jews and 77,000 were Christians (with almost all of these speaking Arabic and being resident principally in Nazareth, Bethlehem, and Jerusalem). Although some Arabs had arrived from elsewhere, the biggest increase was clearly caused by Jewish immigration – as Jews (mainly from Europe) made *aliyah*, "going up" to Jerusalem and to the "land of their forefathers". The number of immigrants arriving each year steadily increased and would rise yet further as the tide of anti-Semitism escalated in Europe.

The dawn of Zionism

Before the first Zionist Congress (held at Basle in Switzerland in 1897), there had been some discussion as to whether Jewish people might set up an independent state in Africa or South America. But Palestine – with its biblical resonances – soon emerged as the obvious choice. Even so, the vast majority of those first generations of Jewish settlers seem to have been inspired chiefly by political and practical considerations, and not so much by strictly religious arguments. At this point, Orthodox Jews tended to see any state of Israel as only coming about through the agency of the Messiah – not through ordinary political and social events. It was therefore left to Jews who were more "liberal" or even confessedly "secular" to do the hard work of resettling the land.

And it was hard work. Much of the land had become barren – left undeveloped by absentee landlords. The Huleh Valley (north of Lake Galilee) was a low-lying marsh area, perpetually prone to malaria; but over the years – helped eventually by eucalyptus trees from Australia that soaked up the water – it was gradually and painstakingly reclaimed. *Kibbutzim* (or collective farms) grew up all over the country – encouraging the hard work of farming the land; some were set up in arid areas on the edge of the desert. Meanwhile Tel Aviv was founded (at a public meeting on the beach) in 1909 and began a meteoric expansion; other coastal cities (such as Haifa and Ashkelon) followed suit.

Arab responses

Through much of the nineteenth century relationships between Jews and Arabs had been quite positive. However, after the end of Islamic Ottoman rule, Muslims in particular began to view this resurgent power within the ranks of Judaism with increasing concern. Where was it heading? It was one thing to extend a welcome to hard-working immigrants, but quite another to see them, step by step, gradually take over the Land you considered to be yours.

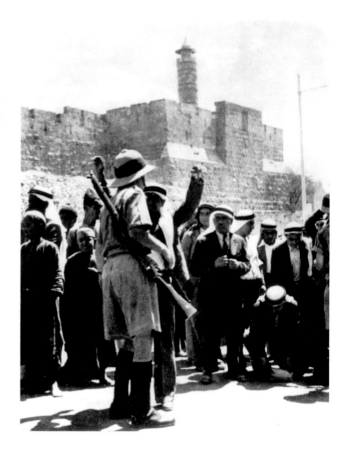

Perhaps not surprisingly, then, during the 1920s there were political uprisings as the Arabs began to protest at this potential take-over bid. The British army had to use force to quell the riots (notably in 1920 and 1929). Things got steadily worse thereafter, with an extended Arab revolt in 1936 and 1937. Then came the challenges of World War II, with the horrific realities of the Holocaust and the need for a safe haven for Jewish refugees. The simmering pot within Palestine was about to explode. When British officials were killed in the bombing of the King David Hotel in 1946 (a plot devised by the Irgun, a Jewish paramilitary group), it was clear the British were losing their grip on the situation. Not surprisingly, in 1947 they announced their intention to pull out of Palestine.

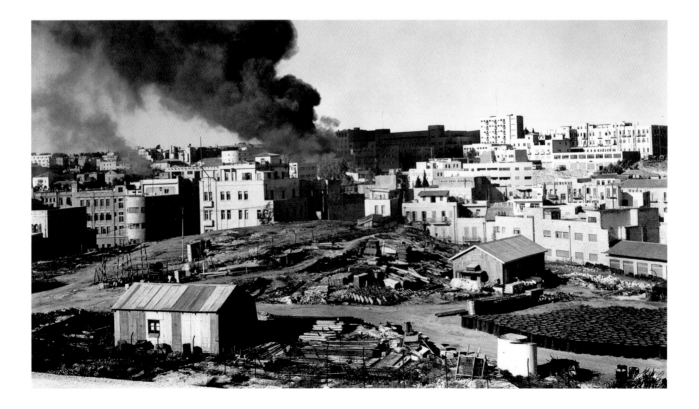

The United Nations had to decide what would happen next. Once Britain walked away, then clearly (or so they thought) sovereignty would have to be given to two independent states, one Jewish and one Arab. In the end their Partition Plan (of November 1947) granted some 54 per cent of "Mandate Palestine" to the Jews (who at that time owned under 10 per cent of the land). However, even though much of this land was desert (the Negev going down to Eilat), this percentage looked excessive to the Arabs, who still made up 65 per cent of the population.

Top left: A British soldier searching an Arab demonstrator outside the Jaffa Gate (1938).

Bottom left: An explosion near the Jaffa Road in the 1930s.

Below: 2,700 "illegal" Jewish immigrants on board *The Guardian*, awaiting their eventual disembarkation at Haifa (April 1947).

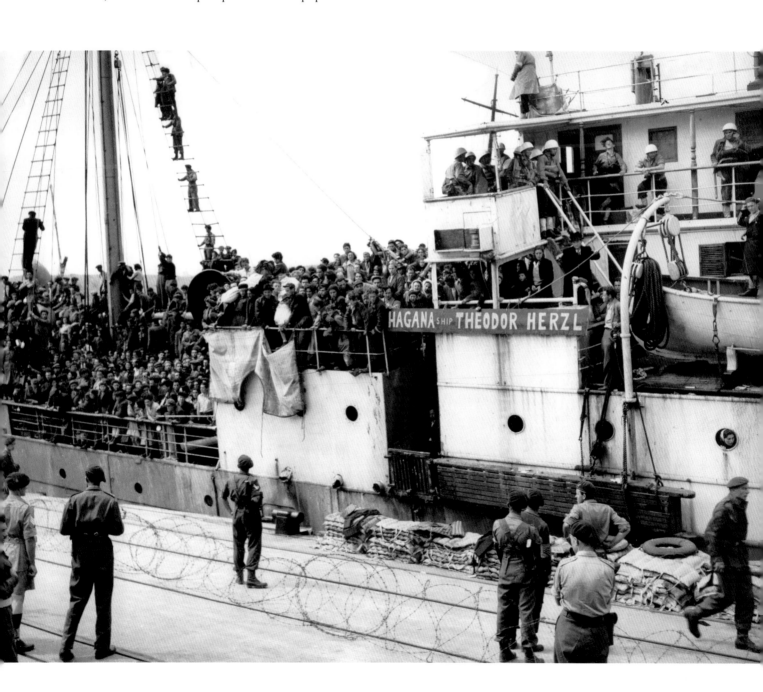

The British depart

In the end, perhaps inevitably, the matter could not be resolved diplomatically. Both sides had been arming themselves and were now waiting for the British to leave – at midnight on Friday 14 May 1948. Earlier that day the British Union Jack flag was ceremoniously lowered from Government House in Jerusalem, and the High Commissioner was escorted to safety. That afternoon, in a room in Tel Aviv, David Ben Gurion

Right: The King David Hotel back in 1932 (*foreground*), with the YMCA and the sparse buildings of "West" Jerusalem beyond.

Below: Despite the growing tensions, Arabs and Jews continue to share the streets of the Old City into the 1940s.

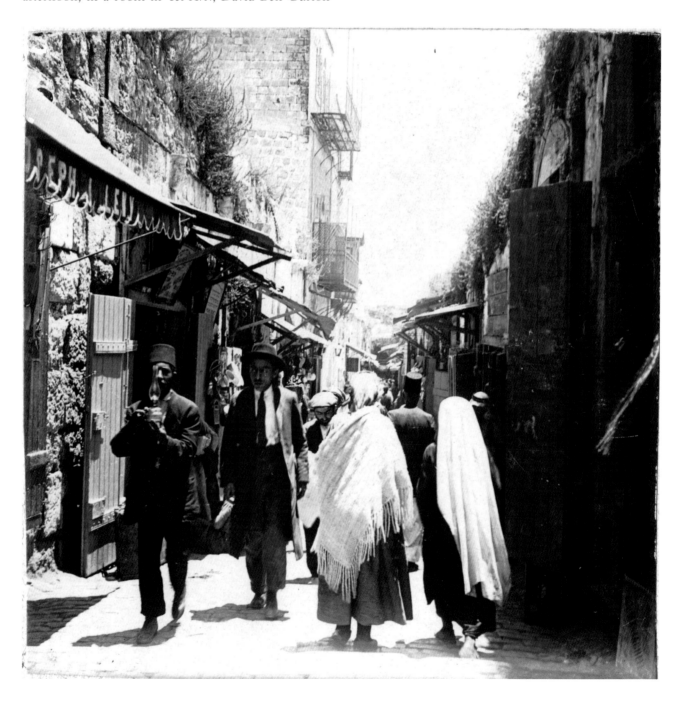

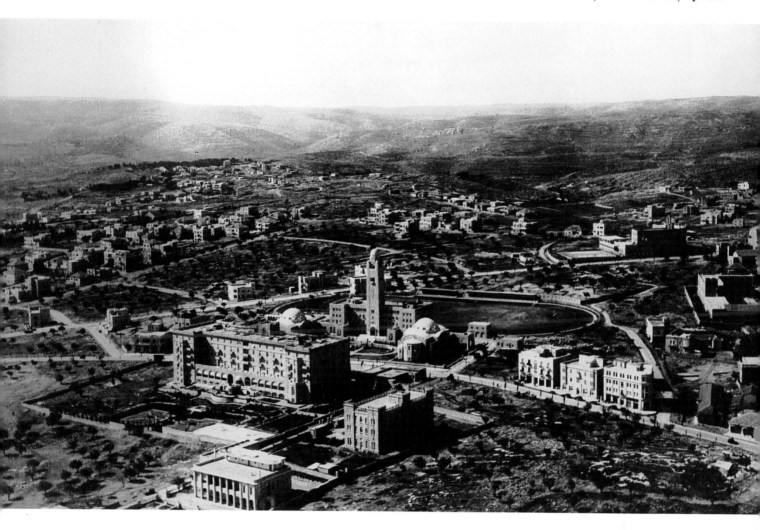

declared the start of the independent state of Israel. Within hours fighting broke out throughout the Land. In due course some 700,000 Arabs would flee for their lives (some to Jericho, others to Jordan or Lebanon), running from their homes and abandoning over 400 towns and villages to Israeli control. When at last there was a ceasefire, 78 per cent of the Land was within the borders of Israel. The remaining area included the Gaza strip (taken over by the Egyptians) and the West Bank of the River Jordan, which now came under Jordanian control.

Yet, crucially, this Jordanian control included the Old City of Jerusalem. Israelis only controlled *West* Jerusalem. So there was a narrow strip of land – a no man's land – bisecting the city. This "green-line" ran immediately adjacent to some of the Old City walls, causing several city gates to be locked up.

Entering the city

One of these gates was that same Jaffa Gate, opened to larger traffic exactly fifty years before. The question was: When would the gate next be opened? Who would then be in control of Jerusalem? And, once inside, how would they share this beautiful prize – this crowning jewel in the centre of the Land – with those who, in this endless battle for Jerusalem, had just lost?

YAD VASHEM HOLOCAUST MEMORIAL: A candle's reflection for every lost child…

SINCE THEN...

Since that year, 1948, so much has happened. The long, sometimes slow, story of the Holy Land now rushes on at an alarming pace: books about it are being written each year, because history is being made each day.

During this last century there has been so much pain and human conflict – two world wars, the Holocaust, and other genocides. And the Holy Land, far from being spared this pain, has instead been something of a microcosm of the world's ills, playing host to an ongoing conflict that reflects the tragedy of the human condition – our inability to live together in peace and harmony.

Two main people groups – both with long histories and high hopes – find themselves locked together in a struggle to share a small stretch of land whose history (both religious and political) means so much to both of them and upon which they pin their respective hopes for the future.

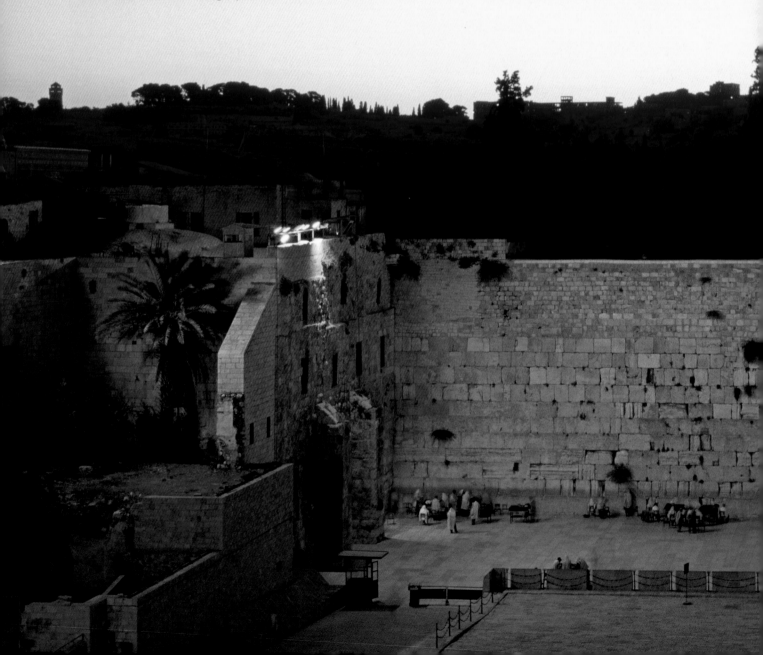

There has been a struggle for survival, a desire to be independent of the other; and in such struggles, deep wounds have been inflicted, deep wounds received. Too often tragedy has been compounded by tragedy. In such situations there seem to be few, if any, victors – only victims.

And at the centre there stands Jerusalem. Its Hebrew name means "the City of Peace". However, in the words of Jesus as he wept over the city, this *Yeru-Shalaim* seems not – either then or now – to "know the things which belong to its peace". Will it ever become in reality what its name promises?

Moreover, Jerusalem's very skyline (with its minarets and towers; with its synagogues, churches, and mosques) reflects its historic significance to people of different faiths. Jew, Muslim, and Christian alike – each looks back on the city's past through a different lens. Each has hopes for the city's future story. Yet these hopes are inspired by different narratives and therefore have points of conflict with one another. How will these different perspectives ever be resolved?

...

Below: As the sun rises, people gather at the Western Wall to pray (with the churches on the Mount of Olives beyond).

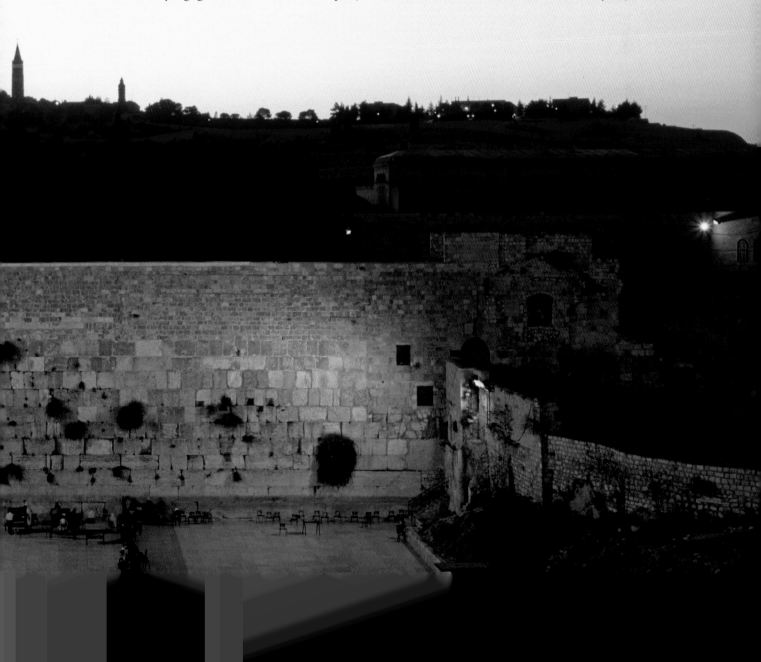

In such circumstances a natural response might be cynicism or even despair. Is that, then, the ultimate moral to be drawn from this review of the Holy Land's long story?

Perhaps, instead, we should return to the story's beginning and, as it were, start out all over again by going back to that figure of Abraham (a figure upheld in all three of these monotheistic faiths), and by noting once more his faith, as well as his practice.

Abraham looked out on this Land – to the north and south, east and west – with eyes of faith in his God and with an attitude of hope for the future. This Land, so he believed, would be a place of fulfilled promises, of historic destiny, of divine activity – and thus a place from which many blessings would flow out to the whole world. And in this regard, who can say that he was wrong?

In the meantime he also determined to conduct himself appropriately in such an awesome landscape – for example, we are told how he paid the proper price to the local inhabitants for the plot that would mark his own grave (Genesis 23). If this was to be a "holy" land, then this might demand – from Abraham as well as from its future inhabitants – more "holiness", not less.

Yet Abraham might well have wondered too about the more distant future:

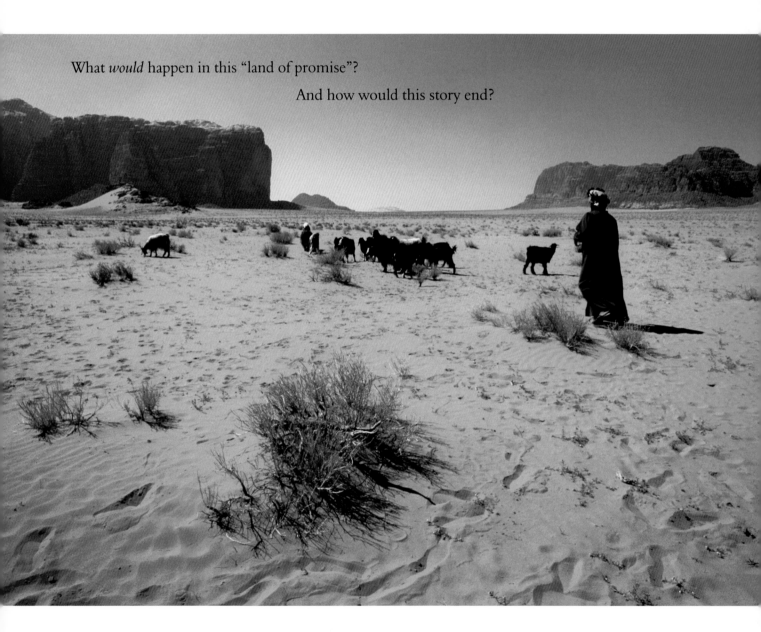

What *would* happen in this "land of promise"?

And how would this story end?

The same questions can be ours as we also look around the Land today: to the west, Tel Aviv…

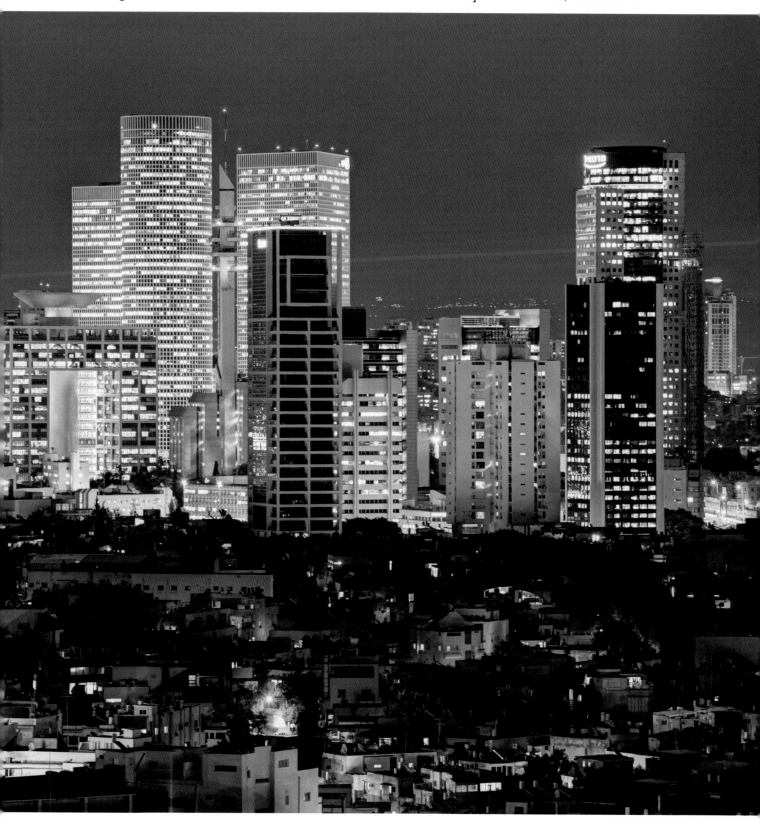

to the north, Nazareth…

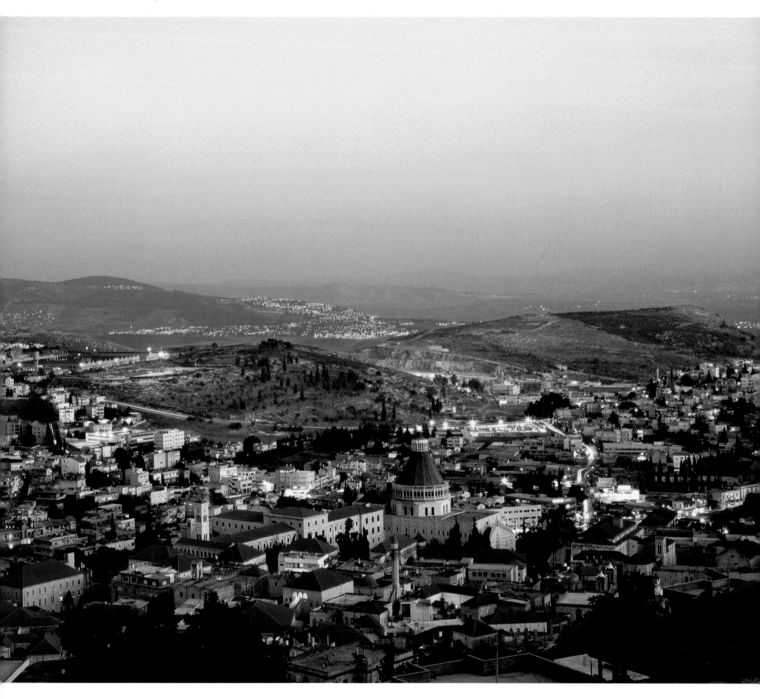

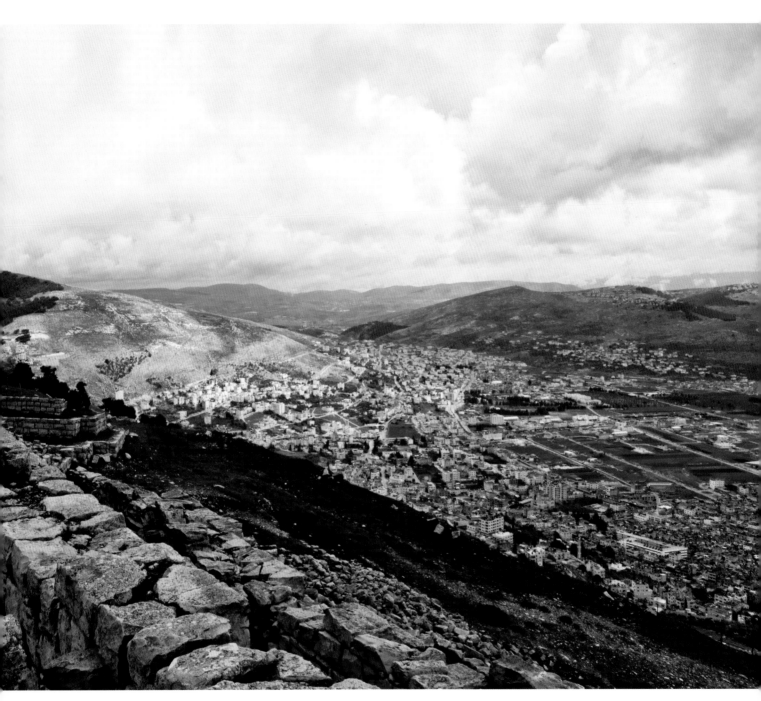

to the east, Nablus…

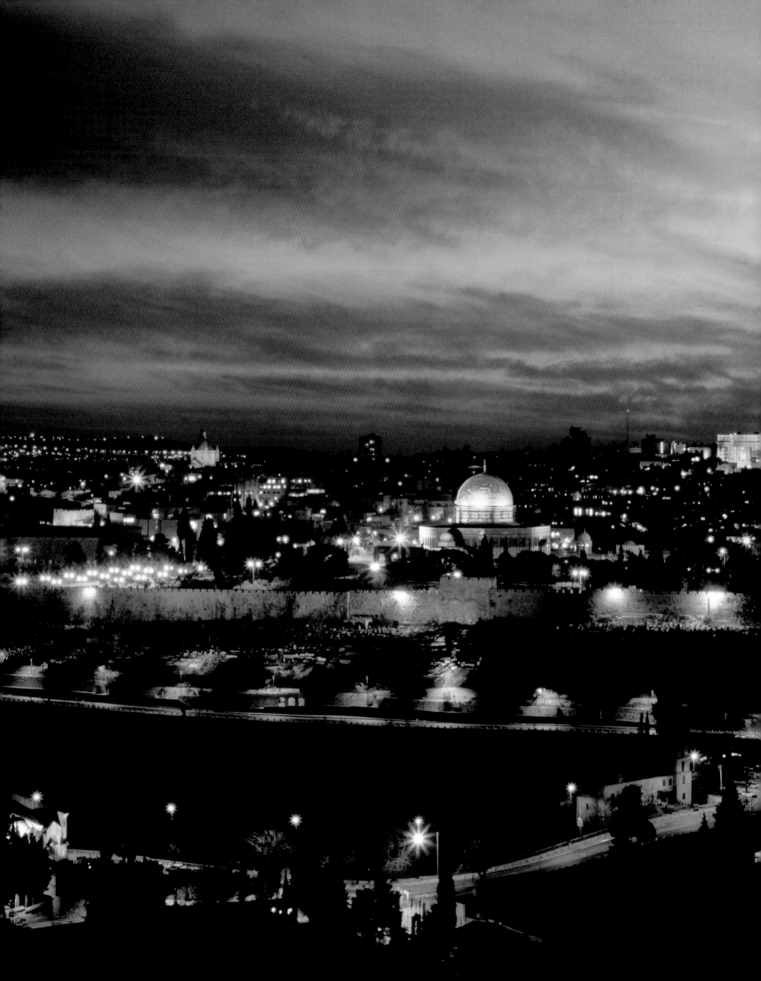

… and in the centre, Jerusalem.

Looking around the Land – with all its simmering contrasts – we cannot but wonder:
yes, how *will* this great, age-long story reach its end?

THE STORY OF THE HOLY LAND…

FOR FURTHER READING

Y. Aharoni, *The Land of the Bible: A Historical Geography* (London: Burns & Oates, 1967; revised 1979)

M. Avi-Yonah, *The Jews of Palestine: A Political History from the Bar Kokhba War to the Arab Conquest* (Oxford: Clarendon, 1976)

Y. Ben-Arieh, *Jerusalem in the 19th Century: The Old City* (Jerusalem: Ben Zvi, 1984)

J. Bright, *A History of Israel* (3rd edn, Philadelphia: Westminster Press, 1981)

M. Gil, *A History of Palestine, 634–1099* (Eng. trans. from Hebrew, Cambridge: Cambridge University Press, 1992)

O. Grabar, *The Shape of the Holy: Early Islamic Jerusalem* (Princeton: Princeton University Press, 1996)

K. A. Kitchen, *On the Reliability of the Old Testament* (Grand Rapids: Eerdmans, 2003)

L. I. Levine, *Jerusalem: Portrait of the City in the Second Temple Period* (538 B.C.E. – 70 C.E.) (Philadelphia: Jewish Publication Society, 2002)

A. Millard, *Treasures from Bible Times* (Tring: Lion, 1985)

S. S. Montefiore, *Jerusalem: The Biography* (London: Orion, 2011)

J. Murphy O'Connor, *The Holy Land: An Archaeological Guide* (5th edn, Oxford: Oxford University Press, 2008)

J. Prawer, *The Latin Kingdom of Jerusalem: European Colonialism in the Middle Ages* (London: Weidenfeld & Nicholson, 1972)

S. Runciman, *A History of the Crusades* (3 vols, Cambridge: Cambridge University Press, 1951, 1952, 1956)

P. W. L. Walker, *Holy City, Holy Places? Christian Attitudes to Jerusalem and the Holy Land in the Fourth Century* (Oxford: Oxford University Press, 1989)

P. W. L. Walker, *Jesus and the Holy City: New Testament Perspectives on Jerusalem* (Grand Rapids: Eerdmans, 1996)

P. W. L. Walker, *In the Steps of Jesus: An Illustrated Guide to the Places of the Holy Land* (Oxford: Lion Hudson, 2006)

R. T. Wilken, *The Land Called Holy: Palestine in Christian History and Thought* (New Haven: Yale University Press, 1992)

J. Wilkinson, *Jerusalem as Jesus Knew It: Archaeology as Evidence* (London: Thames & Hudson, 1978)

For English translations of primary texts: see Josephus, *Antiquities of the Jews* and *The Jewish War* by William Whiston (1737); see Eusebius of Caesarea, *Church History* by Kirsopp Lake (1926) and *Life of Constantine* by E. H. Gifford (1903); and see Cyril of Jerusalem, *Catechetical Lectures* by L. McCauley and A. Stephenson (1969, 1970).

Published by Lion Books
an imprint of
Lion Hudson plc
Wilkinson House, Jordan Hill Road,
Oxford OX2 8DR, England
www.lionhudson.com/lion

ISBN 978 0 7459 5582 7

First edition 2013

Acknowledgments
Unless otherwise noted, scripture quotations taken from the Holy Bible, Today's New International Version. Copyright © 2004 by International Bible Society. Used by permission of Hodder & Stoughton Publishers. A member of the Hachette Livre UK Group. All rights reserved. "TNIV" is a registered trademark of International Bible Society.

Scripture quotations marked RSV are from The Revised Standard Version of the Bible copyright © 1346, 1952 and 1971 by the Division of Christian Education of the National Council of Churches in the USA. Used by permission. All Rights Reserved.

Scripture quotations marked NRSV are from The New Revised Standard Version of the Bible copyright © 1989 by the Division of Christian Education of the National Council of Churches in the USA. Used by permission. All Rights Reserved.

A catalogue record for this book is available from the British Library

Printed and bound in China, June 2013, LH06

ACKNOWLEDGMENTS

How long does it take to write a book? In one sense this book, compared with others I have written, took the shortest time: perhaps thirty working days between late June and early October 2012, while in a time of transition (from Oxford to Pittsburgh, via Jerusalem and Cyprus!). I am so grateful for the help and support I received during that time: from my travelling companion in Jerusalem, Tim, and from those who gave much help there with the selection of photos (especially Jean-Michel Tarragon and Garo); from our friends in Cyprus (who had travelled with me to the Holy Land in 2011) and those who read the manuscript in its first drafts (my daughter Hannah, then Ali and Miranda, and Professor Alan Millard); from my colleagues in "design" at Lion Hudson (Margaret, Jessica, Jude, and Jonathan); and especially from my wife, Georgie.

Yet in another sense, this book took longer than any other. Ever since my first visit to Jerusalem over thirty years ago, this Land has occupied my attention: four full years of research into Byzantine pilgrimage to the Holy Land; three years of research on New Testament attitudes towards Jerusalem; a summer spent investigating nineteenth-century Jerusalem; over fifteen years of teaching biblical theology in Oxford; and (perhaps most instructive of all) four successive summers meeting with Israelis and Palestinians to look together at the hard issues of the Bible's teaching on the Land. In *this* sense, this book took not thirty days, but thirty years! So the words may be quite few, but perhaps here they are indeed the "tip of the iceberg" of what *might* have been written.

A first glance at this book will immediately reveal that the words are fewest for the period since 1948. A decision was made at the outset of this project – both because of the sheer number of modern photos and because of the massive complexity of these last sixty years – that this would be a book which made no attempt to describe recent and contemporary events. Not, of course, because they are not important, but because the purpose of this book is different: its aim is to give an accessible, but brief, account of the *age-long* history of the Holy Land. Much of this detail is little known, and all of it can serve as a useful springboard of shared history, allowing us to come to terms with the demands of the present complex situation. This means, then, that informed choices can be made about how we can build for the future.

This book is dedicated to Hannah and Jonathan, my daughter and son, and to Jen and David, my sister and brother. *Fewer words, more pictures: hopefully, then, more reading, fewer excuses!*

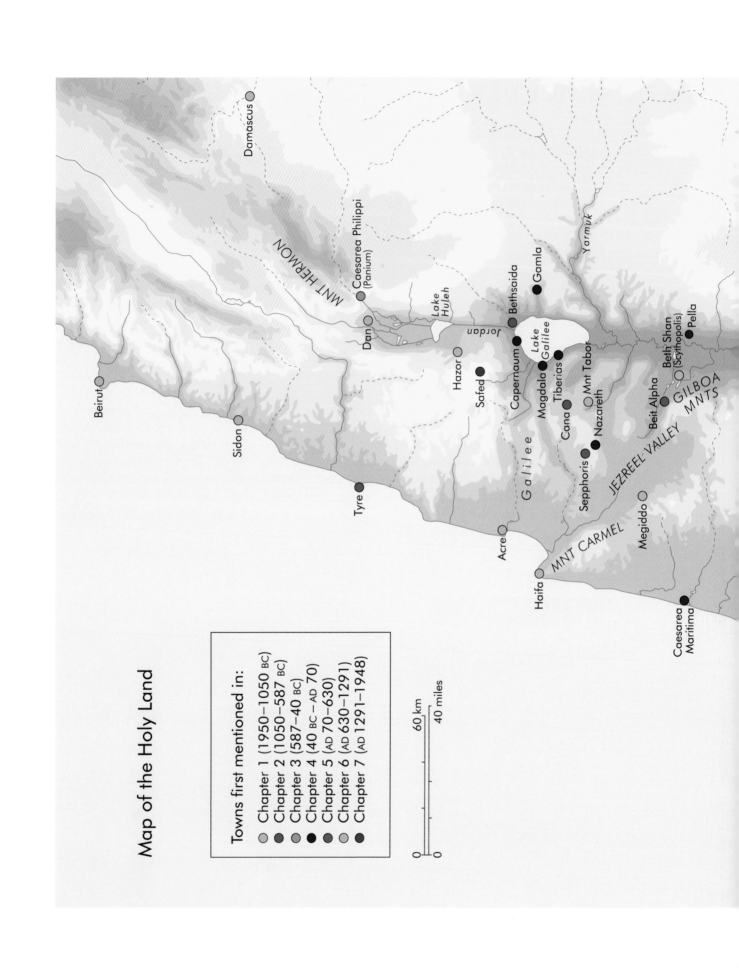

Map of the Holy Land

Towns first mentioned in:
Chapter 1 (1950–1050 BC)
Chapter 2 (1050–587 BC)
Chapter 3 (587–40 BC)
Chapter 4 (40 BC – AD 70)
Chapter 5 (AD 70–630)
Chapter 6 (AD 630–1291)
Chapter 7 (AD 1291–1948)

60 km
40 miles

Damascus

Caesarea Philippi
(Panium)

MNT HERMON

Dan

Lake
Huleh

Jordan

Bethsaida

Gamla

Yarmuk

Beth Shan
(Scythopolis)

Pella

Lake
Galilee

Capernaum

Magdala

Tiberias

Mnt Tabor

Hazor

Safed

Cana

Nazareth

Beit Alpha

GILBOA
MNTS

Beirut

Galilee

Sepphoris

JEZREEL VALLEY

Sidon

Tyre

Megiddo

Acre

MNT CARMEL

Haifa

Caesarea
Maritima

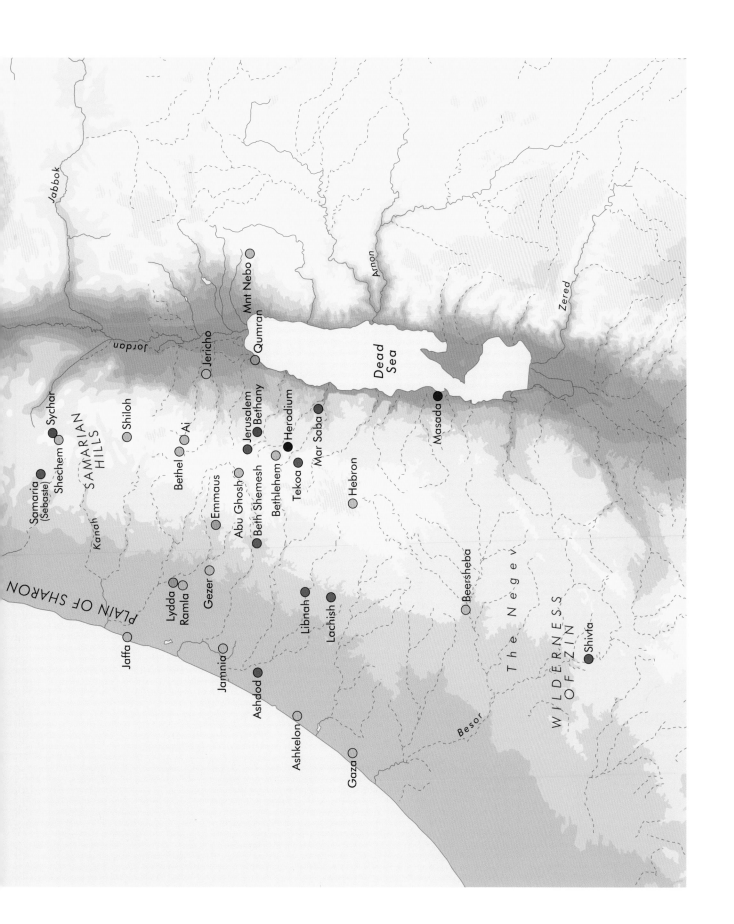

PICTURE ACKNOWLEDGMENTS

Alamy: pp. 28, 128 Israel images; pp. 40, 49b, 65tl, 80, 96m, 99t, 99b, 136 BibleLandPictures; p. 51 Eddie Gerald; pp. 60–61, 66–67 Duby Tal/Albatross; p. 64 Peter Horree; p. 78 Jon Arnold Images Ltd; pp. 122–23 LOOK Die Bildagentur der Fotografen GmbH; pp. 124–25 Dimitry Bobroff; pp. 132–33 Hanan Isachar; p. 169 Yagil Henkin – Images of Israel

Art Archive: p. 14 Jane Taylor; p. 19b Stephanie Colasanti; p. 23tr Gianni Dagli Orti; p. 55t Archaeological Museum Cividale Friuli/Gianni Dagli Orti (Hebrews weeping by the river of Babylon, thirteenth century Gothic manuscript, Beatae Elisabeth Psalter); pp. 82t, 83 Culver Pictures; p. 145 American Colony Photographers/NGS Image Collection

BibleWalks.com: pp. 52–53, 111t

Bridgeman: pp. 96b, 140–41

Corbis: p. 24; pp. 6–7, 80–81, 131b Richard T. Nowitz; p. 15t Michael S. Yamashita; p. 18 Archibald Forder/National Geographic Society; p. 25t Radius Images; p. 44t National Geographic Society; p. 54 Frederic Soltan/Sygma; p. 55b Ed Darack/Science Faction; p. 60 Tetra Images; p. 74 Bojan Brecelj; pp. 74–75 Nathalie Darbellay; pp. 101, 114–15 Jon Hicks; p. 105t Remi Benali; p. 142 Rieger Bertrand/Hemis; p. 148 Stapleton Collection; p. 168 Atlantide Phototravel

École Biblique: pp. 147t, 147b, 150–51, 151, 152b, 153, 155t, 156, 157, 158b, 160 own collection; pp. 146, 149t, 149b, 155b Notre Dame de France

Garo Nalbadian: pp. 58, 62, 63t, 79t, 97, 106, 106–107, 110, 113, 118–19, 119, 120t, 120b, 134t, 134b, 164–65, 170–71, 176

Getty: pp. 8–9 Planet Observer; p. 22 Travel Ink; pp. 72, 73 Michael Melford; pp. 92–93 After David Roberts (*The Destruction of Jerusalem in 70 AD*, engraved by Louis Haghe, 1806–85); p. 105b Zoran Strajin; pp. 162–63 Bill Raften; p. 166 Mark Daffey; p. 167 Gavin Hellier

Hanan Isachar: pp. 26, 29b, 36, 37t, 56–57, 85b, 98t, 108, 109, 111b, 112t, 131t

iStock: p. 133 Ora Turunen

Jonathan Clark: p. 75

Lebrecht: pp. 23tl, 66tl prismaarchivo; p. 48r Z. Radovan

Nazareth Village: p. 79b

Pantomap Israel Ltd: p. 143

Peter Walker: pp. 82b, 126

Richard Watts: pp. 174–75

Shutterstock: pp. 26–27 Peter Zaharov; p. 90t Ariy

Sonia Halliday: pp. 16t, 20–21, 38–39, 45t, 88, 102–103, 122b, 135, 136–37, 161

SuperStock: pp. 2–3 Cubo Images; pp. 4–5, 31b Hanan Isachar; p. 37bl DeAgostini; p. 114 PhotoStock-Israel/age footstock; p. 122t Christie's Images Ltd; p. 127 Spaces Images; p. 129 Robert Harding Picture Library; p. 130 Design Pics

The Garden Tomb, Jerusalem: p. 85t

Topfoto: pp. 121, 154, 158t, 159; pp. 12–13, 15b, 30, 31tr, 32, 32–33, 34–35, 41, 42–43, 44–45, 46, 47t, 47b, 48l, 49r, 64–65, 68–69, 70–71, 76, 77, 86–87, 89, 91, 94–95, 98b, 104, 112b, 116–17, 121, 138–39, 144 Duby Tal/Albatross; pp. 19tr, 59b, 144 The Granger Collection; p. 59t Spectrum/HIP; p. 84 AA World Travel Library; p. 152t Ullsteinbild; p. 173 Robert Piwko

Zev Radovan: pp. 16b, 17, 25b, 29t, 33, 37br, 50t, 50b, 63b, 65ml, 66tr, 87tl, 87br, 90b, 100